comic artist's photo reference

Women and Girls

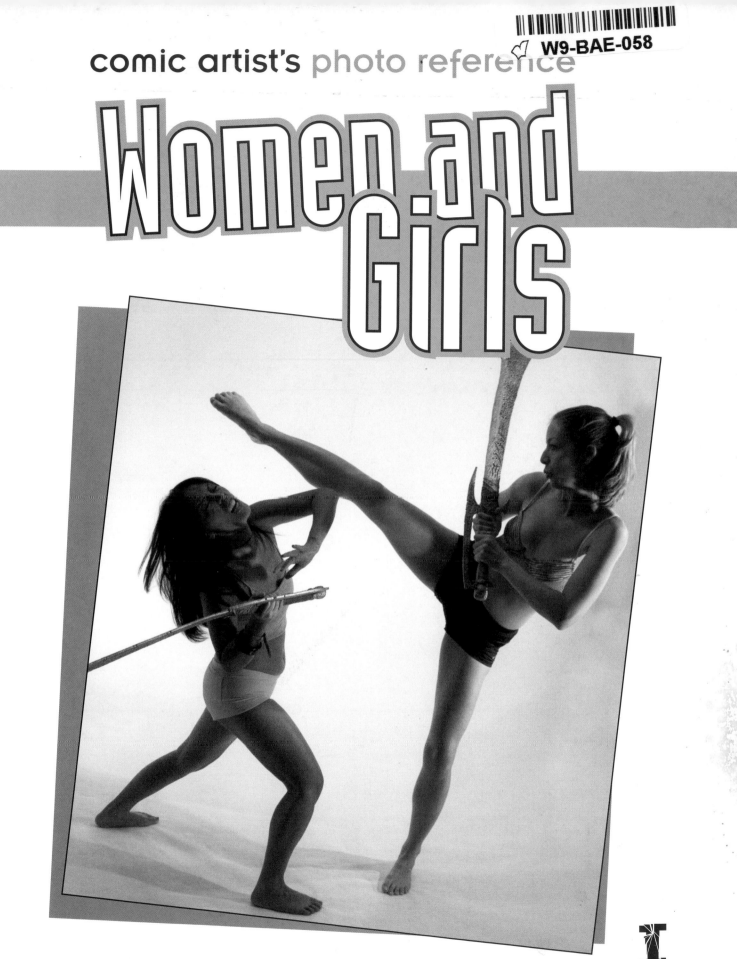

Buddy Scalera

IMPACT

CINCINNATI, OHIO
www.impact-books.com

Comic Artist's Photo Reference: Women and Girls.

Other fine IMPACT Books are available from your local bookstore, art supply store or direct from the publisher at www.fwpublications.com.

12 11 10 09 08 5 4 3 2 1

Distributed in Canada by Fraser Direct
100 Armstrong Avenue
Georgetown, ON, Canada L7G 5S4
Tel: (905) 877-4411

Distributed in the U.K. and Europe by David & Charles
Brunel House, Newton Abbot, Devon, TQ12 4PU, England
Tel: (+44) 1626 323200, Fax: (+44) 1626 323319
Email: postmaster@davidandcharles.co.uk

Distributed in Australia by Capricorn Link
P.O. Box 704, S. Windsor NSW, 2756 Australia
Tel: (02) 4577-3555

Library of Congress Cataloging-in-Publication Data

Scalera, Buddy
 Comic artist's photo reference : women and girls / by Buddy Scalera. -- 1st ed.
 p. cm.
 Includes index.
 ISBN-13: 978-1-60061-003-5 (pbk. : alk. paper)
 1. Women--Caricatures and cartoons. 2. Comic books, strips, etc.--
Technique. 3. Drawing from photographs--Technique. I. Title.
NC1764.8.W65S32 2008
741.5'1--dc22
 2007048253

Edited by Amy Jeynes
Production edited by Mary Burzlaff
Cover and interior design by Terri Woesner
Page layout by Kelly Piller
Production coordinated by Matt Wagner

Metric Conversion Chart

To convert	to	multiply by
Inches	Centimeters	2.54
Centimeters	Inches	0.4
Feet	Centimeters	30.5
Centimeters	Feet	0.03
Yards	Meters	0.9
Meters	Yards	1.1

about the author

Buddy Scalera is a writer, editor and photographer. He is the author of the bestselling *Comic Artist's Photo Reference: People and Poses* (IMPACT Books, 2006). Scalera is also known for his bestselling photography CD-ROM series, *Visual Reference for Comic Artists,* and for his writing work on Marvel Comics' *Deadpool*, *Agent X* and *X-Men Unlimited*. He has written and self-published several comic books, including *Necrotic: Dead Flesh on a Living Body* and *7 Days to Fame*. Buddy was the creator and editor of Wizard Entertainment's WizardWorld.com and Wizard-School.com websites. He continues to work as an interactive multimedia developer in the entertainment industry. Visit his website, www.buddyscalera.com.

acknowledgments

Special thanks to Dad for letting me convert your garage into a studio. I owe you dinner.

thank you to . . .

. . . Chanel, Sarah, Pamela, Vanessa, Loukas and Veronica, who spent hours under hot lights to make sure we got the shots.

. . . JG Jones, Jamal Igle, Josh Howard and Terry Moore for doing these outstanding demos. I appreciate your time, effort and professionalism. Thank you.

. . . Guy Kelly and Terri Woesner for the inspired designs.

. . . Pam Wissman for giving me a chance to work with IMPACT. You made all of this possible, and I thank you.

. . . Amy "The Professor" Jeynes for finding ways to make everything better. We make a good team.

dedication

To Janet.
You are my best friend, and I am lucky to have you.

To Danielle and Nicole.
Laugh, sing, dance and dream. Daddy and Mommy love you no matter what. Unconditionally and forever.

To Dad and Mom.
Thank you for a lifetime of inspiration, guidance and support.

table of contents

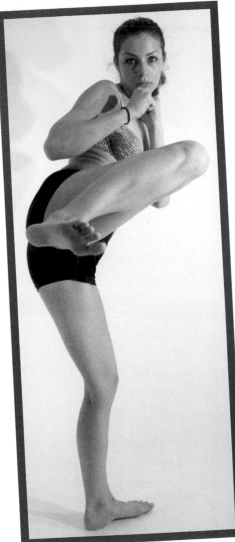

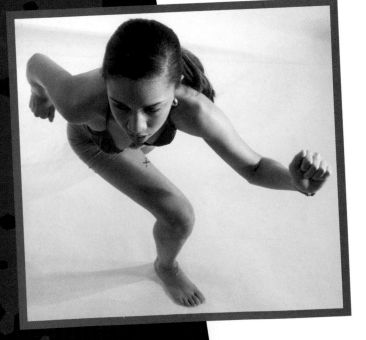

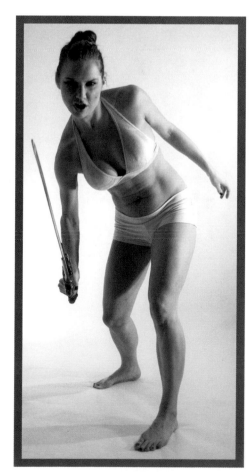

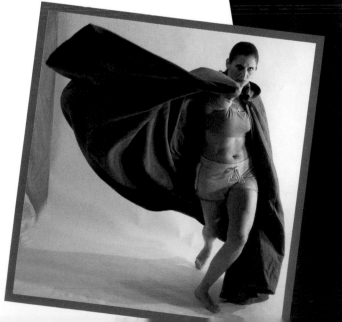

Chanel

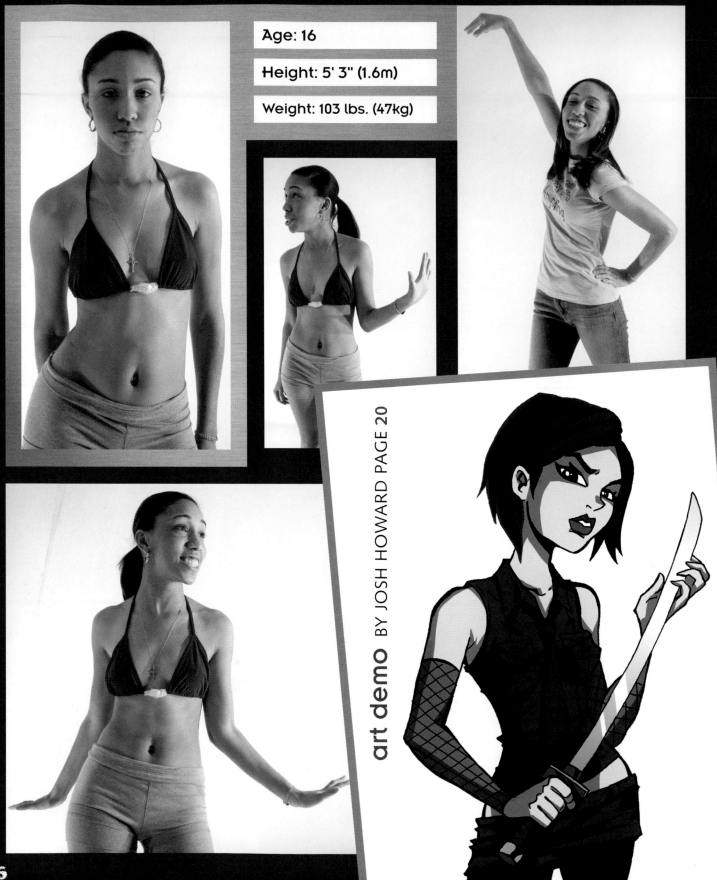

Age: 16

Height: 5' 3" (1.6m)

Weight: 103 lbs. (47kg)

art demo BY JOSH HOWARD PAGE 20

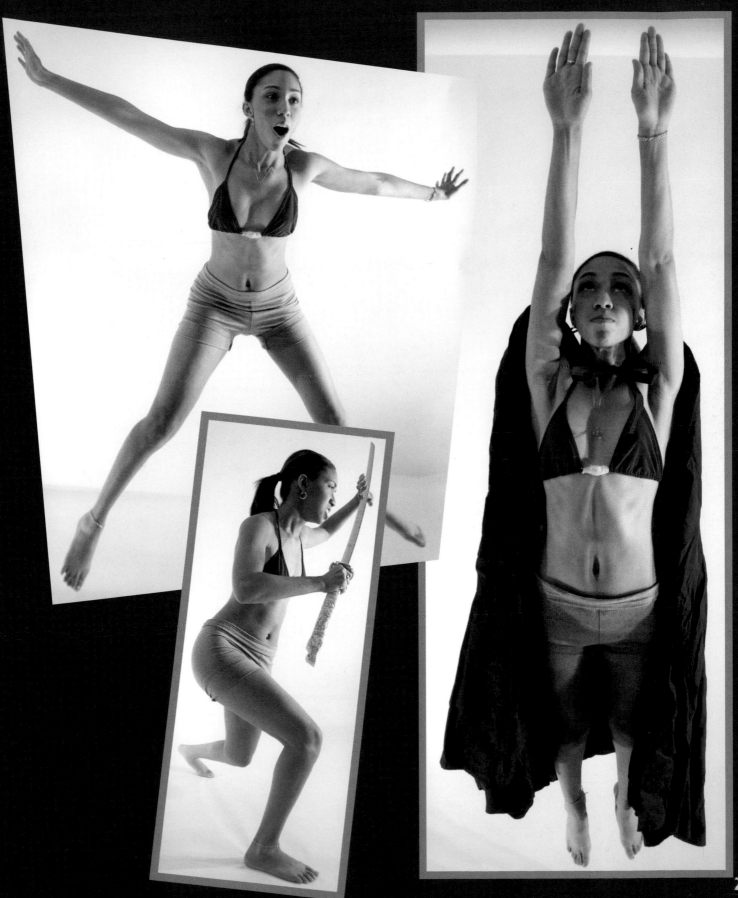

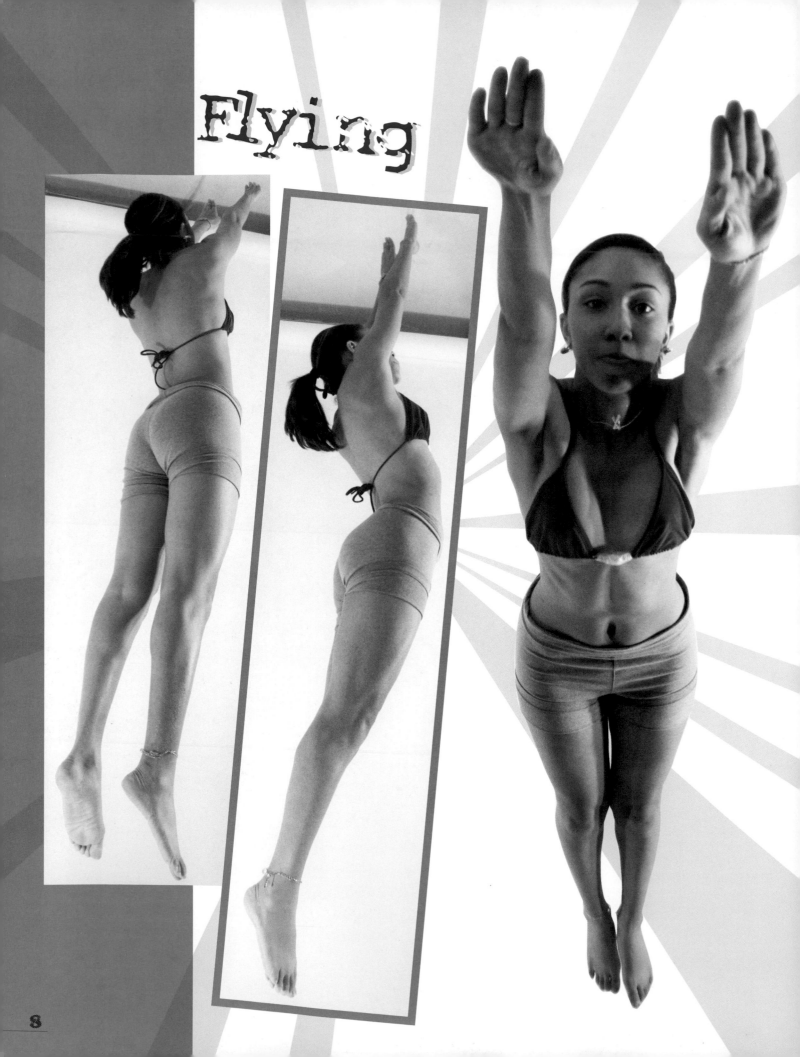

Flying

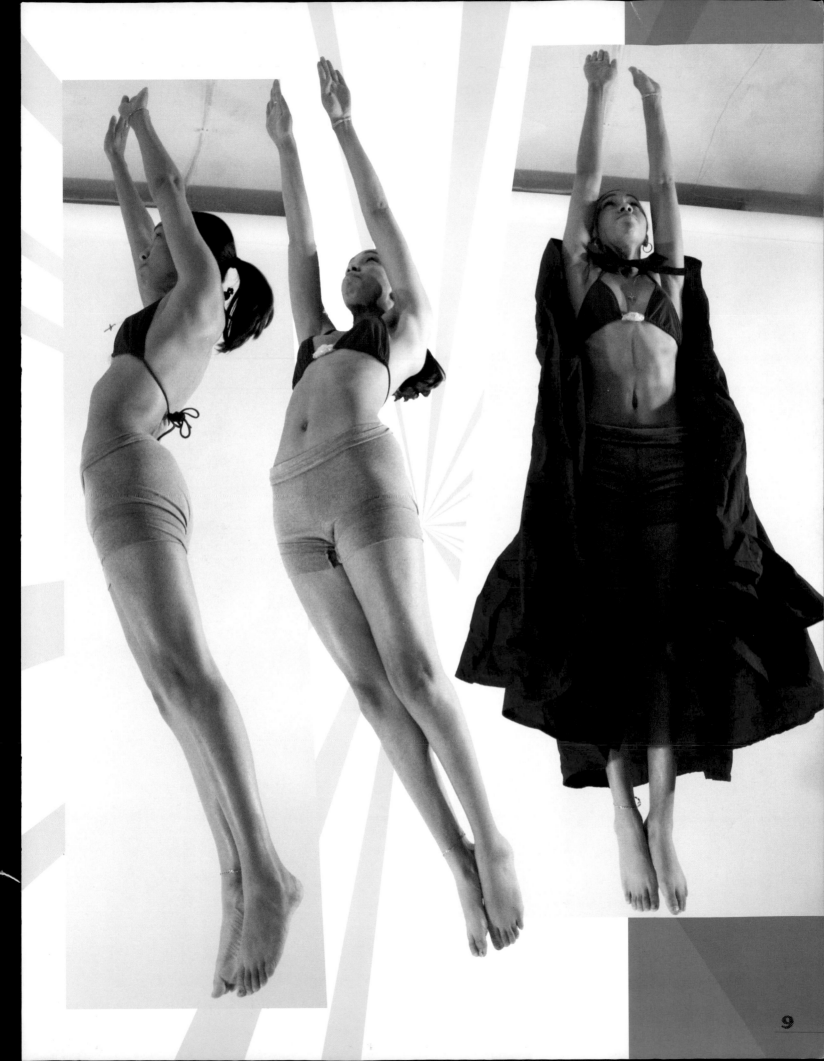

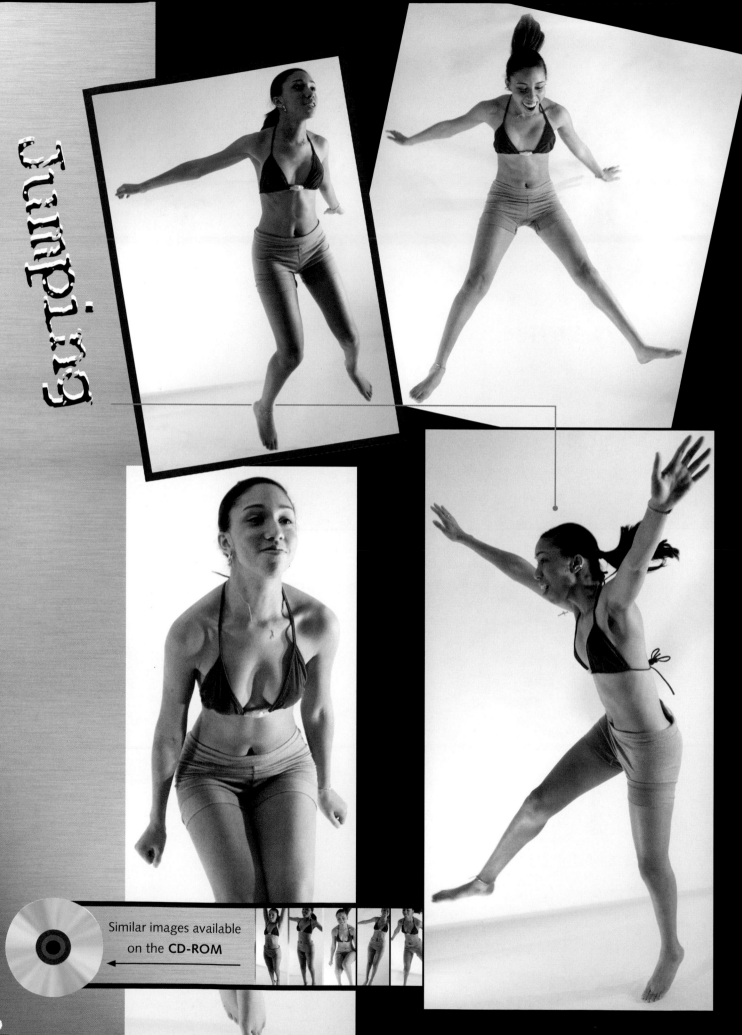

Jumping

Similar images available on the **CD-ROM**

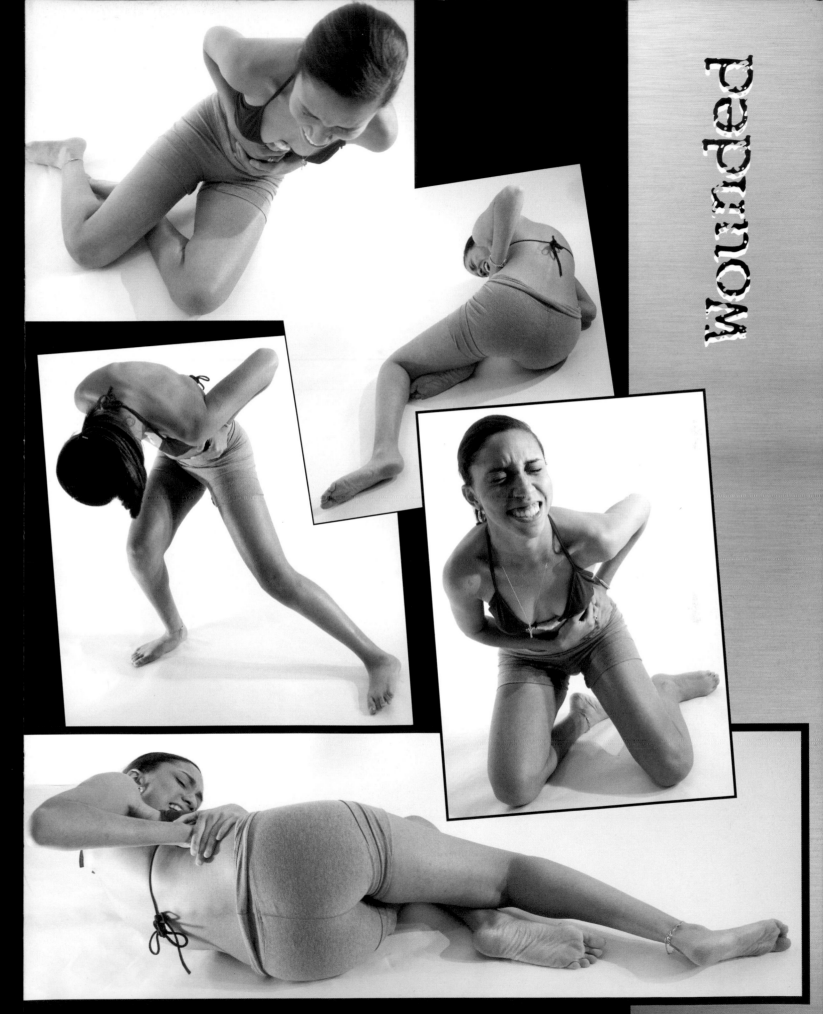

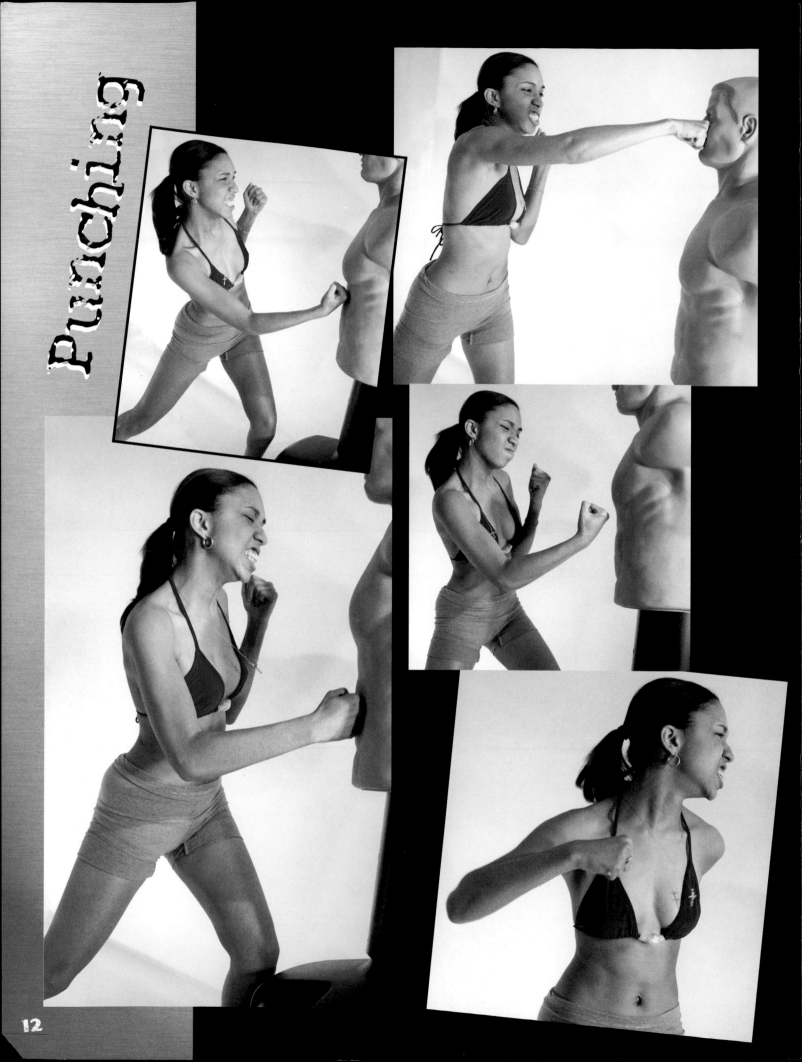

Punching

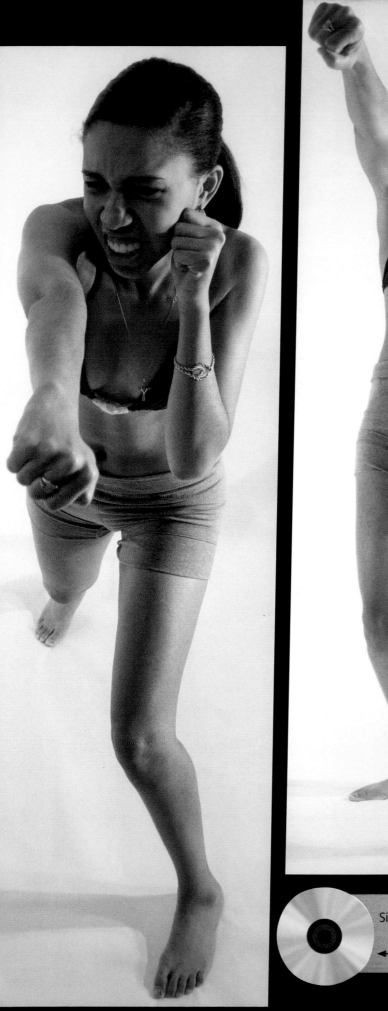

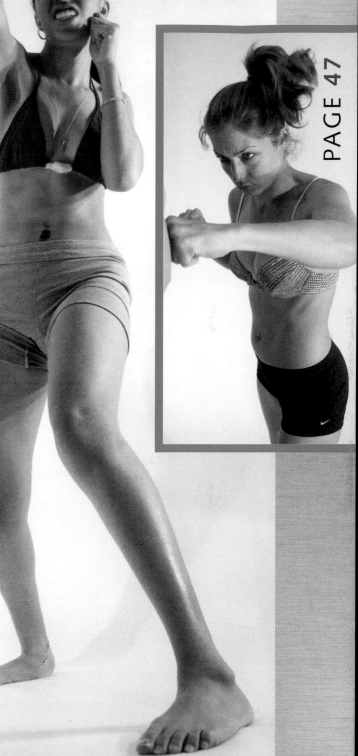

Similar images available on the **CD-ROM**

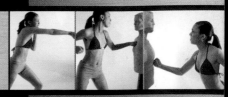

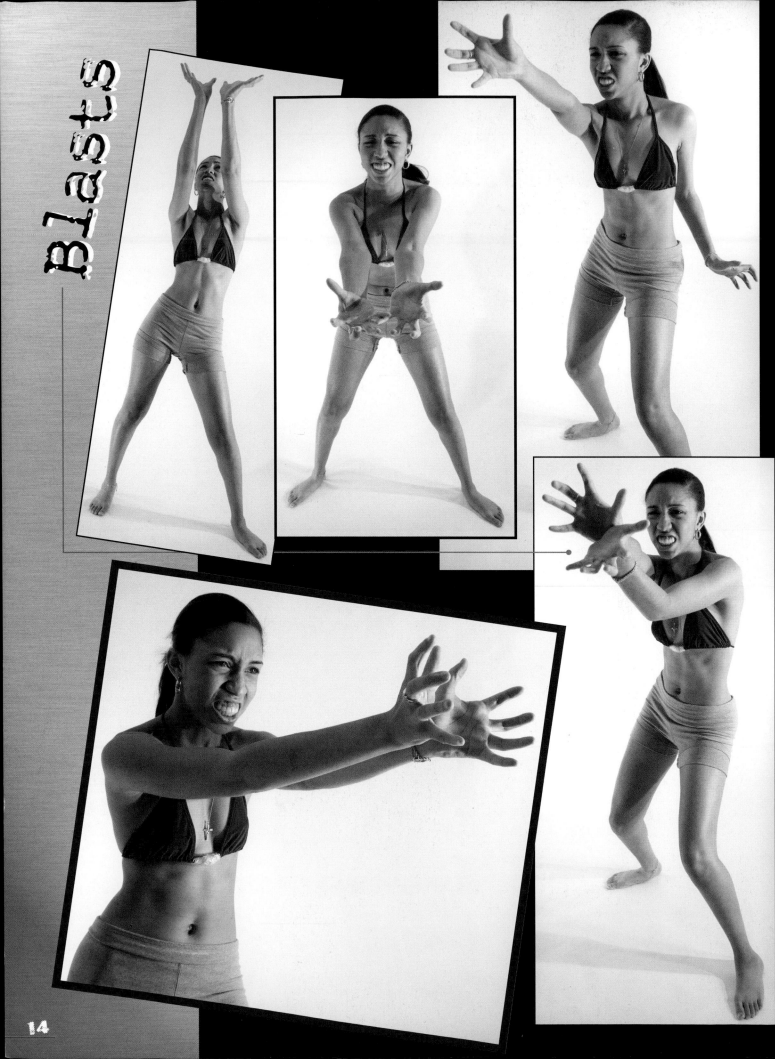

Blasts

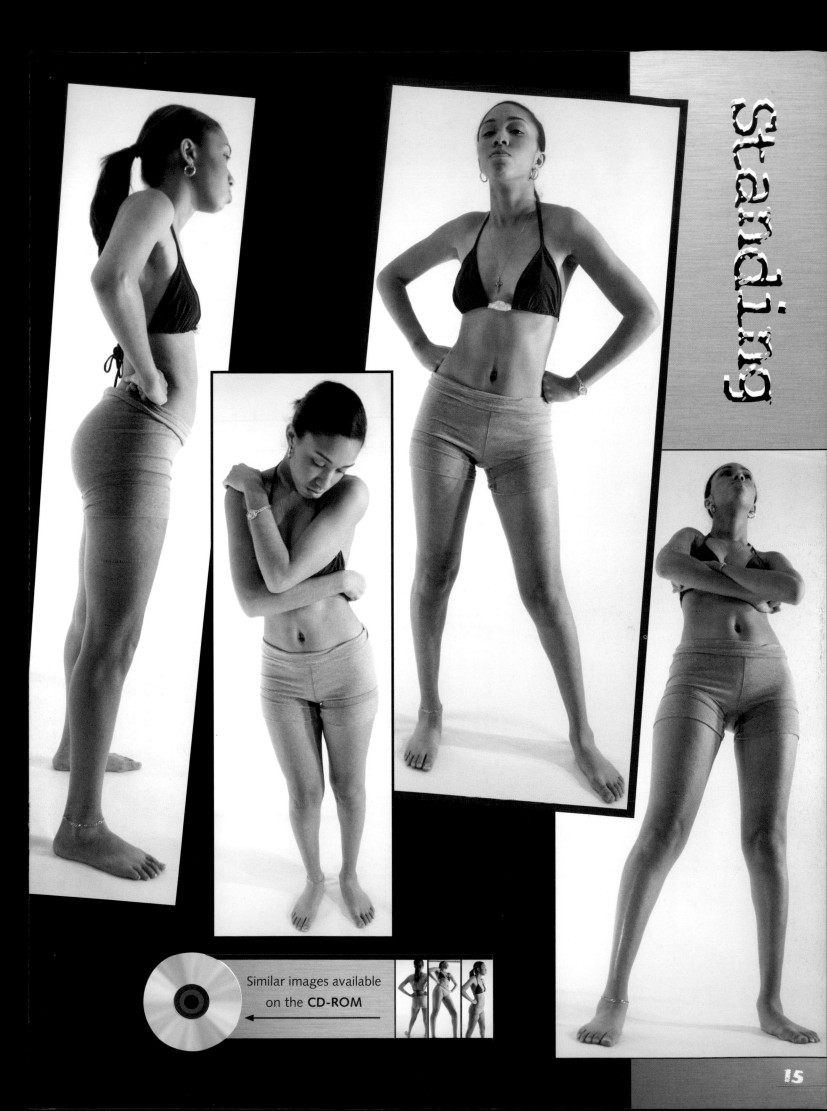

Similar images available
on the **CD-ROM**

Guns

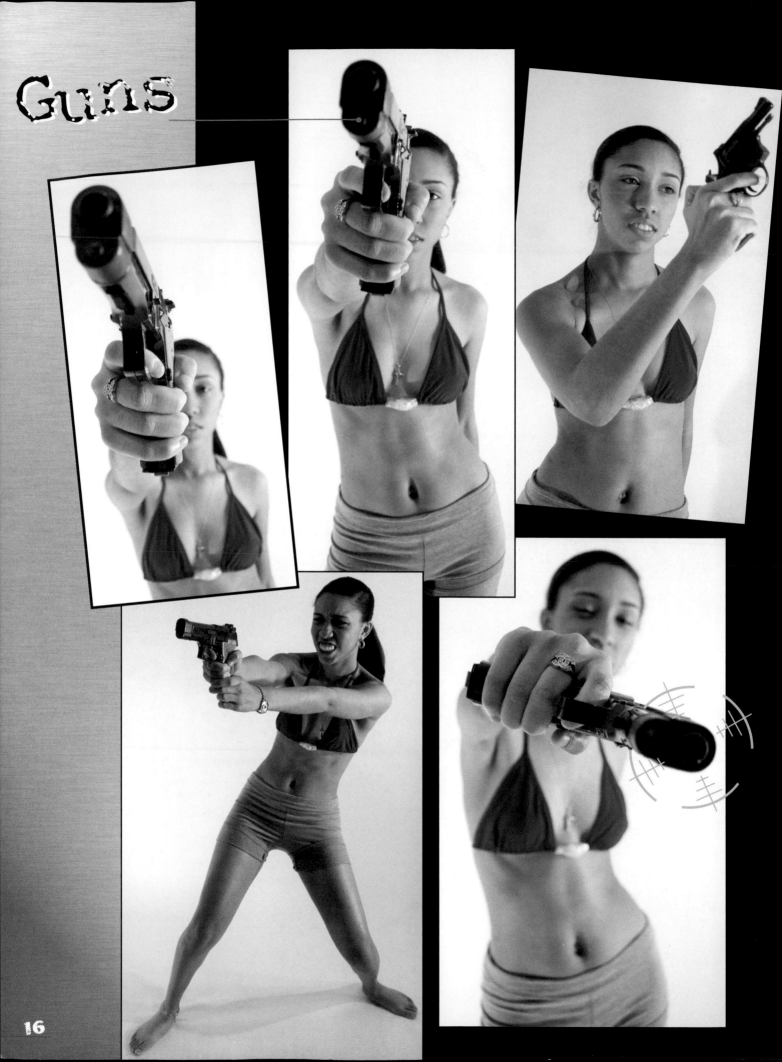

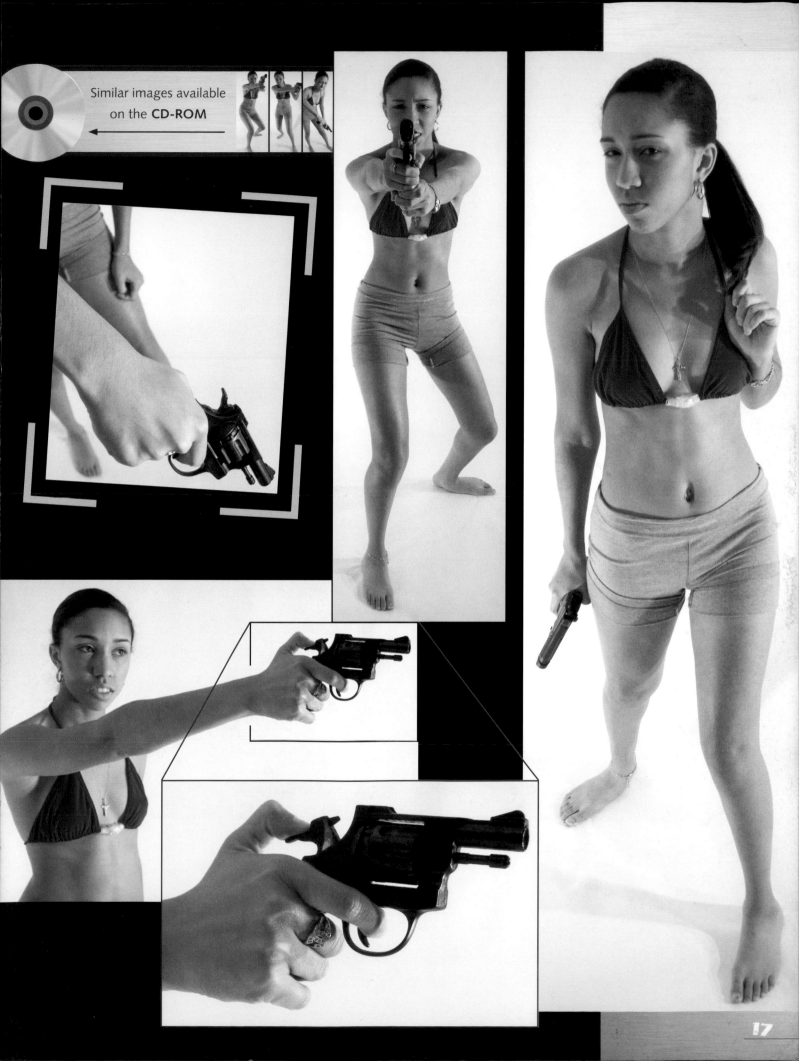

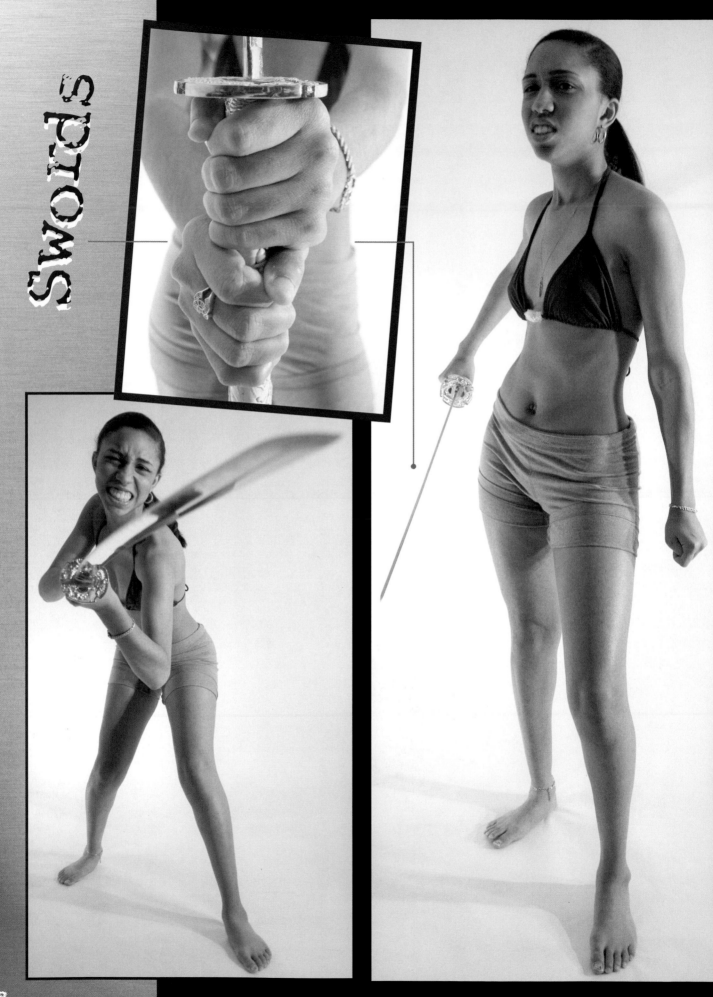

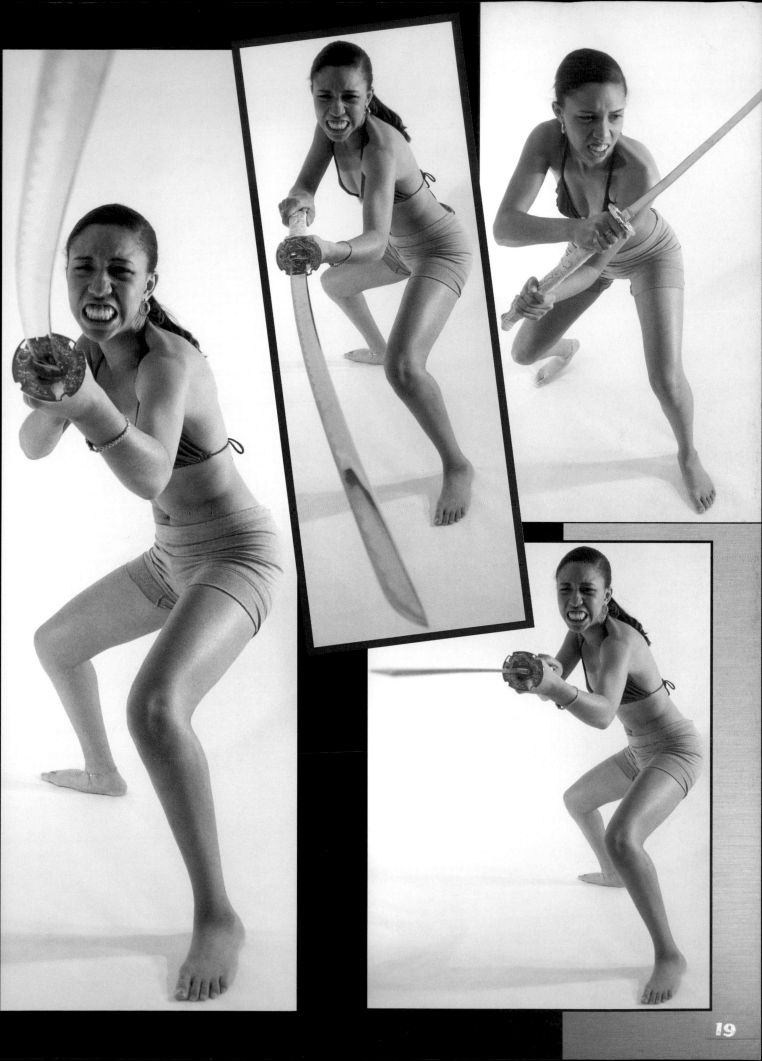

Teen Action Hero

BY JOSH HOWARD

I chose this picture of Chanel for my demo because I liked the tilt of the head and the position of the legs. I remained fairly faithful to the pose but went my own direction with the aesthetics. That's what it's all about—using the photo as inspiration without being a slave to it.

Thumbnail Sketch

First, I sketch the pose with a regular mechanical pencil to capture the shapes, angles and general feel.

I like to do several sketches before deciding which one to run with. I always have three or four sketchbooks going.

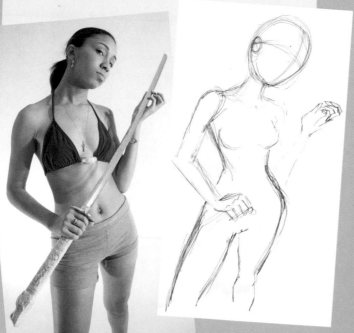

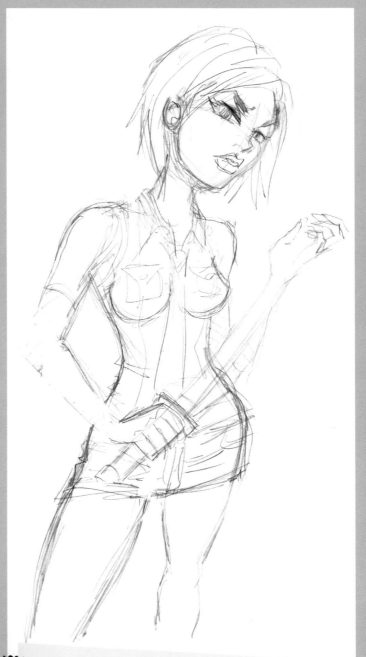

Because I ink my own work,
I can keep my pencils loose,
knowing I'll tighten the drawing during inking.
This is one way I've learned to
streamline my process.

 ### Pencils

I redraw my best sketch onto art board, then rough in the details of the clothing. This is where my illustration begins to deviate from the photo. I'm envisioning a teen hero dressed in a sort of hybrid punk/militaristic style.

Inks

I ink the drawing with fine-point pens and brush pens, then erase the pencil lines. As you just saw, my pencils are loose, so as I ink, I have to "find" the final illustration in my mess of lines. It's not really as chaotic as it sounds, but I almost always make a few corrections.

Colors

I scan my inks, then add color on the computer. The final product is a piece I'd gladly add to my portfolio.

After I scan my inks, I can manipulate the scan before I color. If I decide that the head is at the wrong angle or a hand is too large, I can fix it.

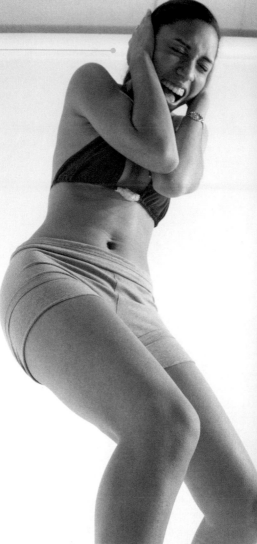

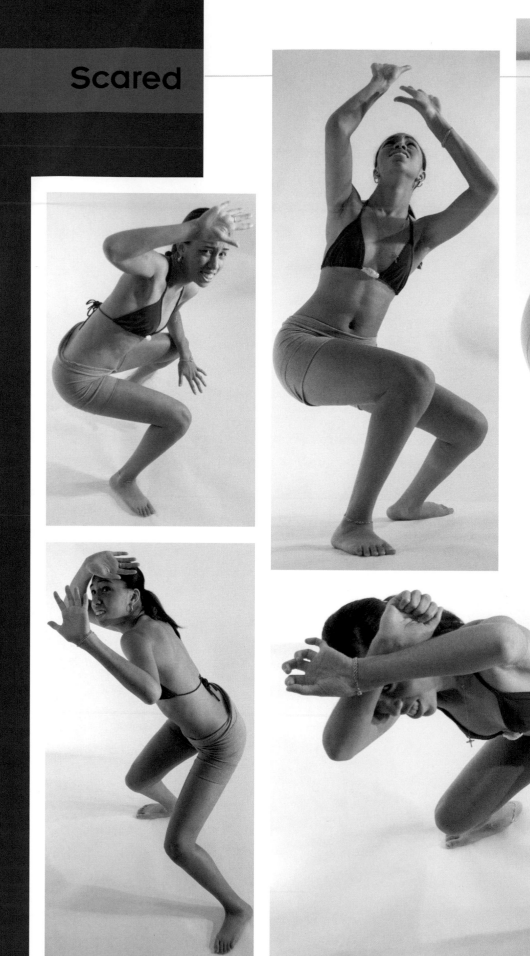

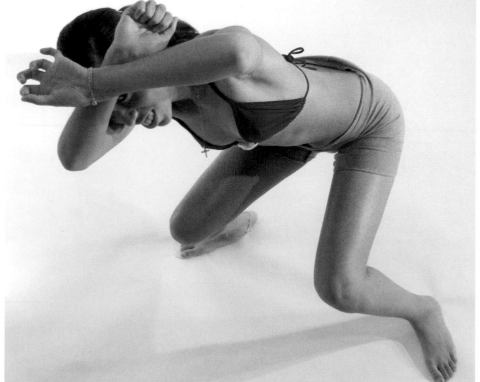

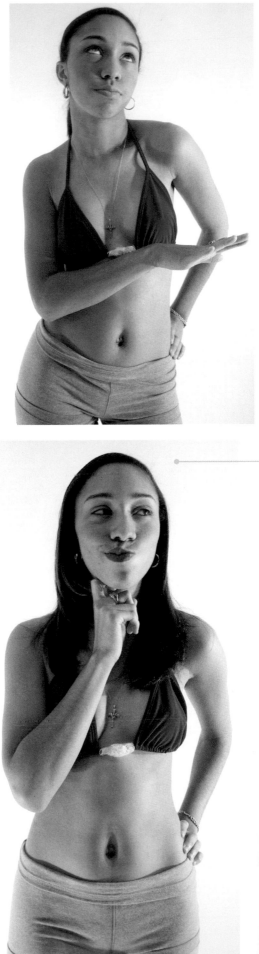

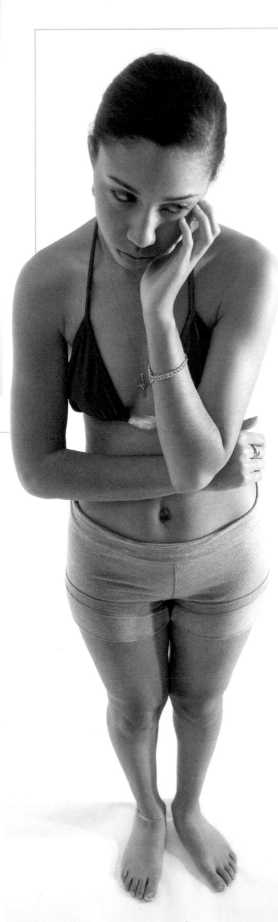

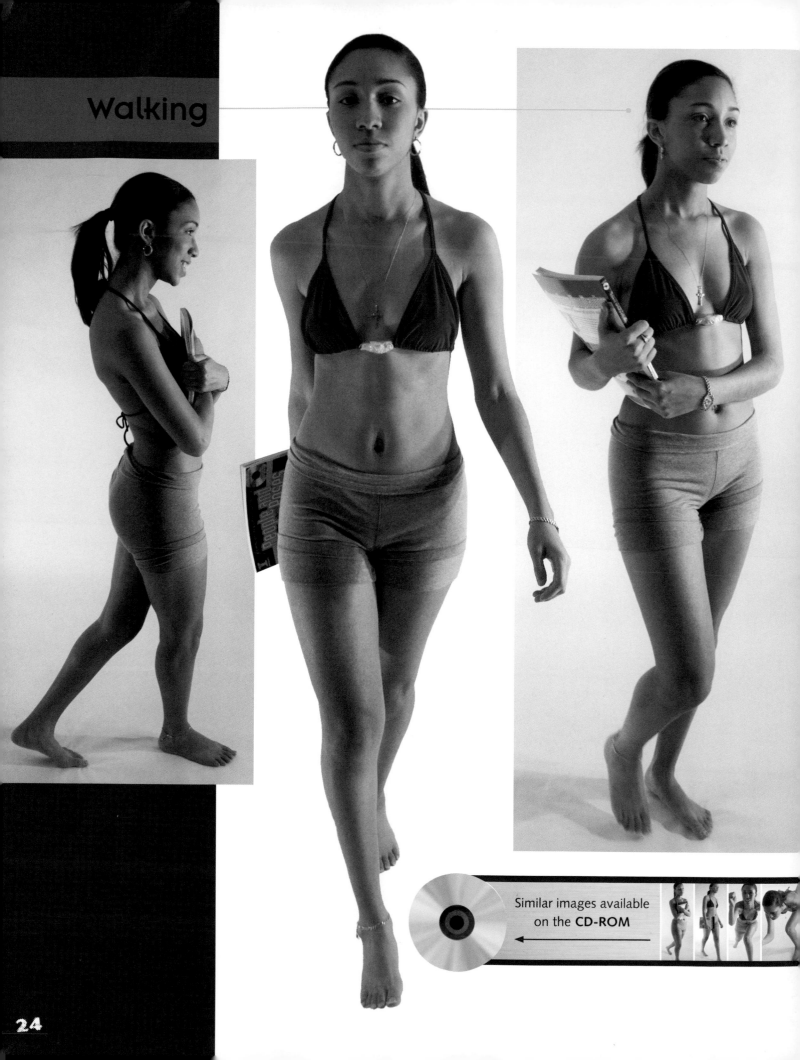

Walking

Similar images available
on the **CD-ROM**

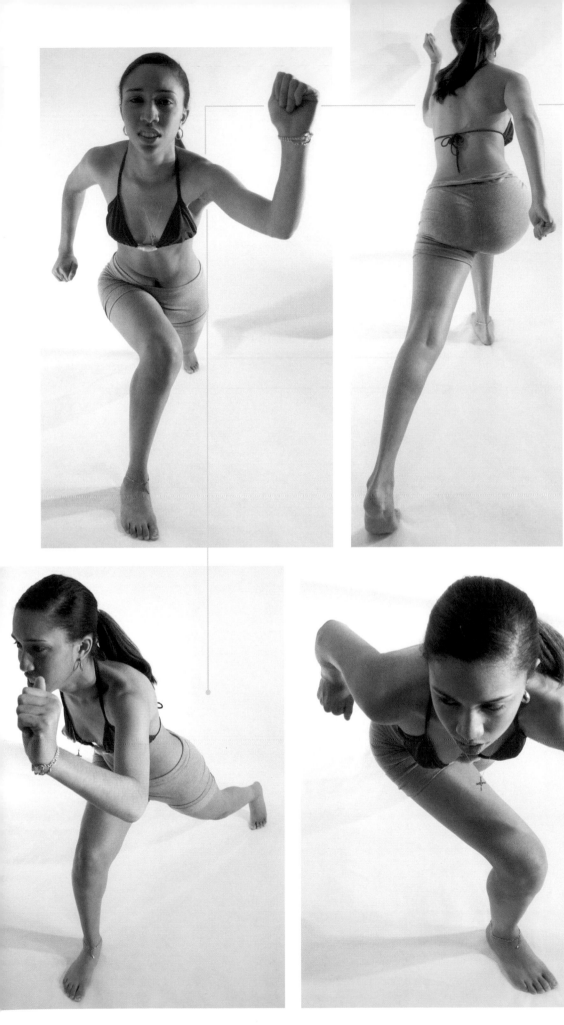

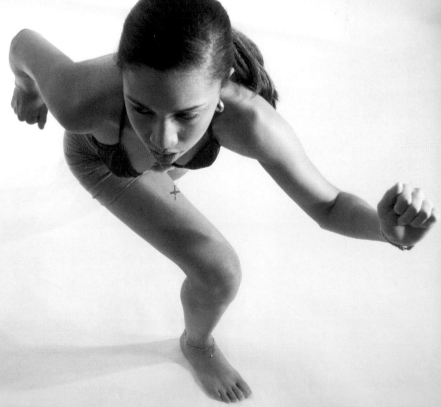

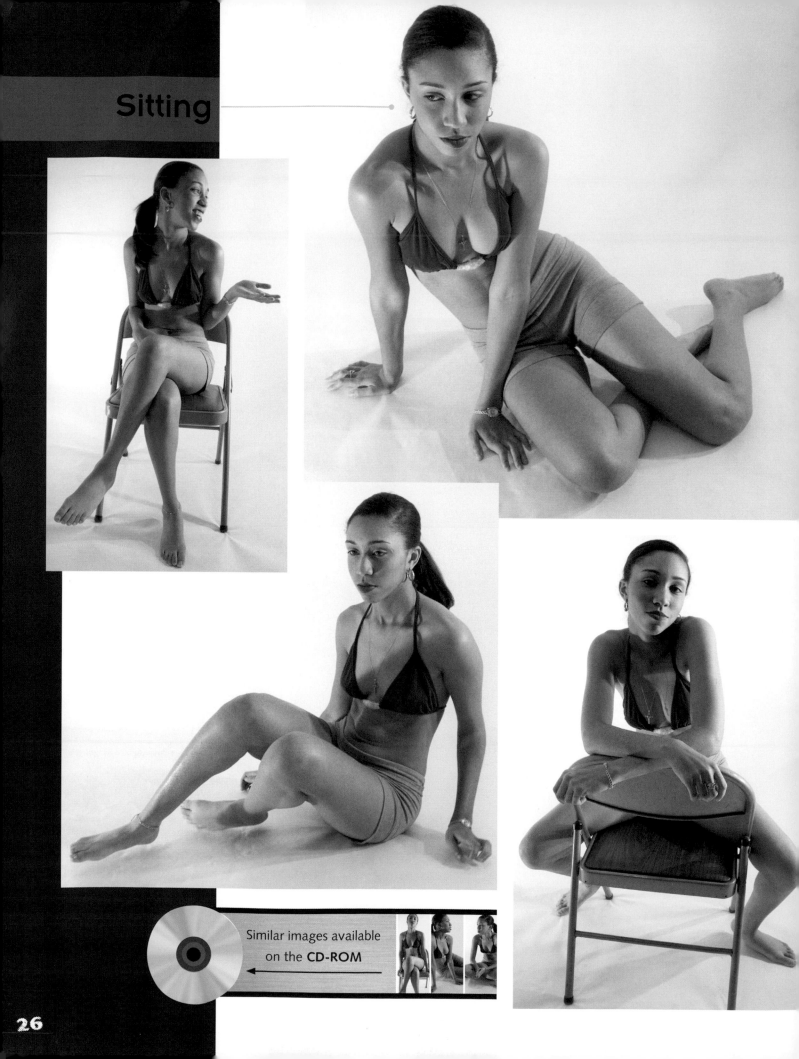

Sitting

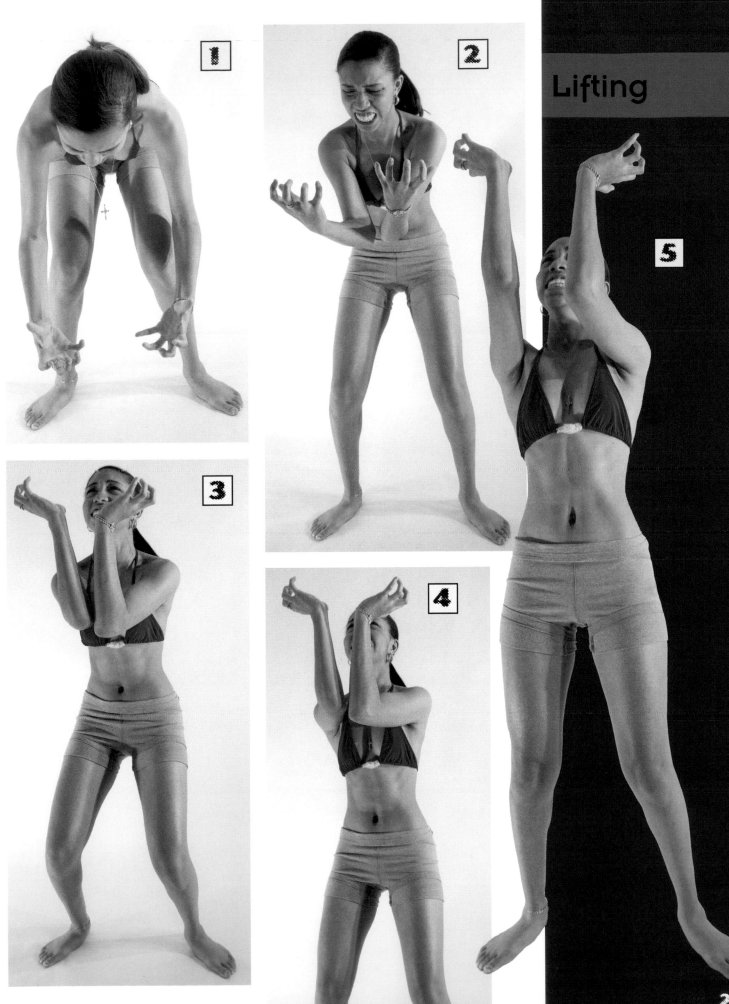

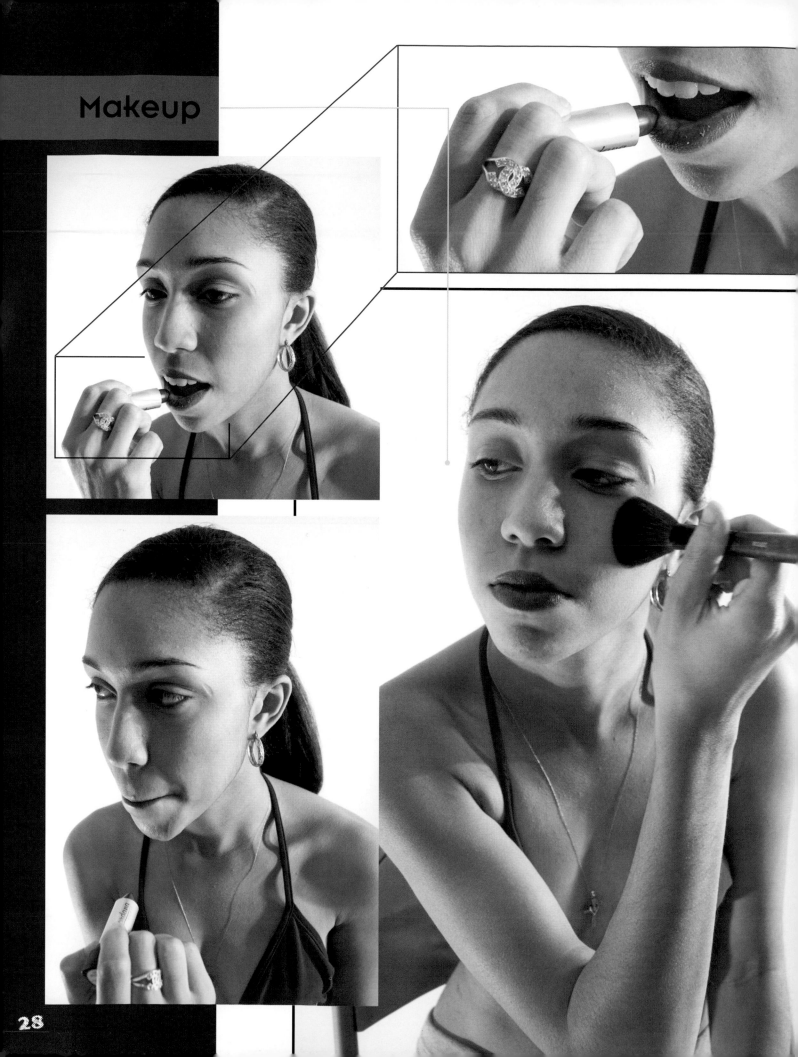

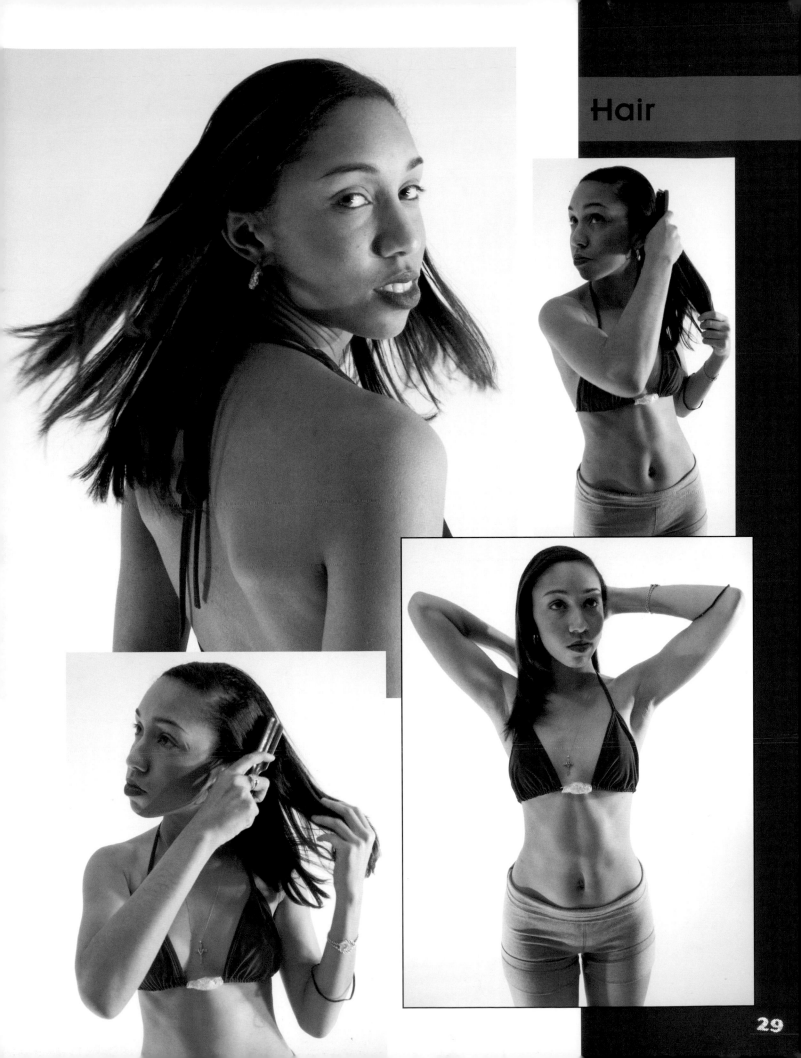

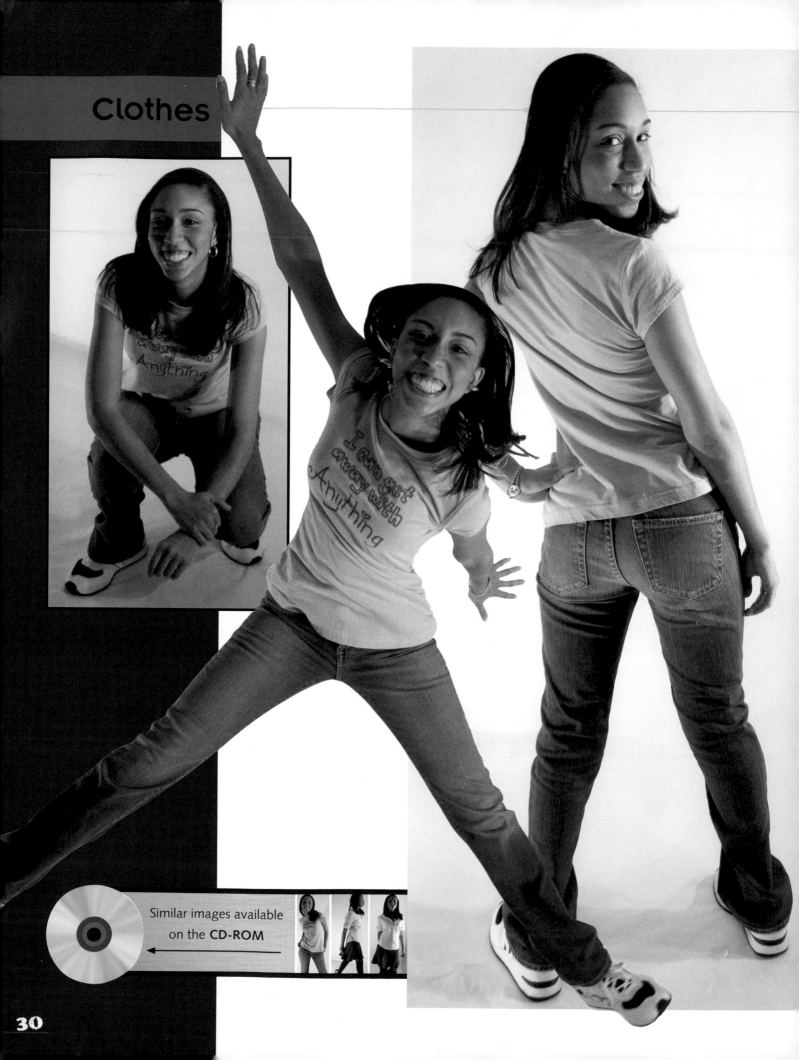

Clothes

Similar images available on the **CD-ROM**

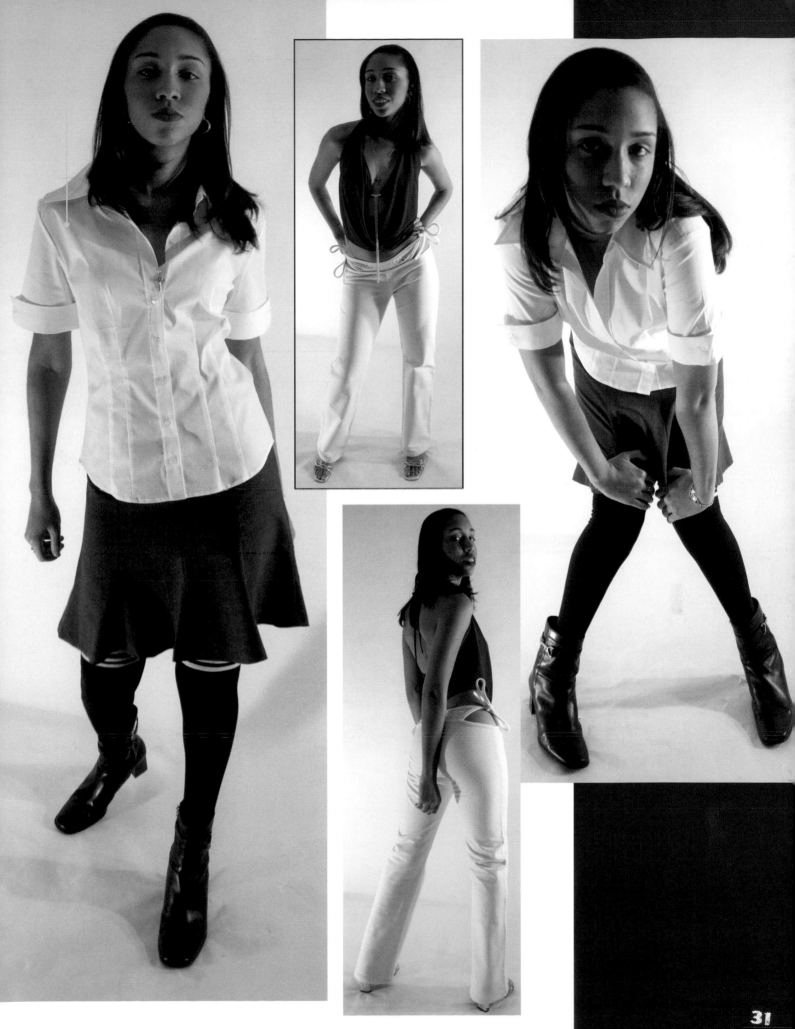

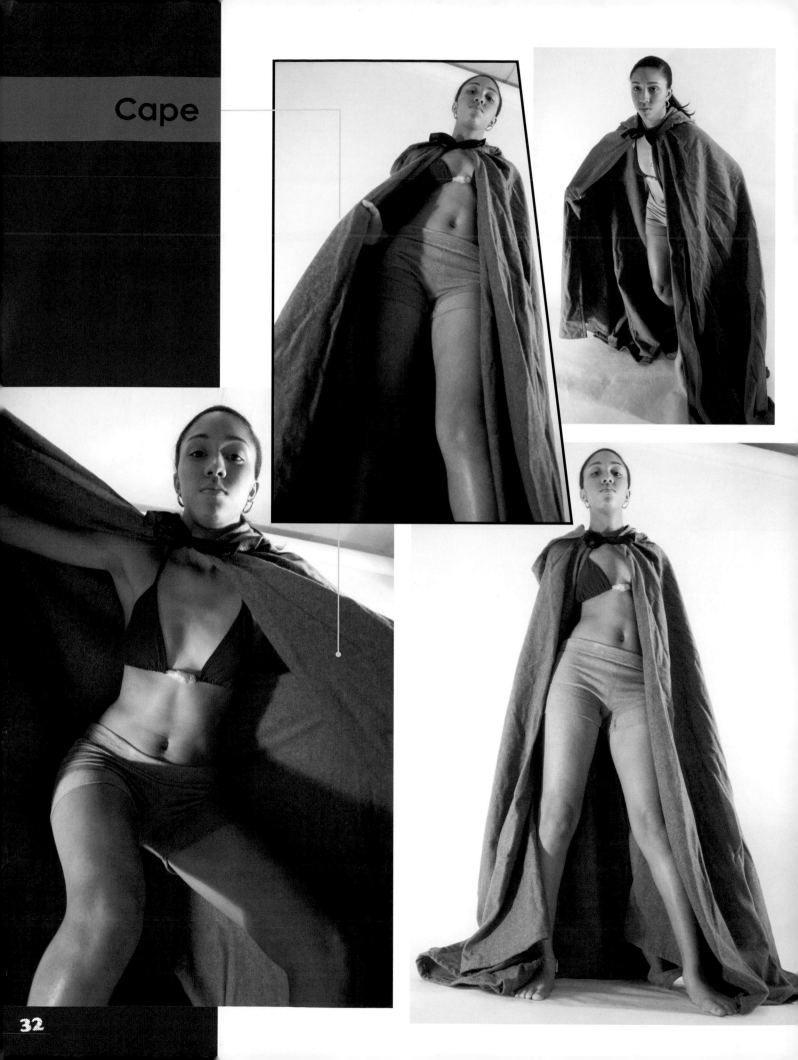

Cape

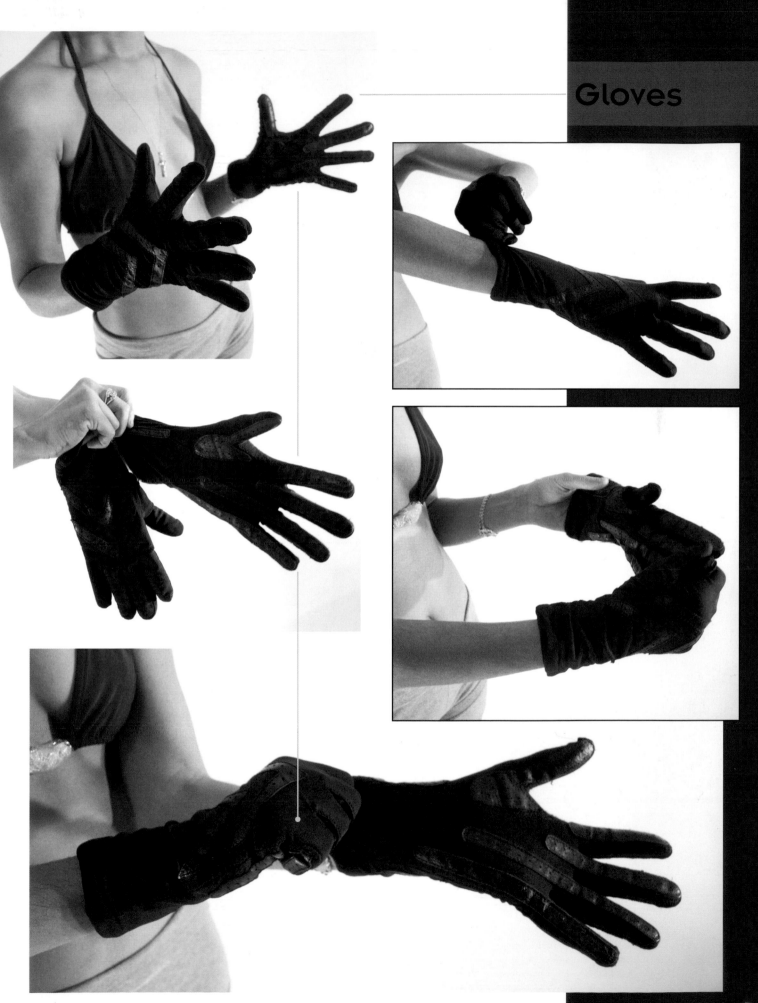

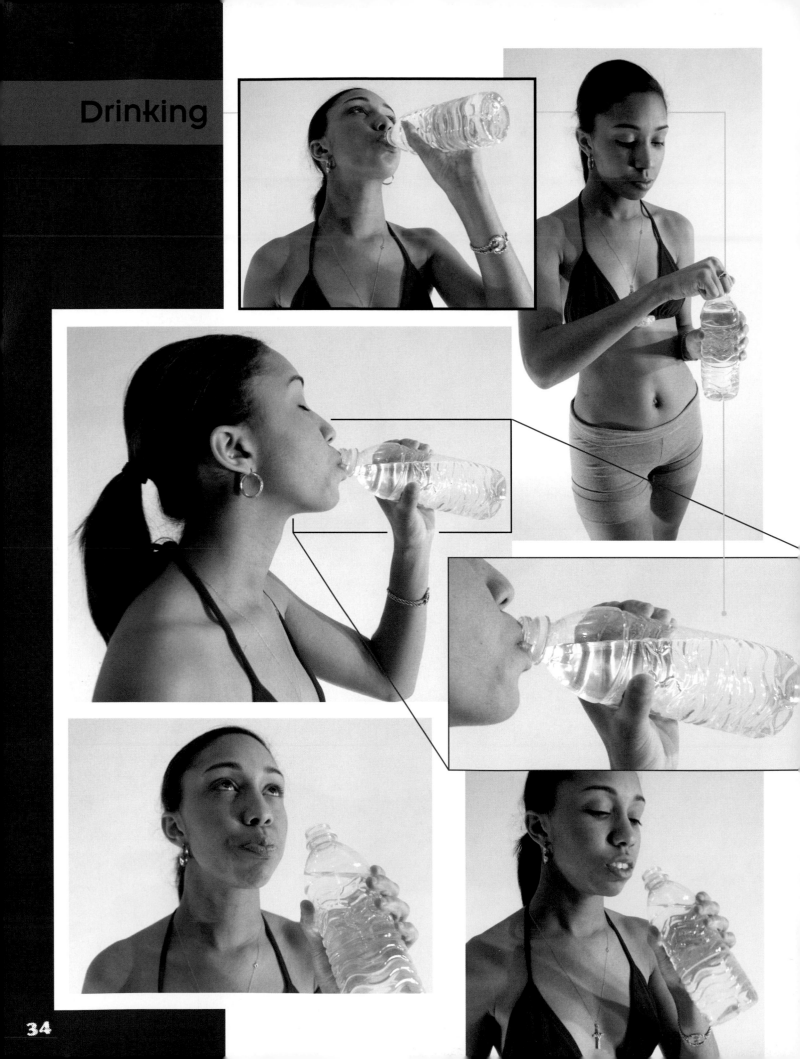

Drinking

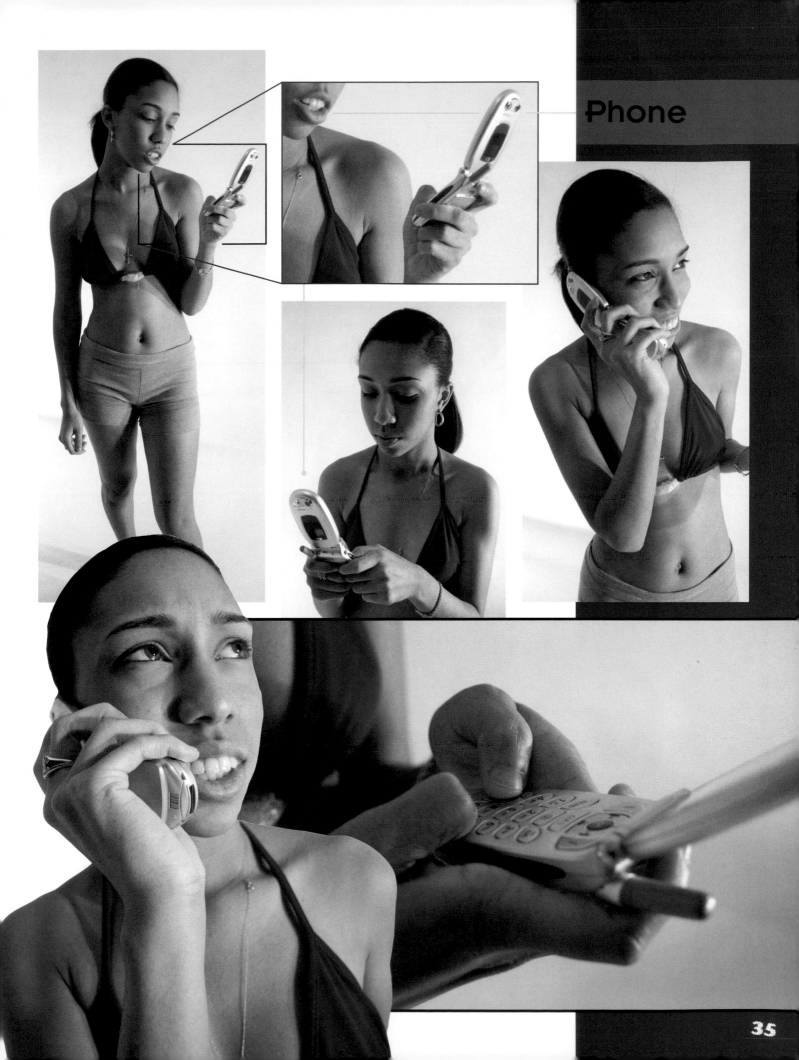

Sarah

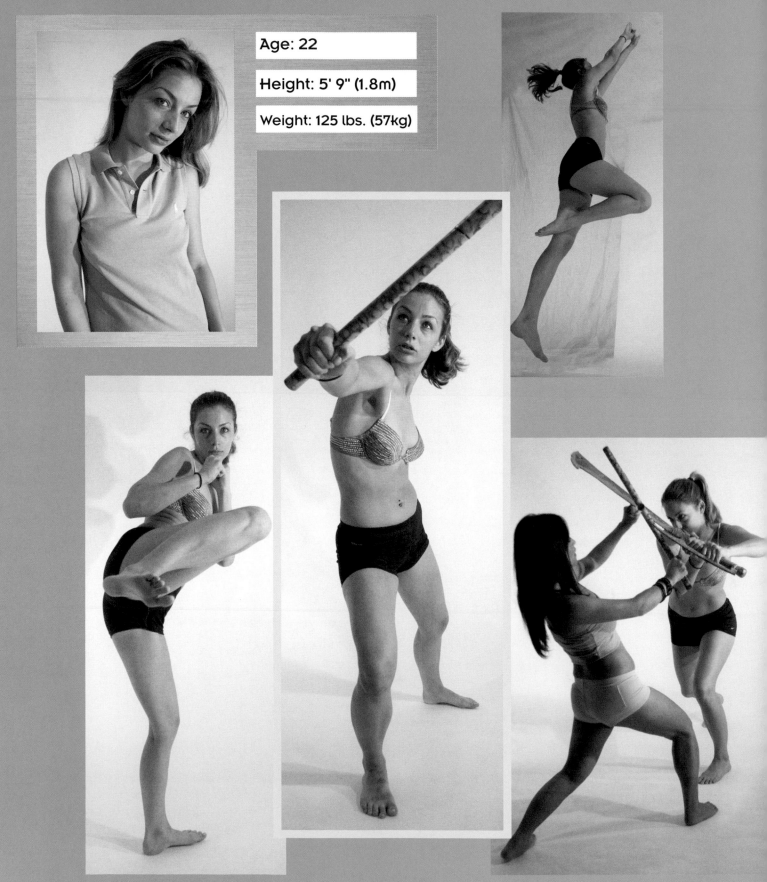

Age: 22

Height: 5' 9" (1.8m)

Weight: 125 lbs. (57kg)

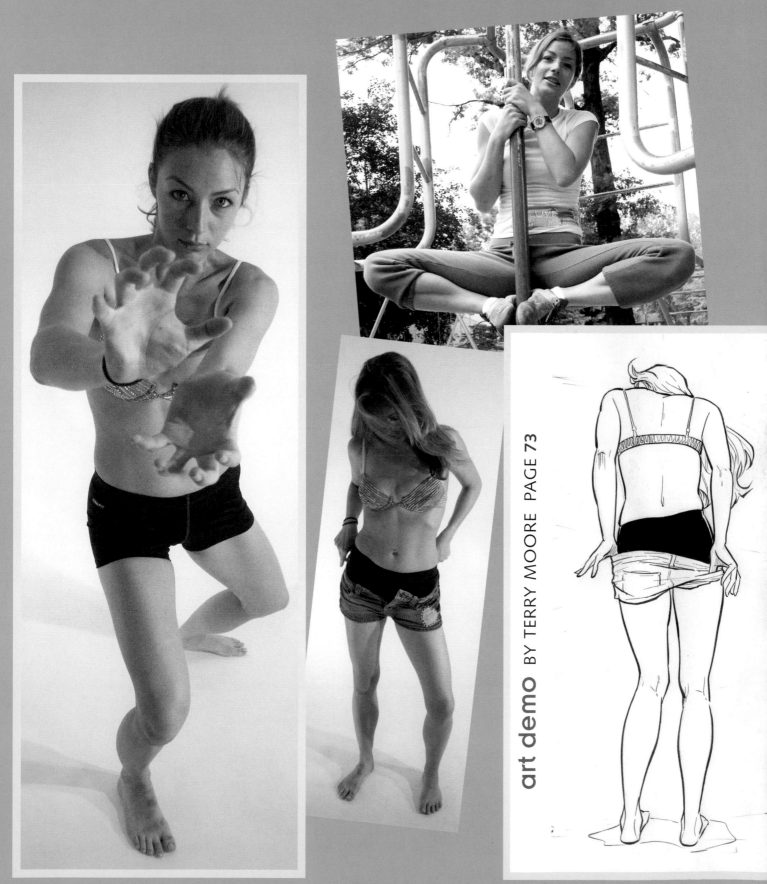

art demo BY TERRY MOORE PAGE 73

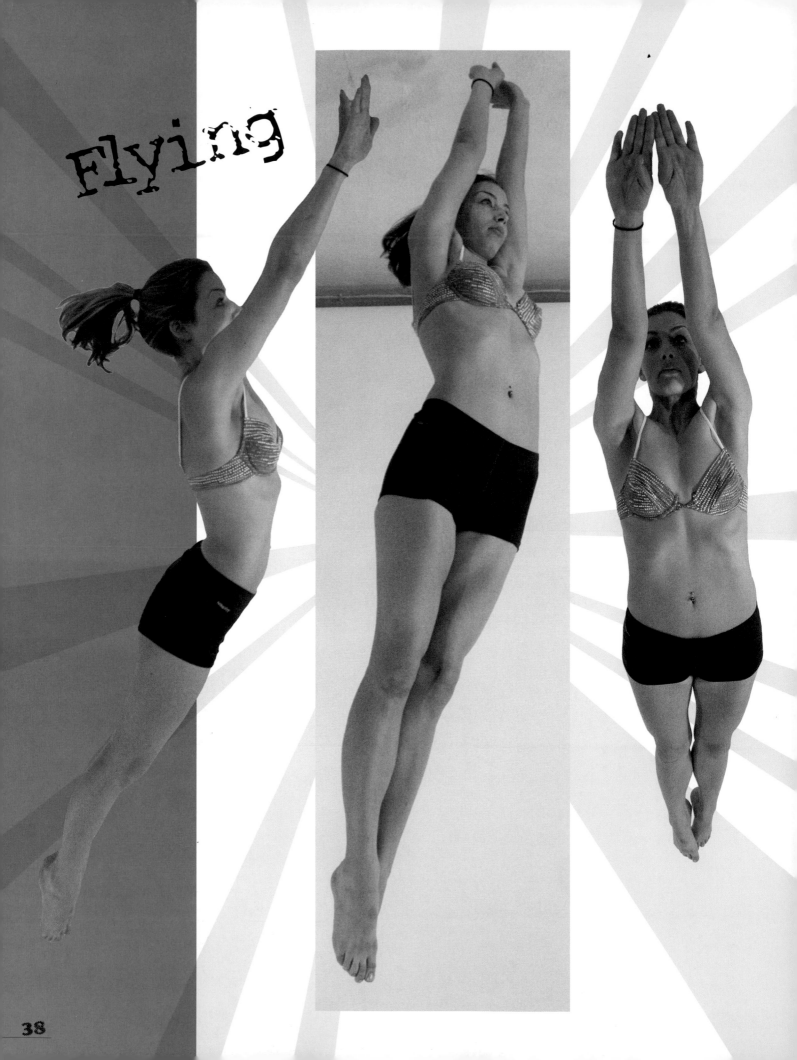

Flying

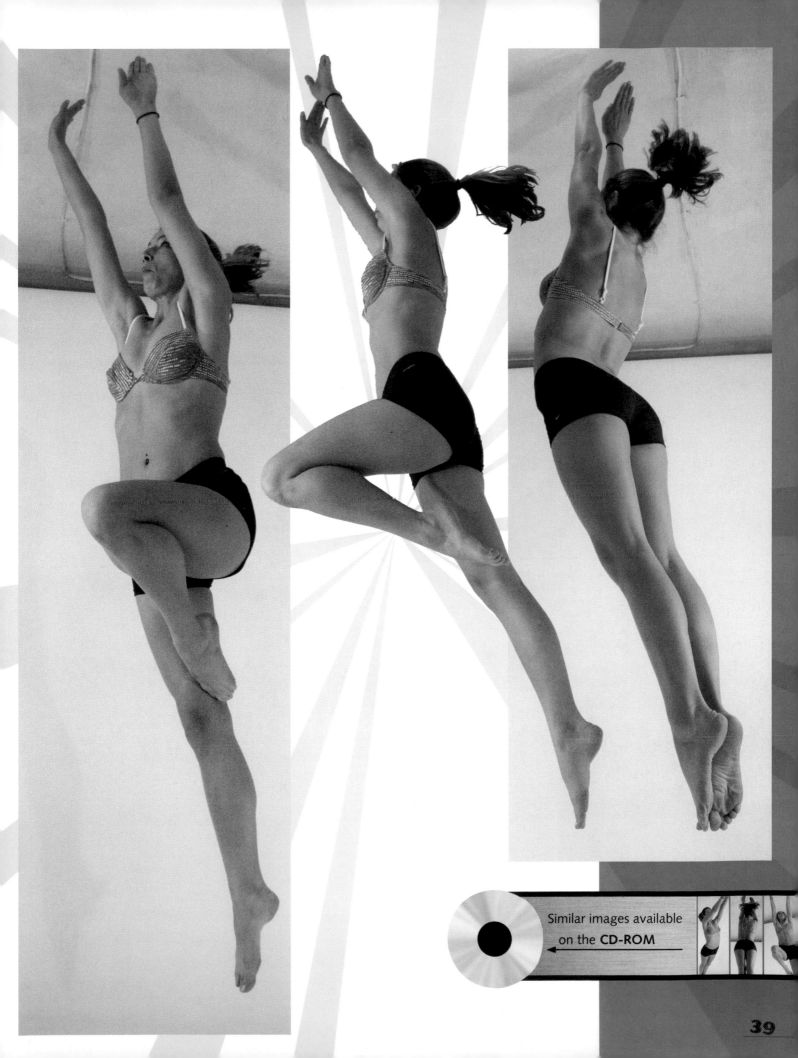

Similar images available on the **CD-ROM**

Jumping

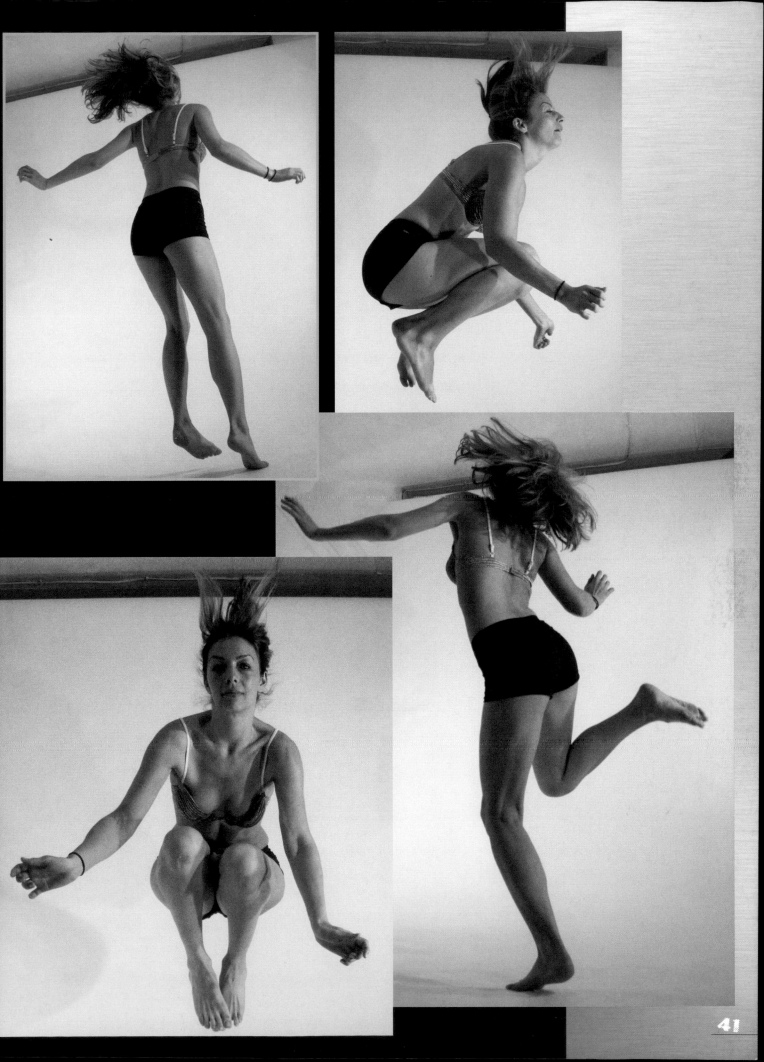

Battle

For more photos of Sarah's opponent, Veronica, see her chapter in *Comic Artist's Photo Reference: People and Poses*.

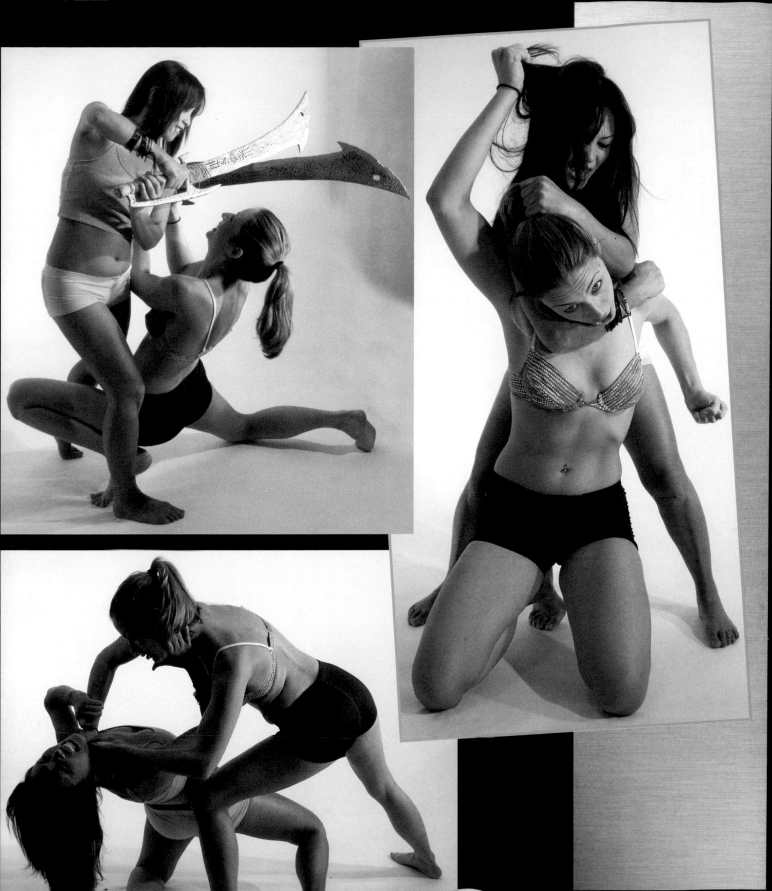

Similar images available on the **CD-ROM**

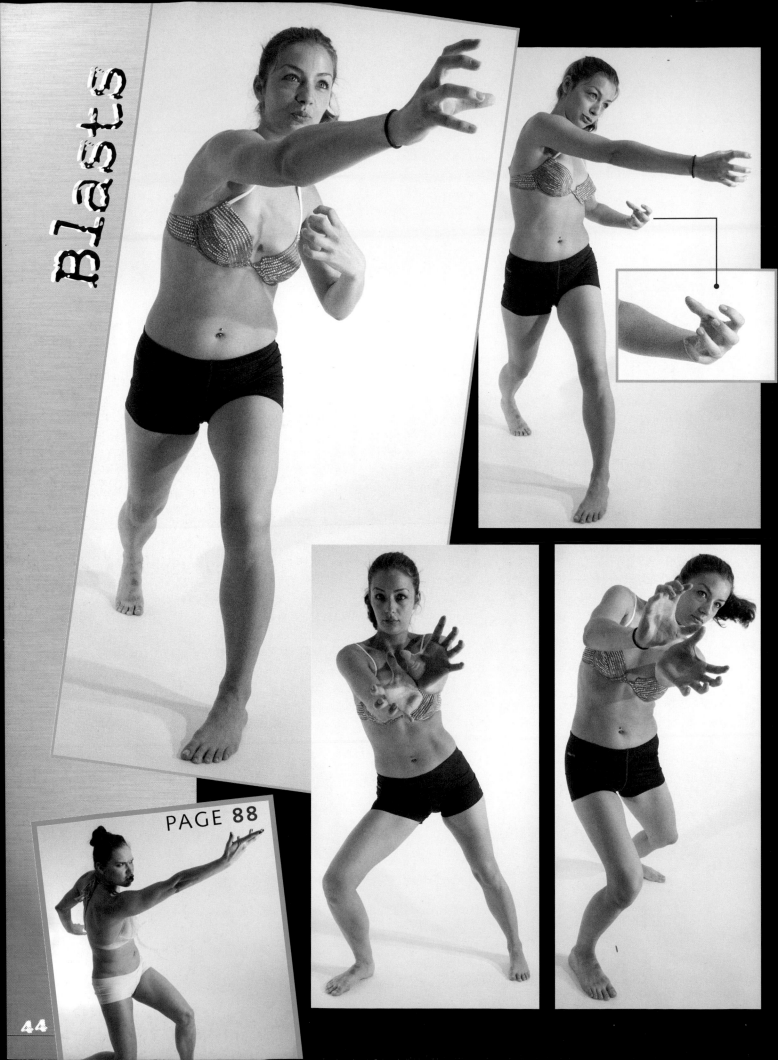

Blasts

PAGE 88

44

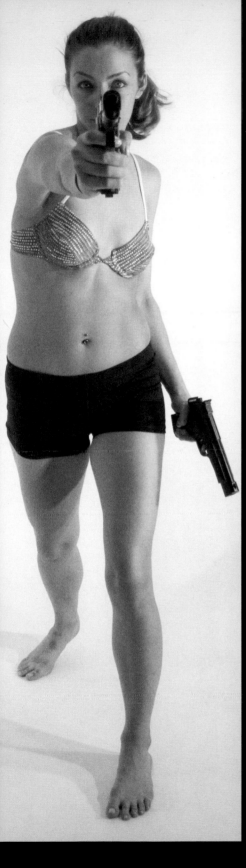
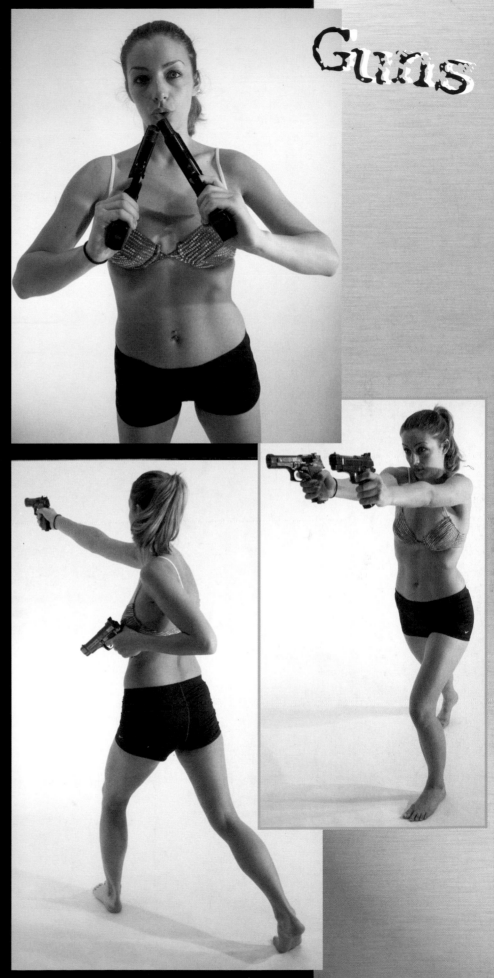

More Guns

Similar images available on the **CD-ROM**

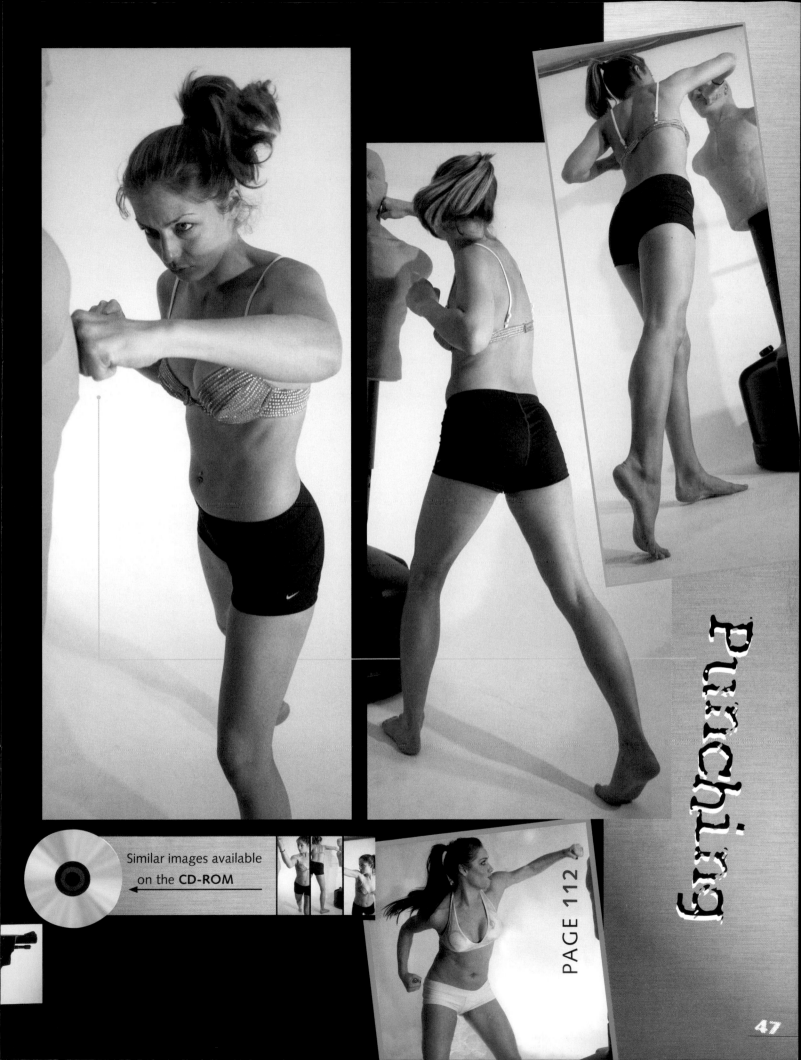

Similar images available on the **CD-ROM**

PAGE 112

Punching

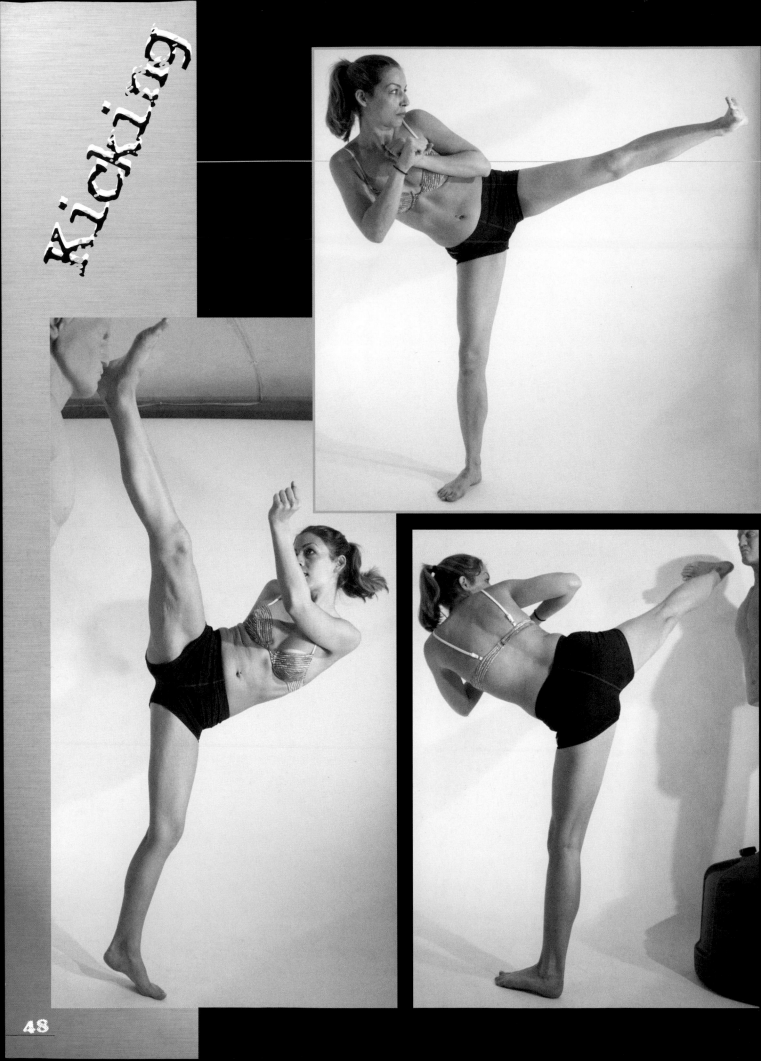

Kicking

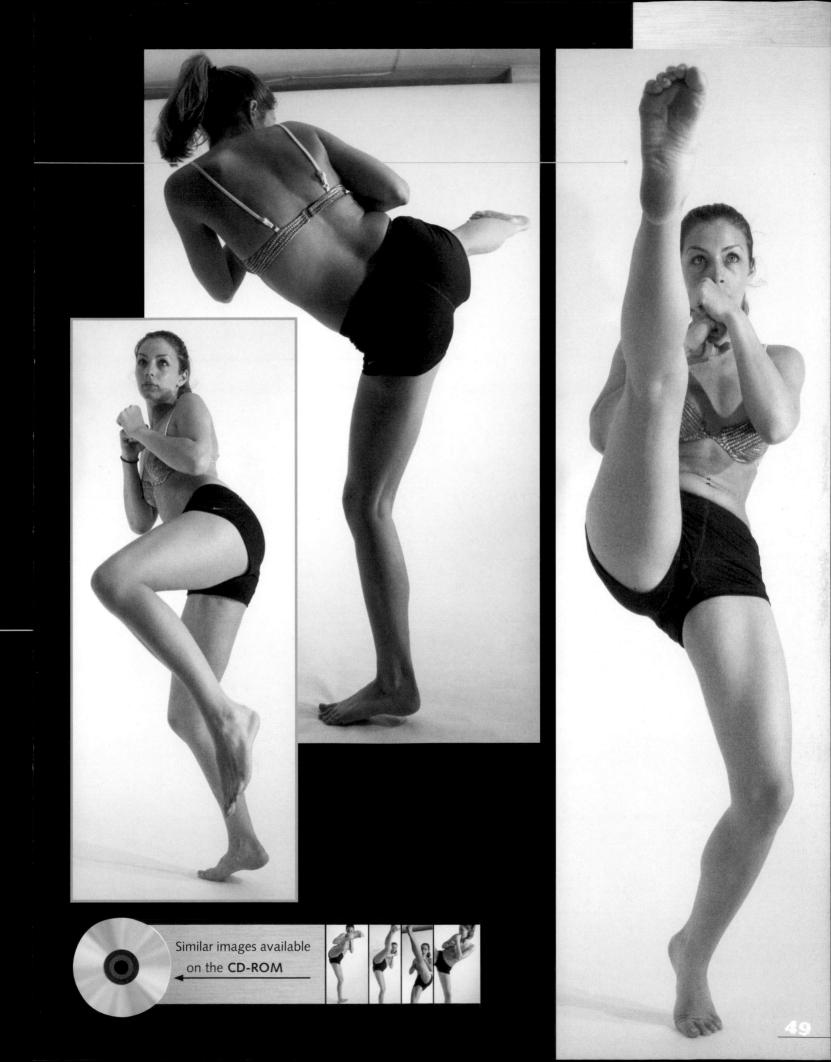

Similar images available on the **CD-ROM**

49

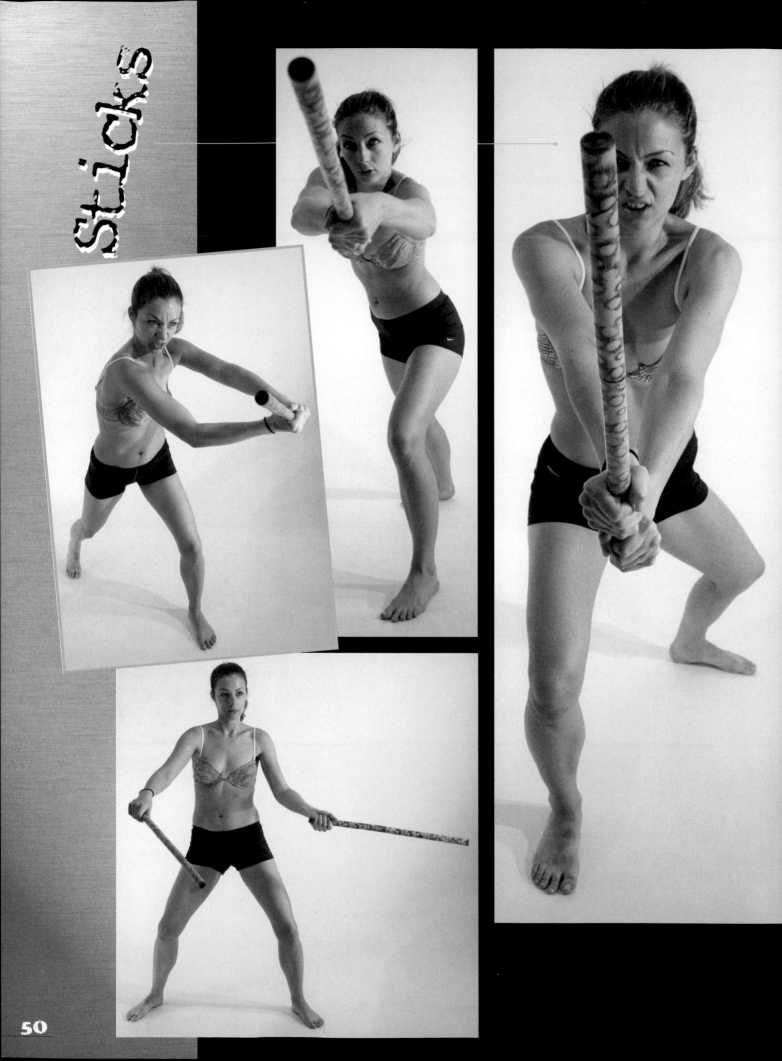

Sticks

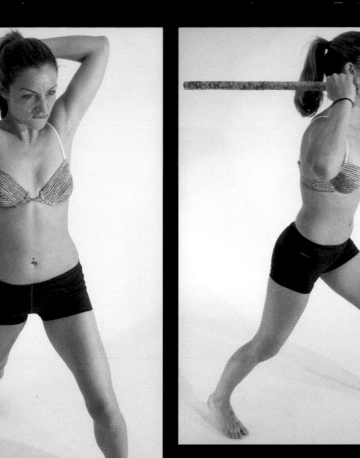

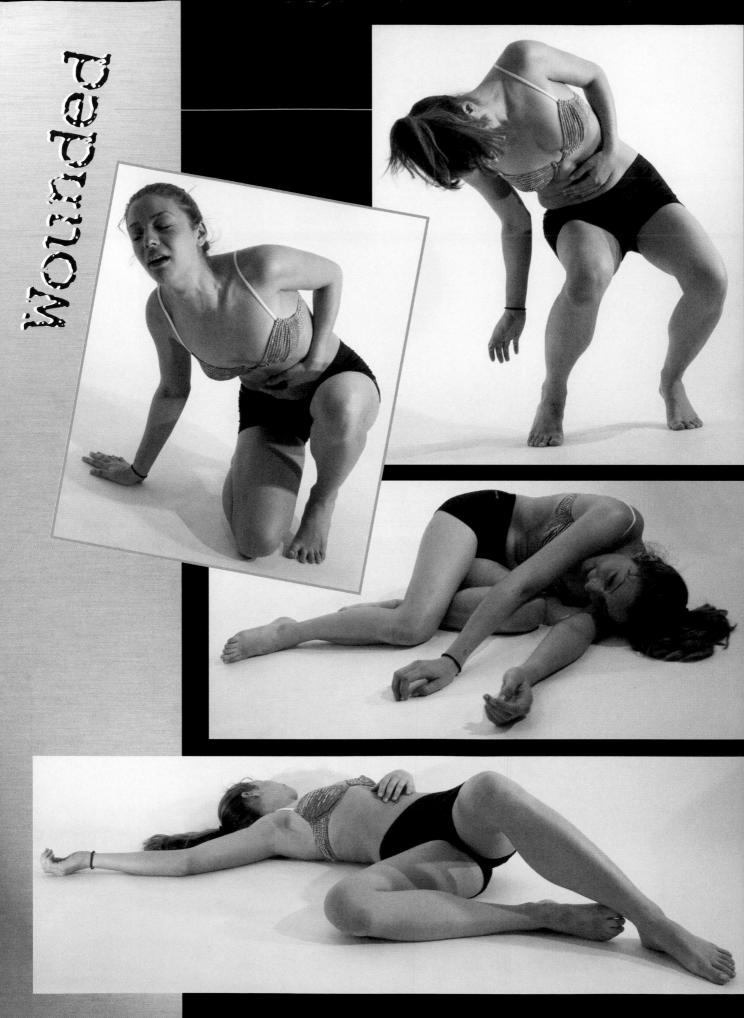

Wounded

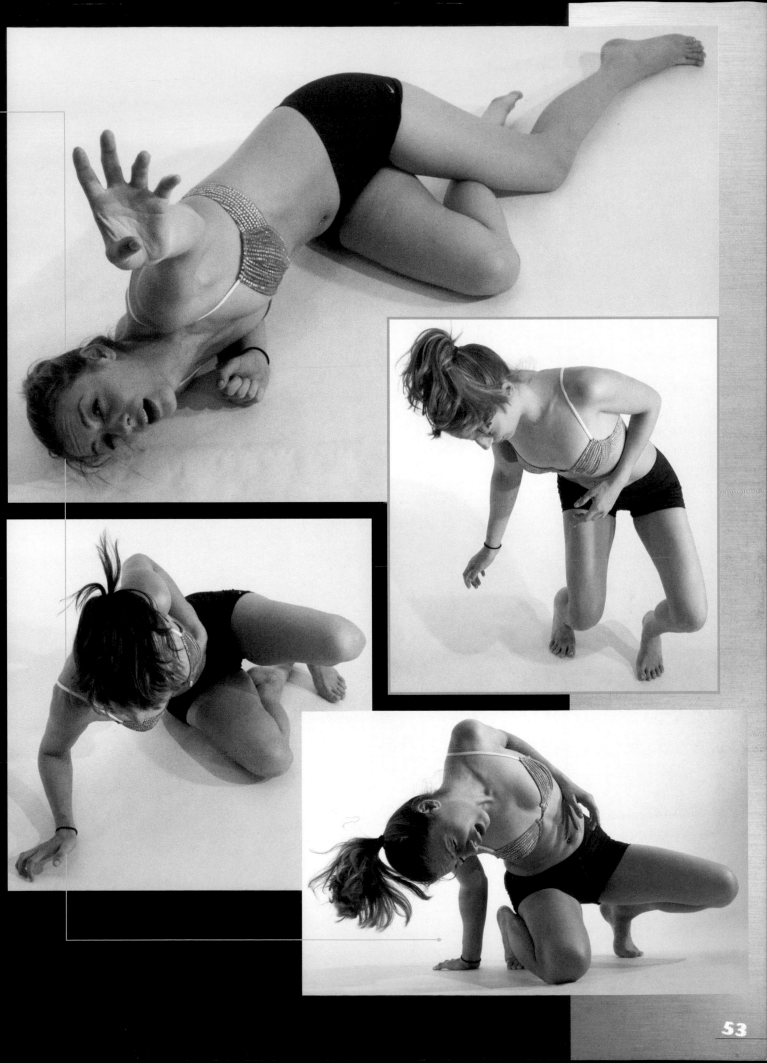

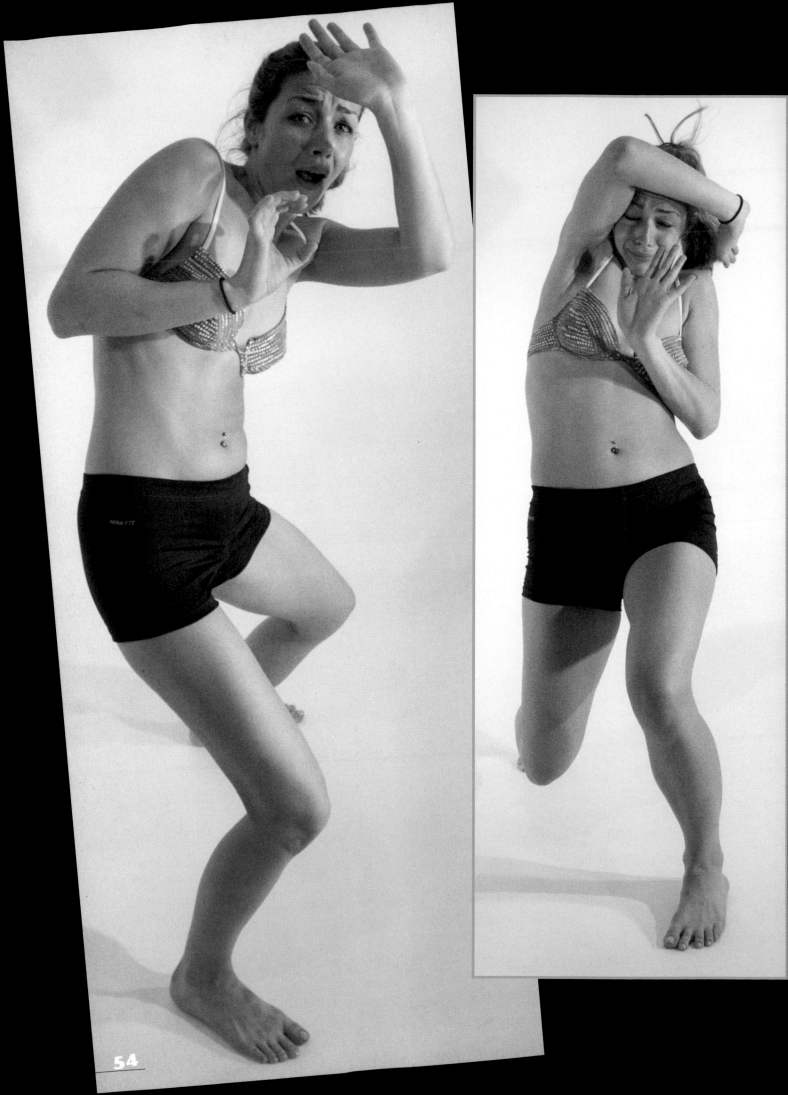

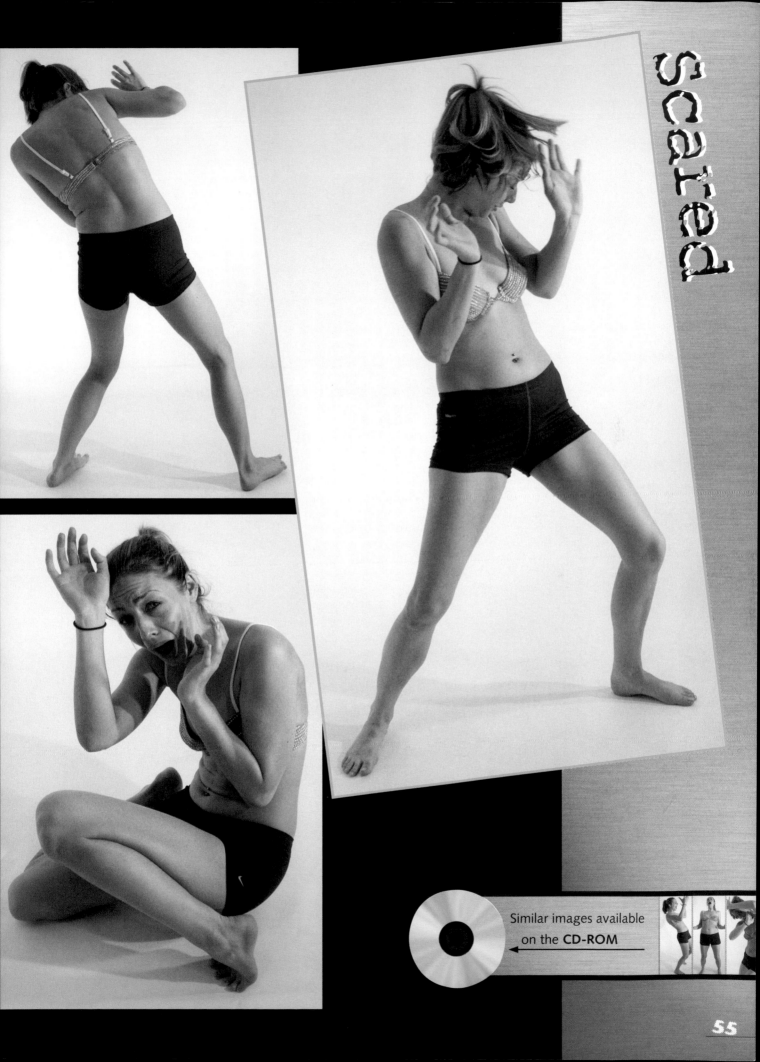

scared

Similar images available on the **CD-ROM**

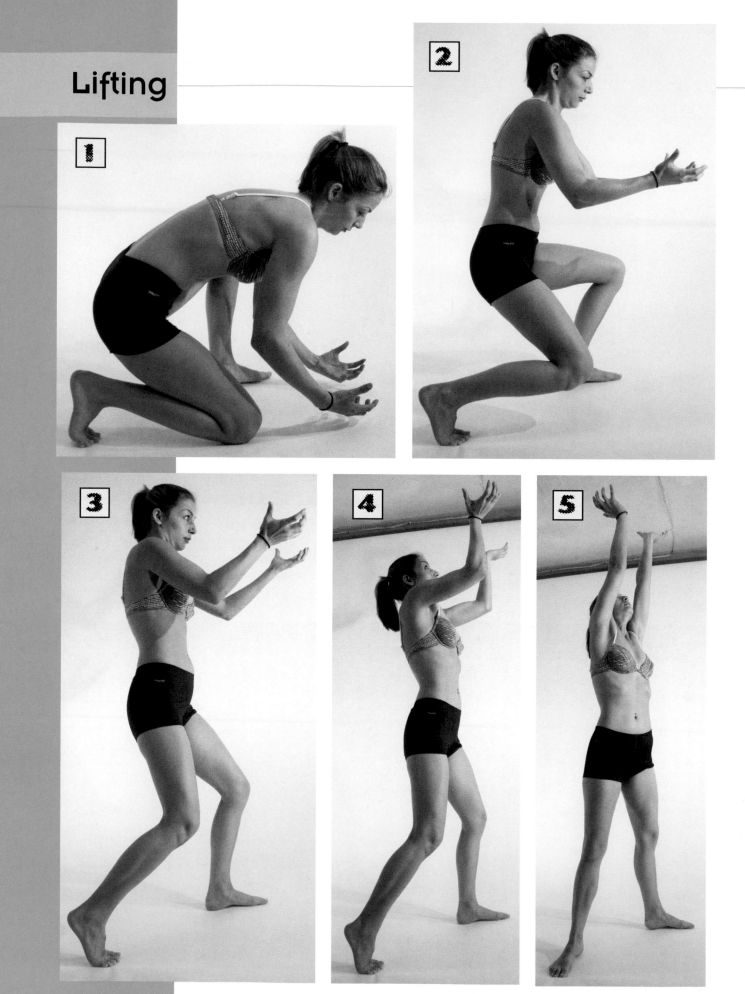

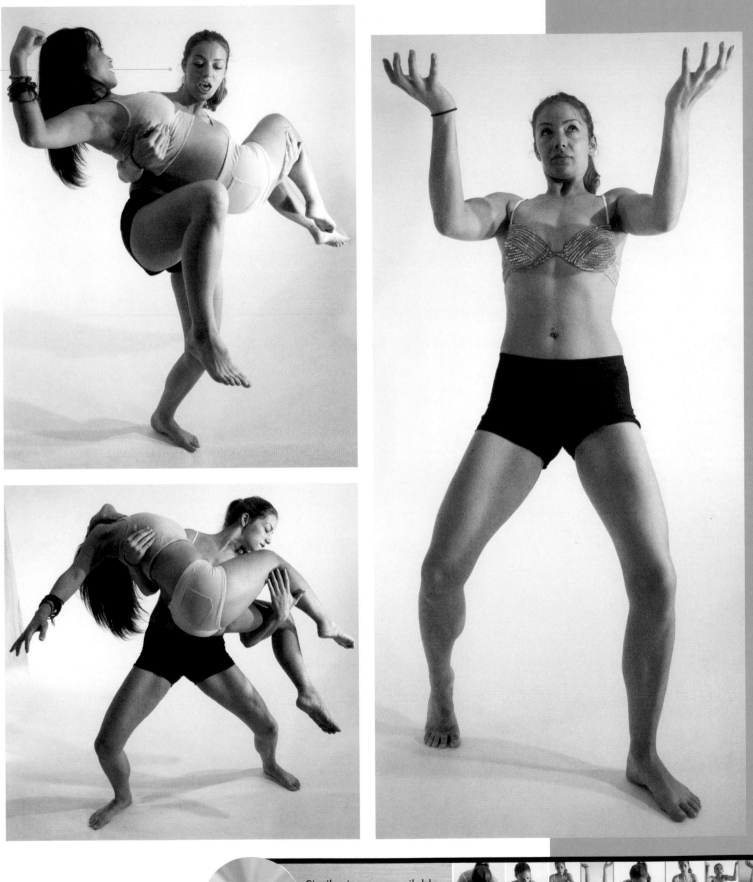

Similar images available on the **CD-ROM**

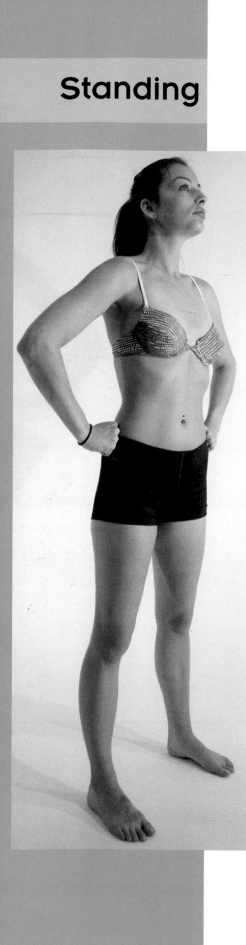

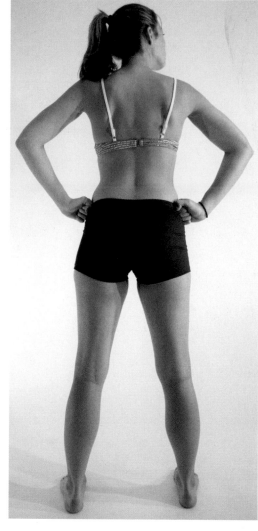

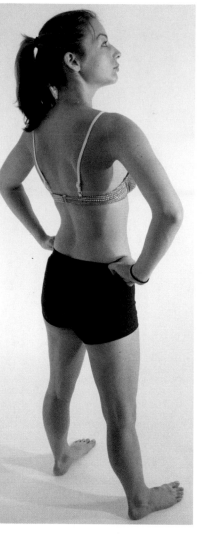

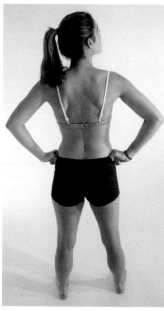

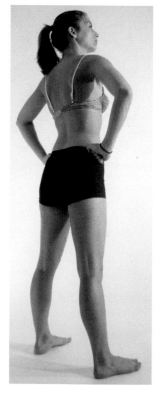

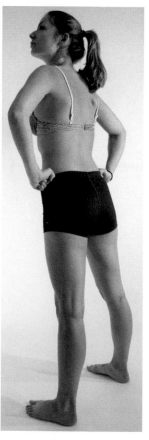

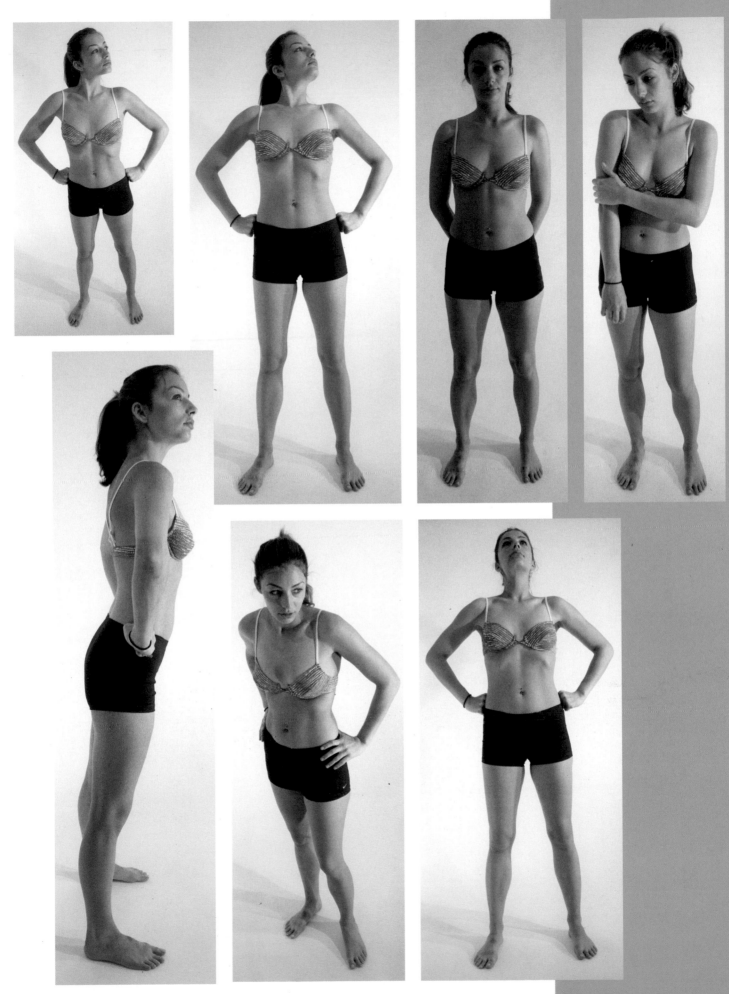

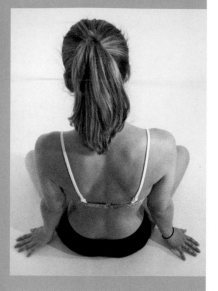

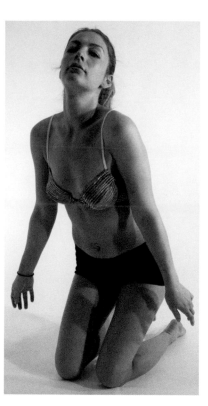

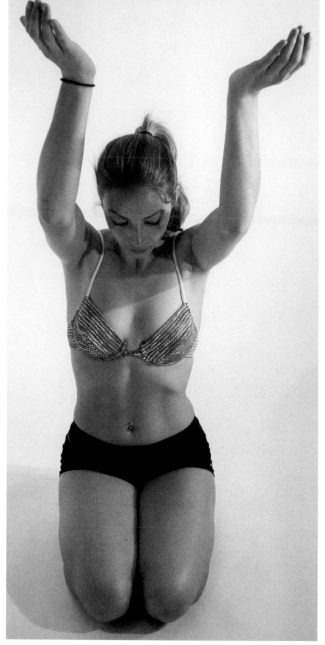

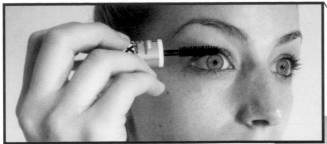

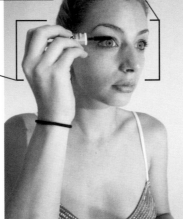

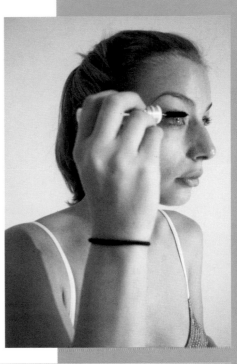

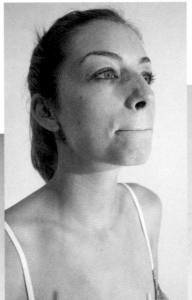

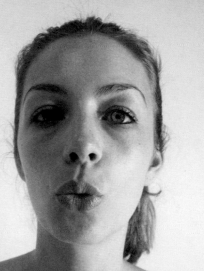

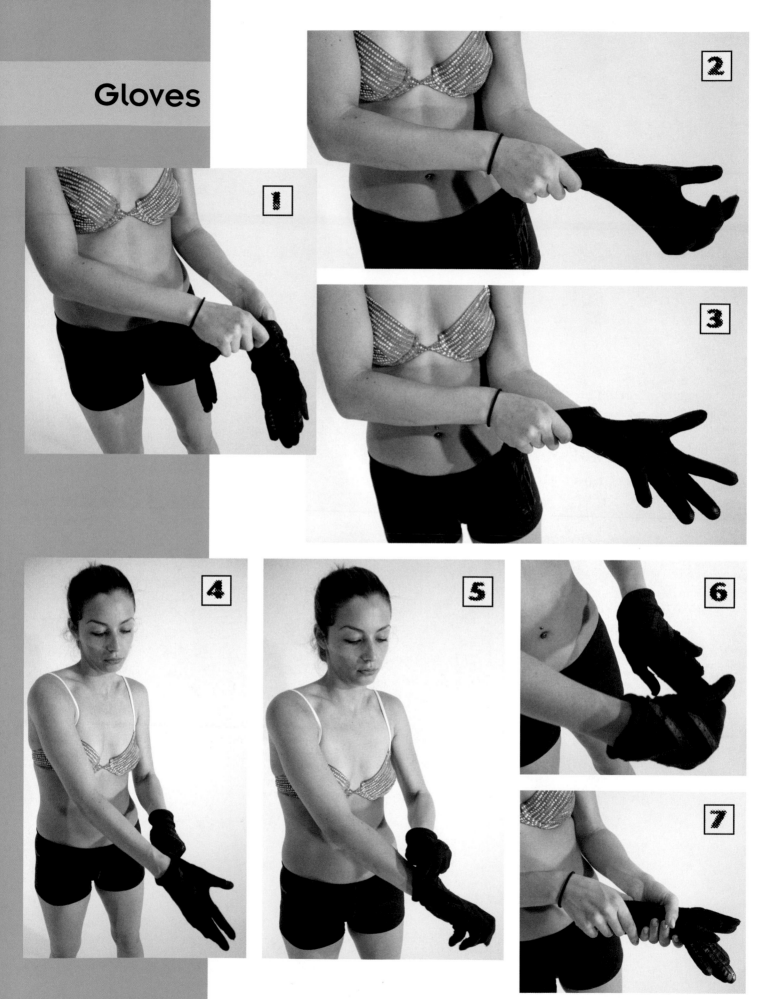

Gloves

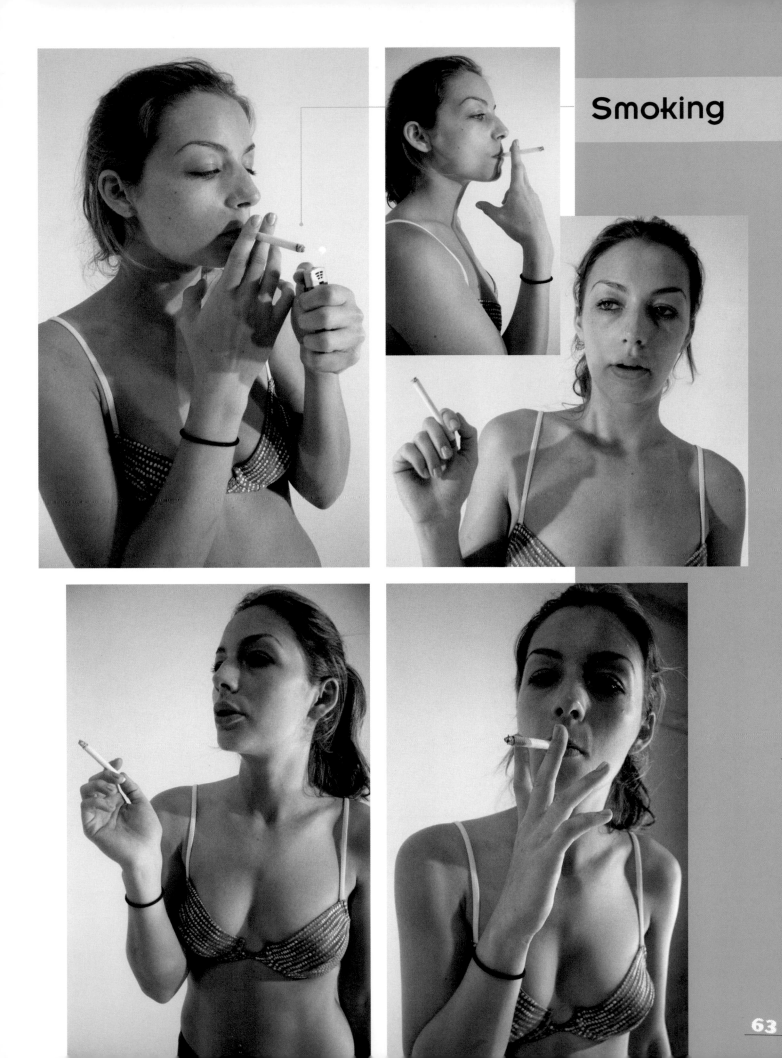

Expressions

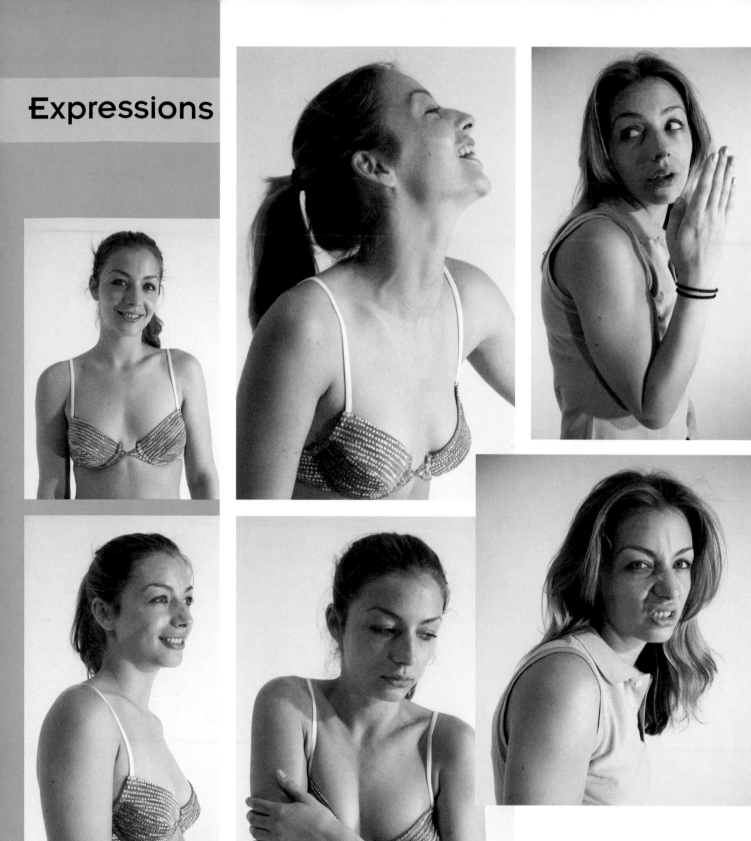

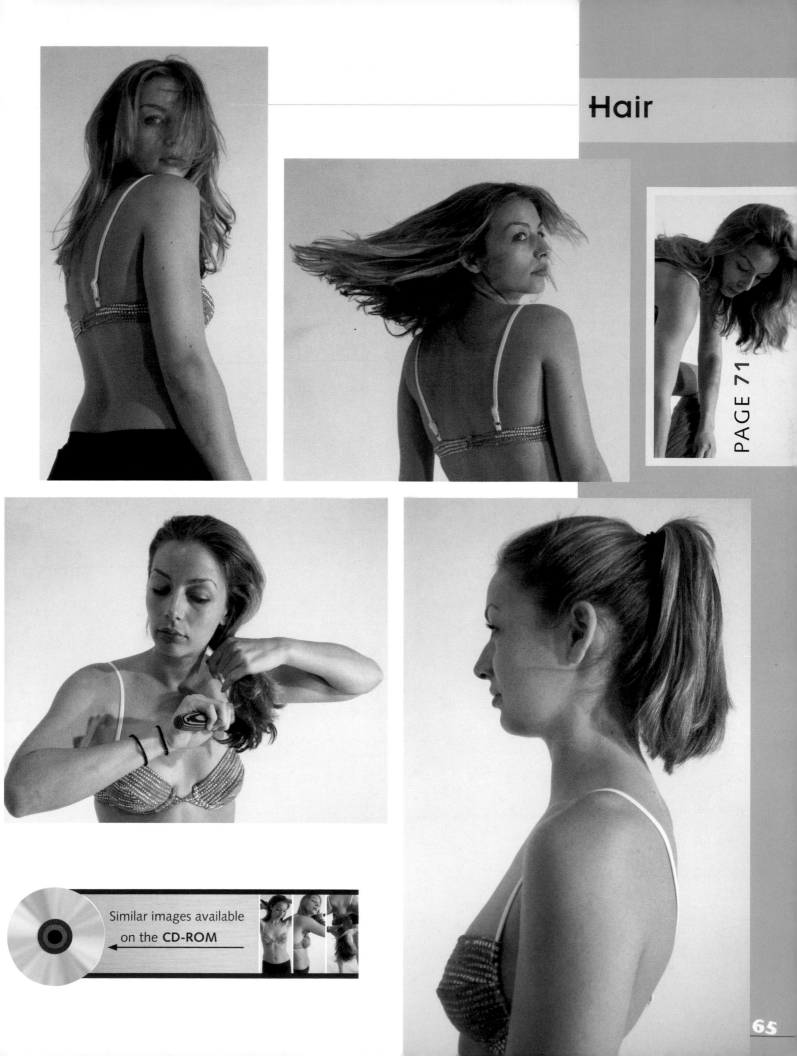

PAGE 71

Similar images available on the **CD-ROM**

Cape

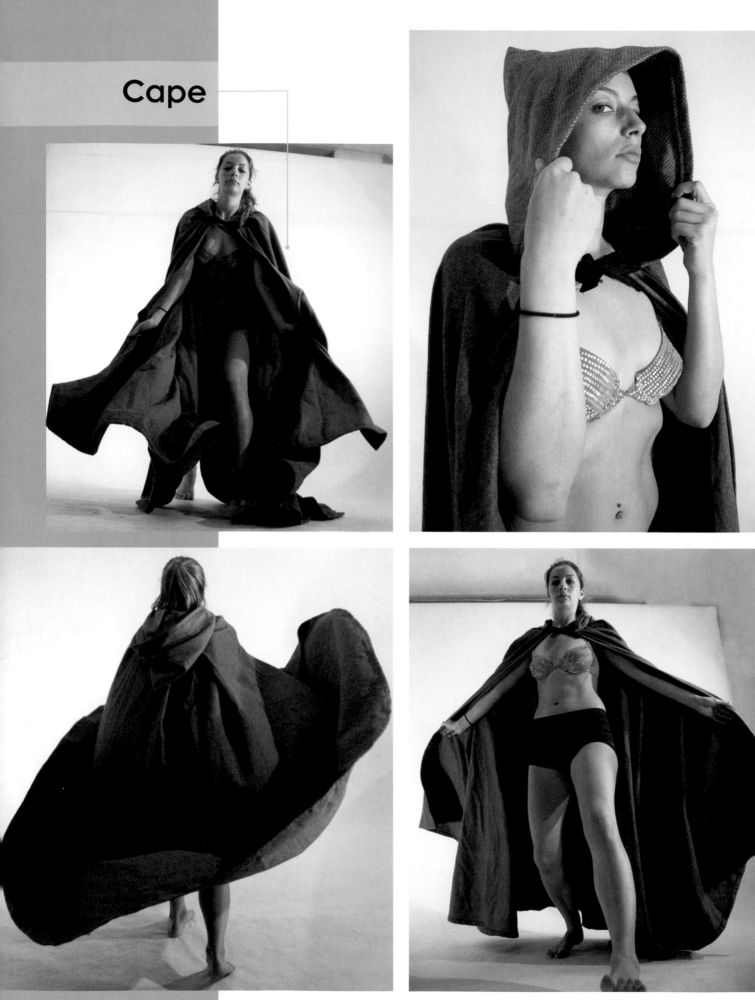

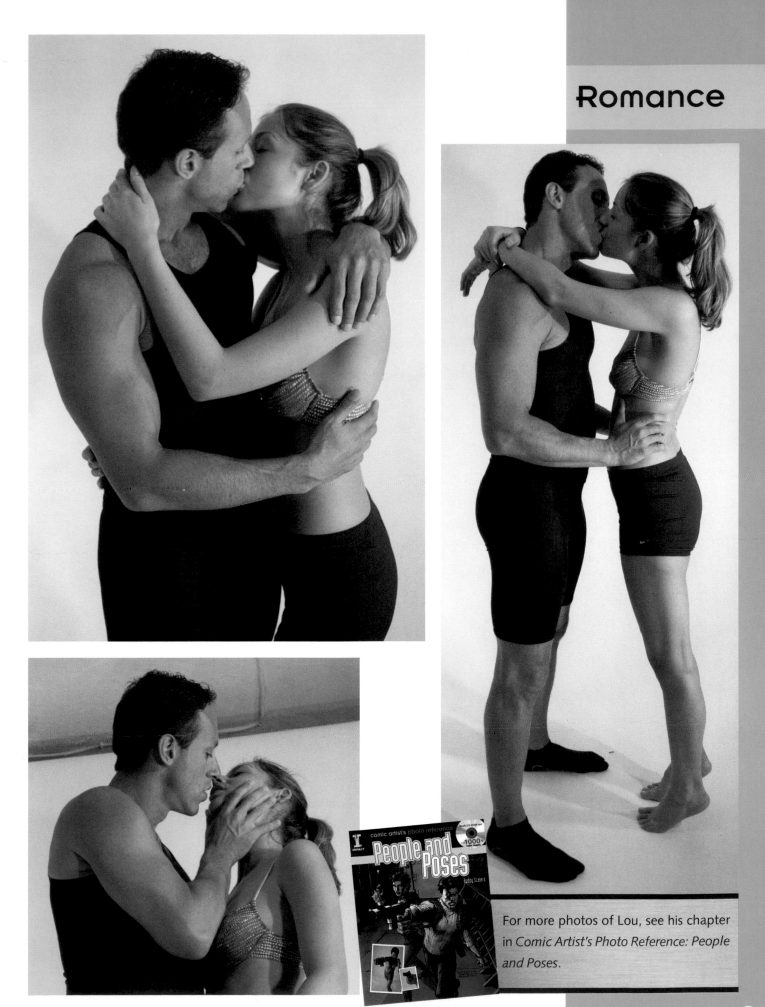

For more photos of Lou, see his chapter in *Comic Artist's Photo Reference: People and Poses*.

More Romance

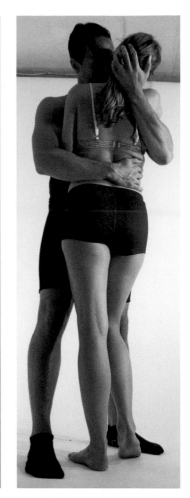

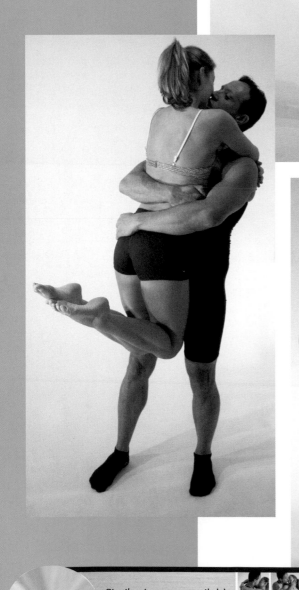

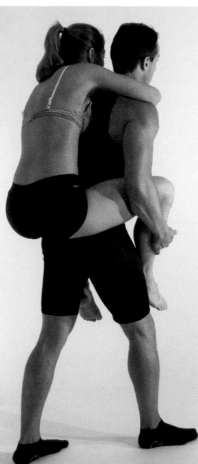

68

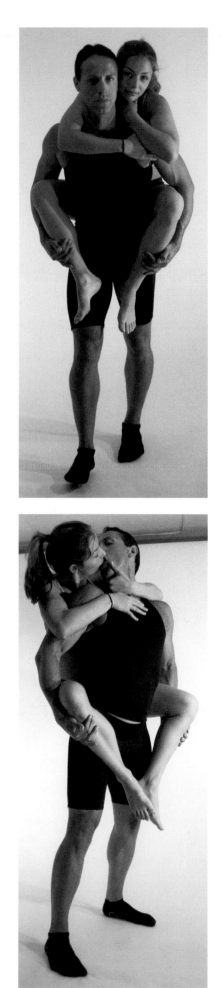

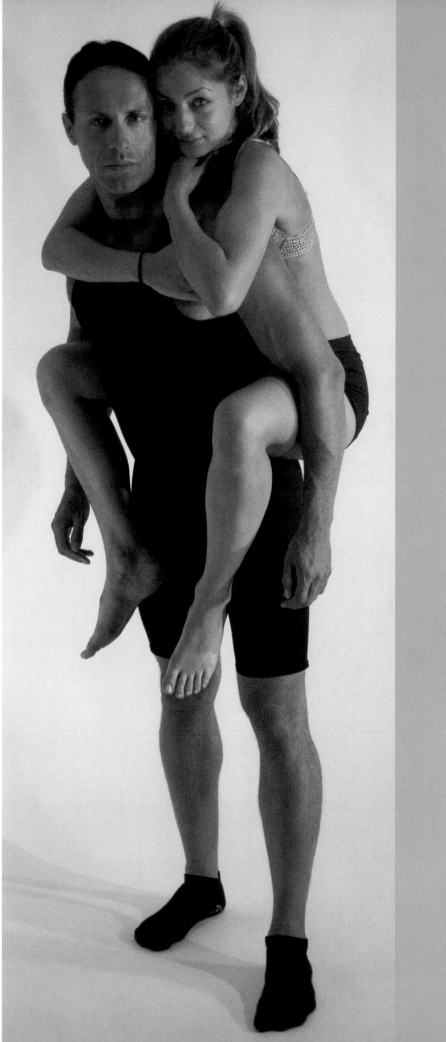

Dressing

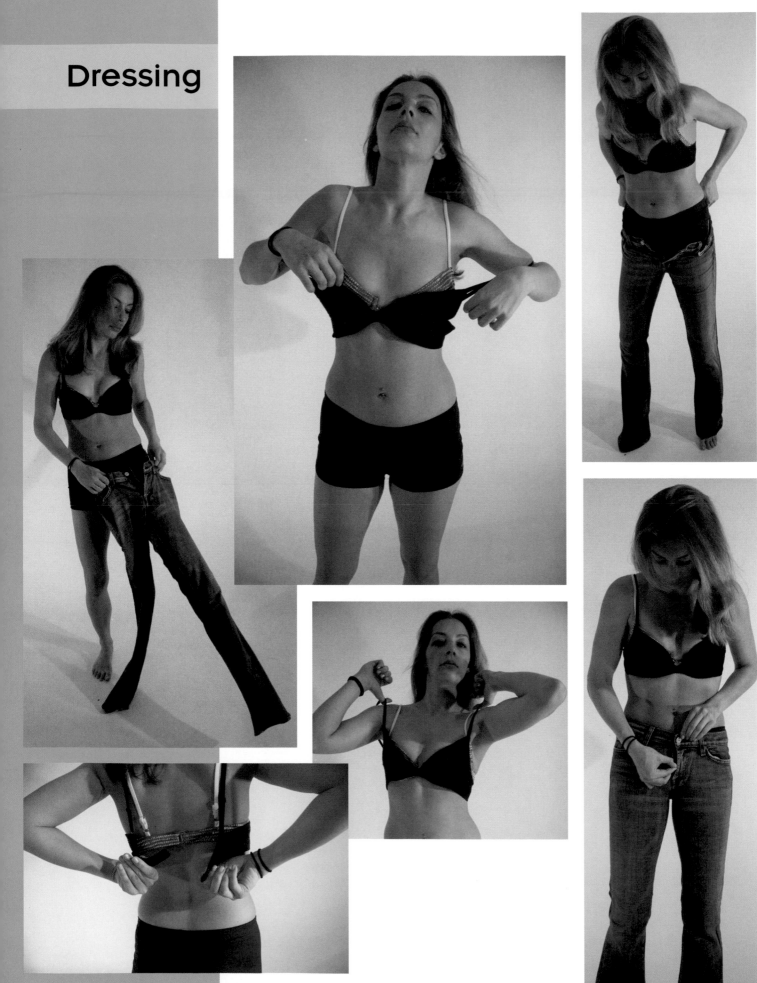

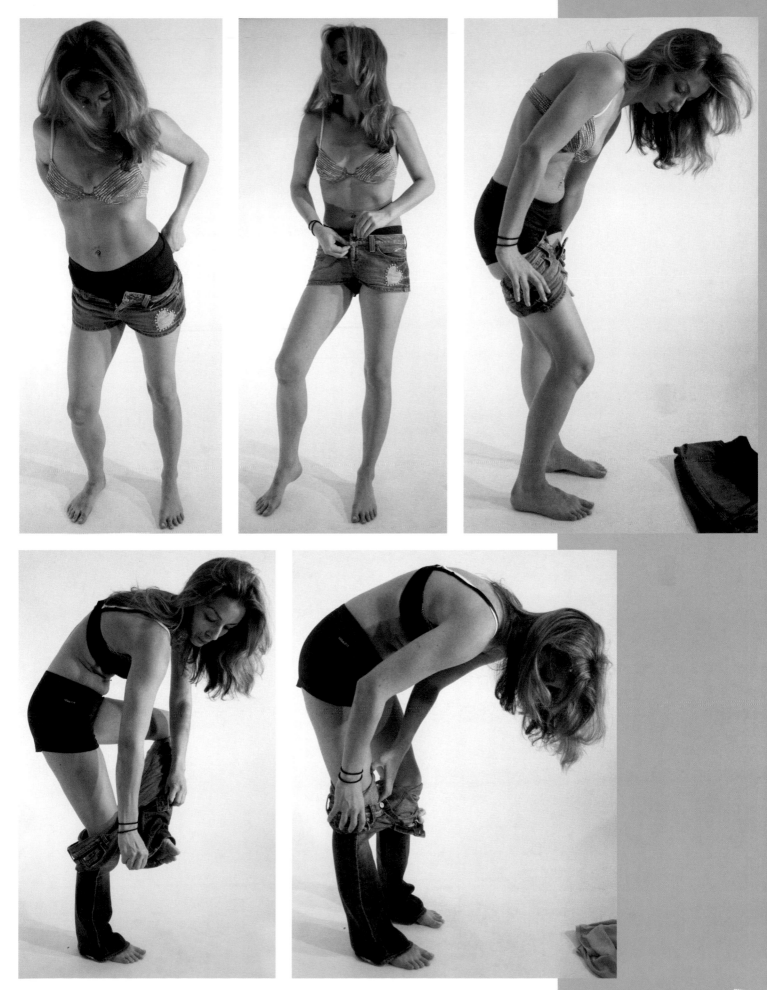

More Dressing

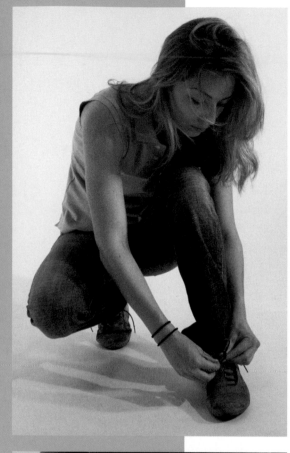

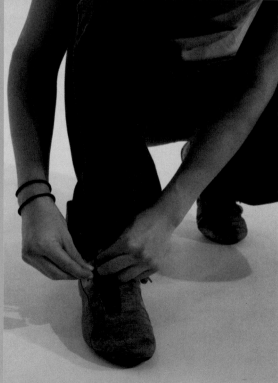

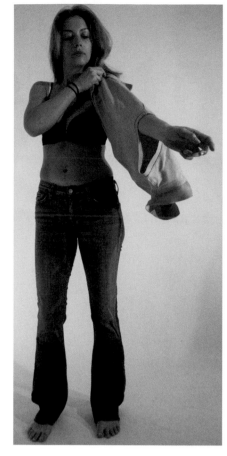

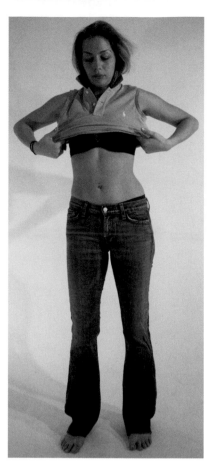

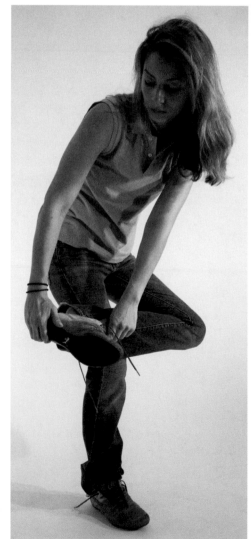

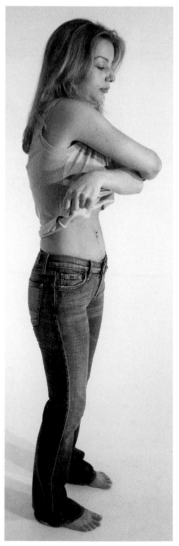

Think 3-D

BY TERRY MOORE

I like the flowing, uninterrupted body lines in this photo of Sarah (below). But when I draw, I like to remind myself that the body isn't just a collection of lines: it's three-dimensional; it's dynamic. If you draw only what the eye sees, your pictures will always look mechanical.

For example, always remember that when you're drawing a person, you're basically drawing muscles and bones with skin stretched over them.

Skin and muscles bend and flex; they respond to gravity differently in people of different ages, weights and sizes. These are the things I'm thinking about when I study the body.

Another suggestion: Imagine (and sketch) what the subject would look like from many different angles, not just the angle shown in the photo. It's important to remember that the muscles and bones you *can* see are connected to ones you *can't* see.

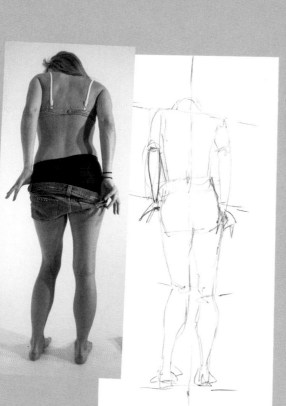

2 Find the Contours

Start darkening the major lines to capture the large shapes of the torso and limbs with more precision. Keep paying attention to balance, as you did in step 1, but add gravity and mass to your considerations. Where can you see the effects of gravity? You can tell her right leg is bearing more weight than the left because it's straight and the tendons above the knee joint are visible. Go ahead and create those tendons with two lines.

You can do this step fairly quickly. Even though you're working from the model, what you've drawn is almost generic: This could be almost any woman of similar height and size.

1 Capture Body Mechanics and Proportions

Lightly sketch the pose with a few crude lines. Early in the process, mark a centerline and use it to keep the body's weight balanced. For example, since Sarah's shoulders go left of center, you know that something else has to go right (in this case, the hips); otherwise she'd fall over.

To help yourself judge the body's proportions, make roughly horizontal marks at the heels, knees, wrists and shoulders.

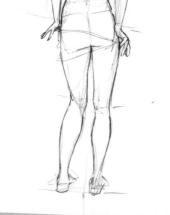

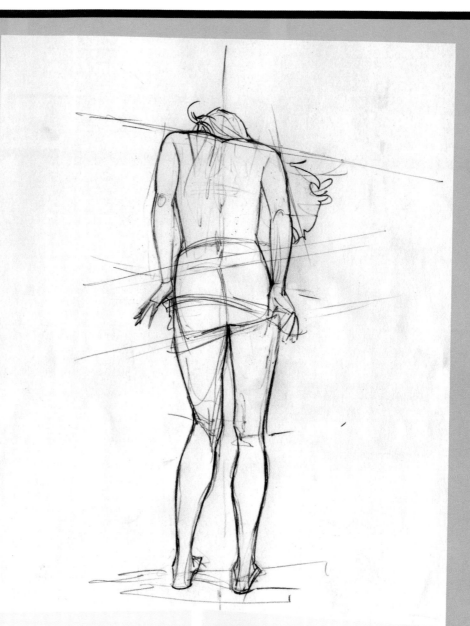

Get Specific

3 Now, check your drawing against the photo on a more detailed level. Study every viewable inch of the model. Does she have long, slender fingers, or are they short and stubby? Sturdy ankles, or skinny ones? Finish her hands and feet. See how the outside ankle bones are lower than the inside ones? And how the Achilles tendon goes all the way down to the heel? Add detail to the hair (and make it longer, if you want to). Now you're taking the drawing beyond a generic representation and making it about this specific woman.

There is so much information about this woman in the photo, I could write an entire chapter on her body type, age and lifestyle. We know that she is not large-breasted, because her bra straps are skinny and the skin on her back and around the band of her bra is taut and unstressed. Her softly contoured waist tells us that she doesn't have pronounced "six-pack" abs, but the indentations at the waistband of her spandex shorts are shallow, so her stomach must be pretty flat. The prominent veins over the muscles of her lower arms indicate that she works out. Her rounded calves, though, are the result of genetics; nice calf muscles are something you have to be born with.

If this is all beginning to sound very personal, it is. To draw the model correctly, you have to know what you're looking at, what it looks like, and how it got that way—even if it's hidden.

Sketch a Few More Angles, Then Add Clothing and Anatomical Detail

Take a moment to scribble the pose from a couple of other angles, imagining what you'd see on other sides. Like I said at the beginning, being able to picture what's going on around the bends is crucial, because everything you see is connected to the parts you can't see.

Remove the generic lines with a kneaded eraser, and draw in more of the details that are specific to this model. I think about the transition points of the muscles on her shoulders,

arms and legs. My pencil runs over her back and tries a few lines to see if I want to go there with the art. Probably not. What are the denim shorts getting hung up on there—what's keeping them up on the left? Ask yourself questions like these; they remind you that these forms are round, they jut out, they bump into things and push and squeeze and deform and bounce back.

OK, in the next step you'll start inking. Whatever you haven't yet penciled, such as the details of the shorts and hair, you will draw as you ink.

Ink Like a Penciller

Using a brush or pen, ink the main lines of the body, leaving the details for your second pass. Start inking at the head, then work your way down: left arm, right arm, torso, legs, feet. As your brush moves around the body, think about the muscles and bones, making bumps and mounds for muscles stretched and contracted. You need both the skill of an inker and the mind of a penciller to make the lines smooth with varying weights that imply mass and light.

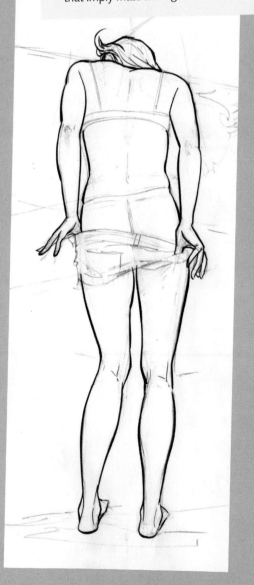

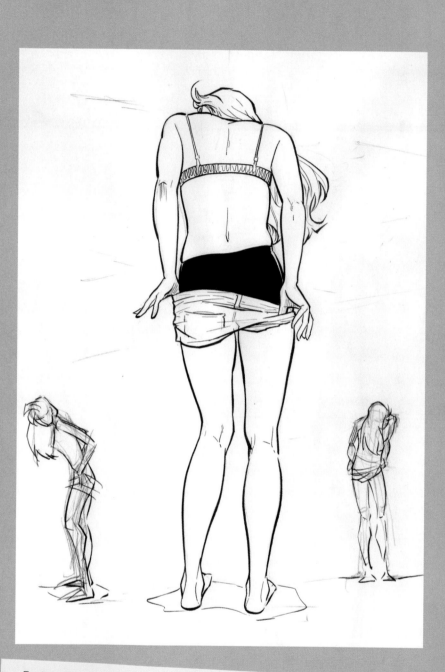

Add Final Details

Ink the details on the elbows, hands, back, knees and clothing. Fill in the solid black area. If the drawing is going to be computer-colored, say for a comic book, these lines will be enough for the colorist to play off of. The colorist can create nice, subtle toning that harsh inking cannot achieve.

Erase the remaining pencil lines with the kneaded eraser, and your art is ready to scan. The few stray ink lines (like around the shorts) can be touched up digitally after scanning.

On the smaller, sketched figures, I tried to illustrate the body language with a few brushstrokes. I think this pose would be interesting from any angle.

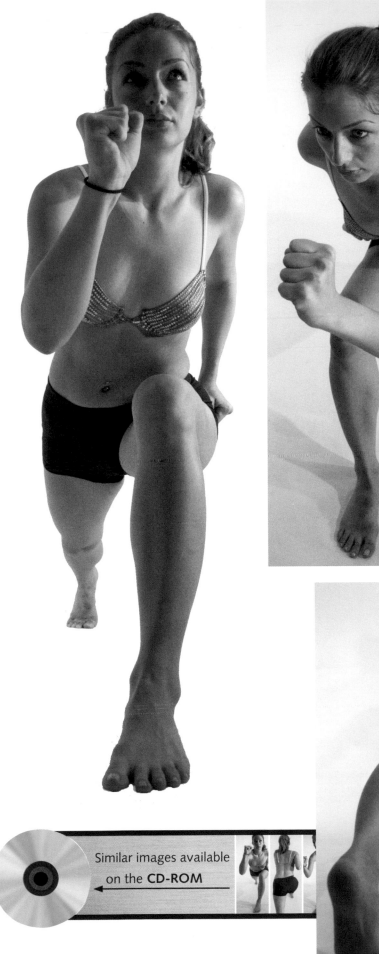

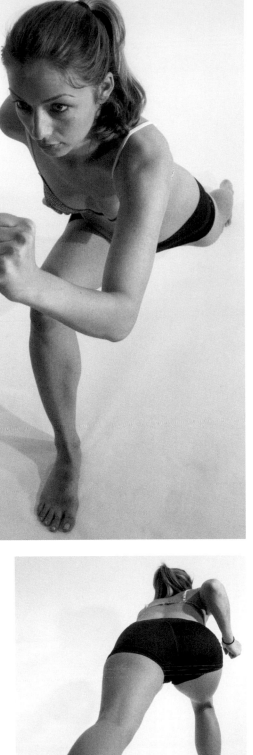

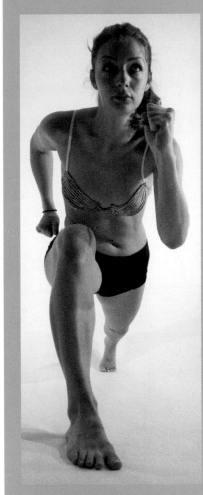

PAGE 78

Similar images available on the **CD-ROM**

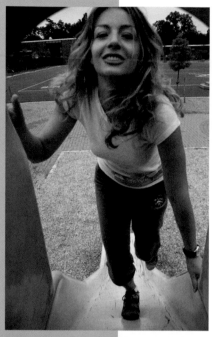

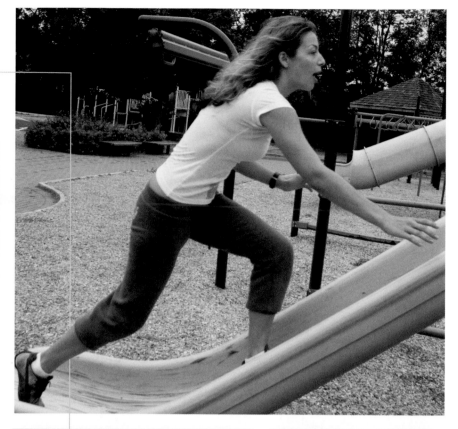

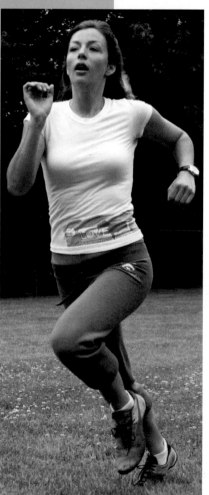

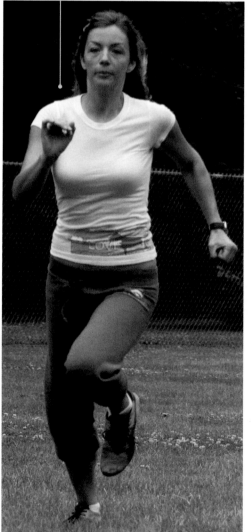

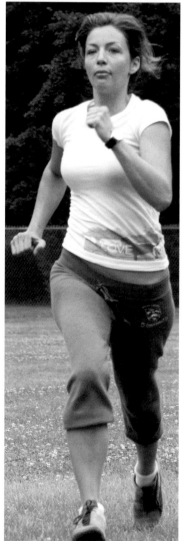

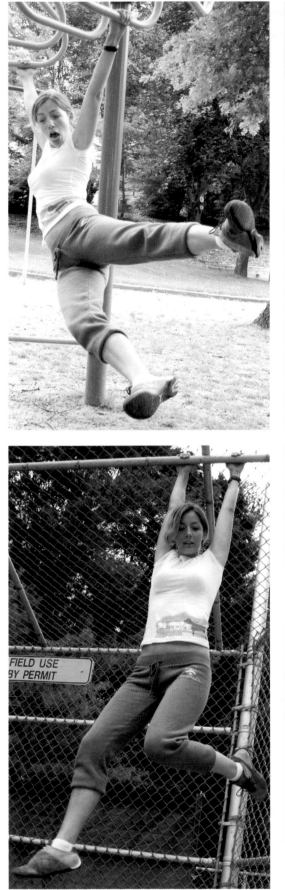

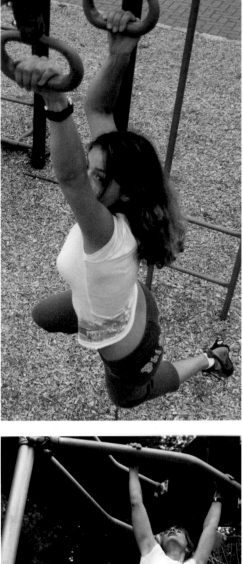

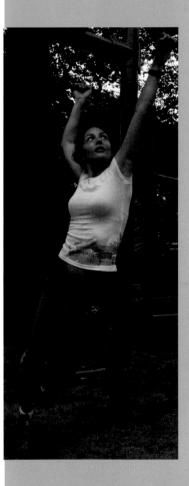

Similar images available on the **CD-ROM**

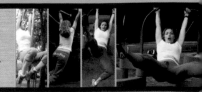

Climbing
& Jumping

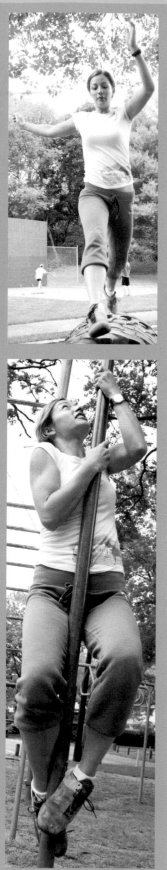

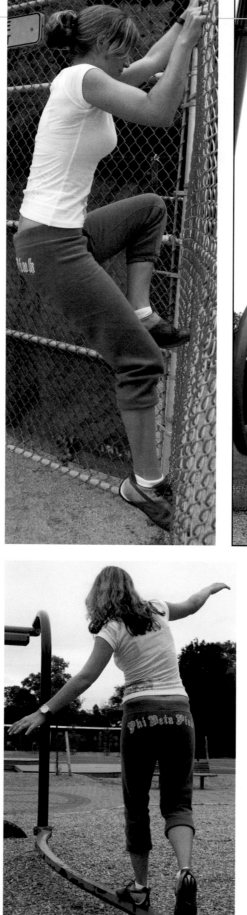

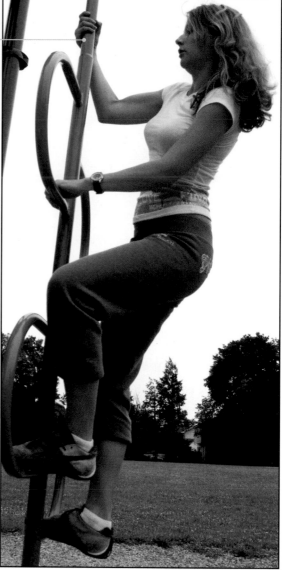

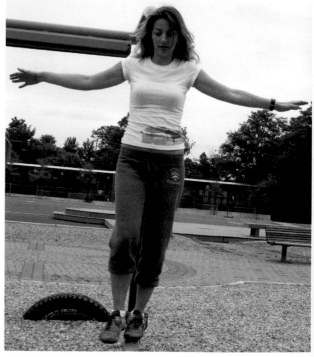

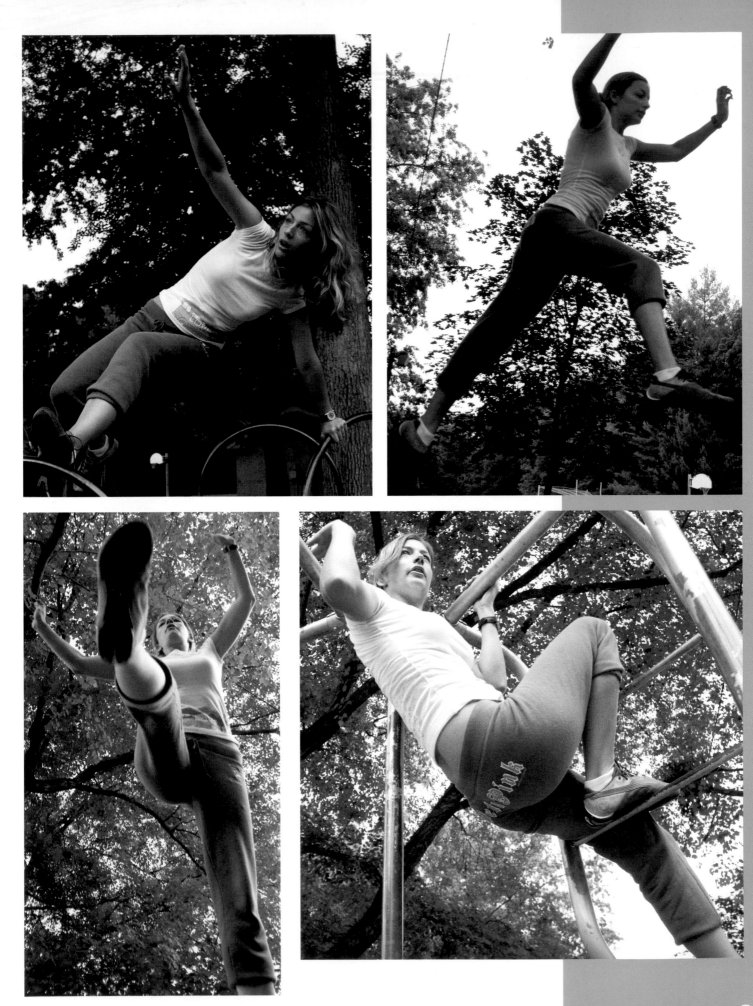

Pamela

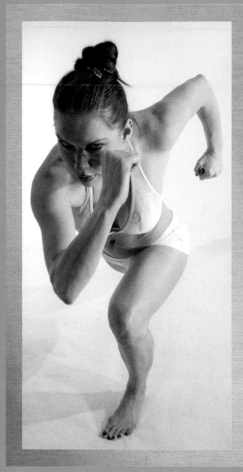

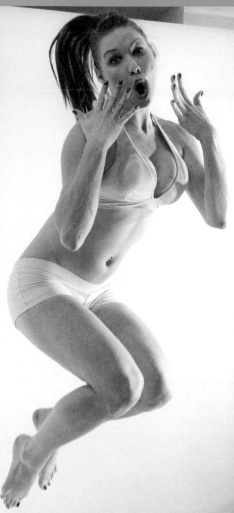

Age: 26

Height: 5' 10" (1.8m)

Weight: 145 lbs. (66kg)

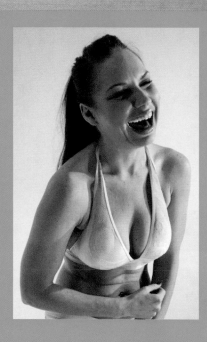

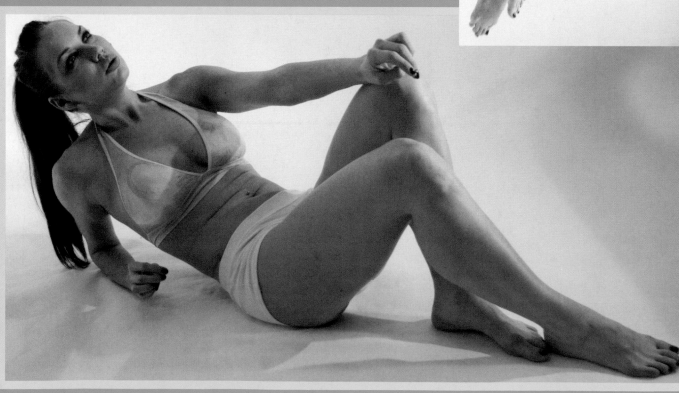

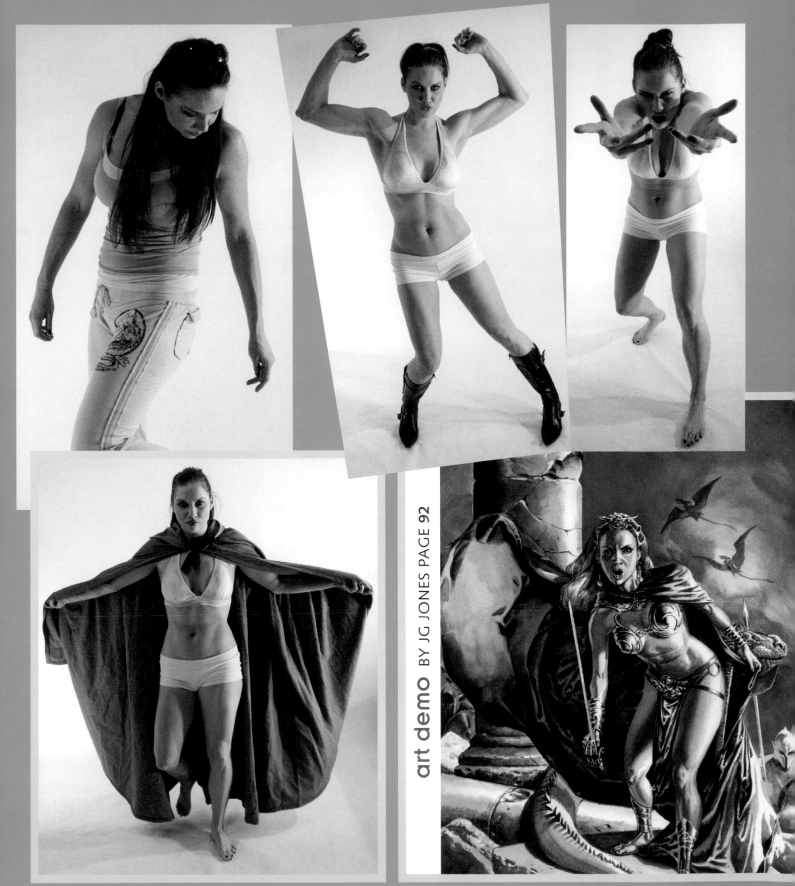

art demo BY JG JONES PAGE 92

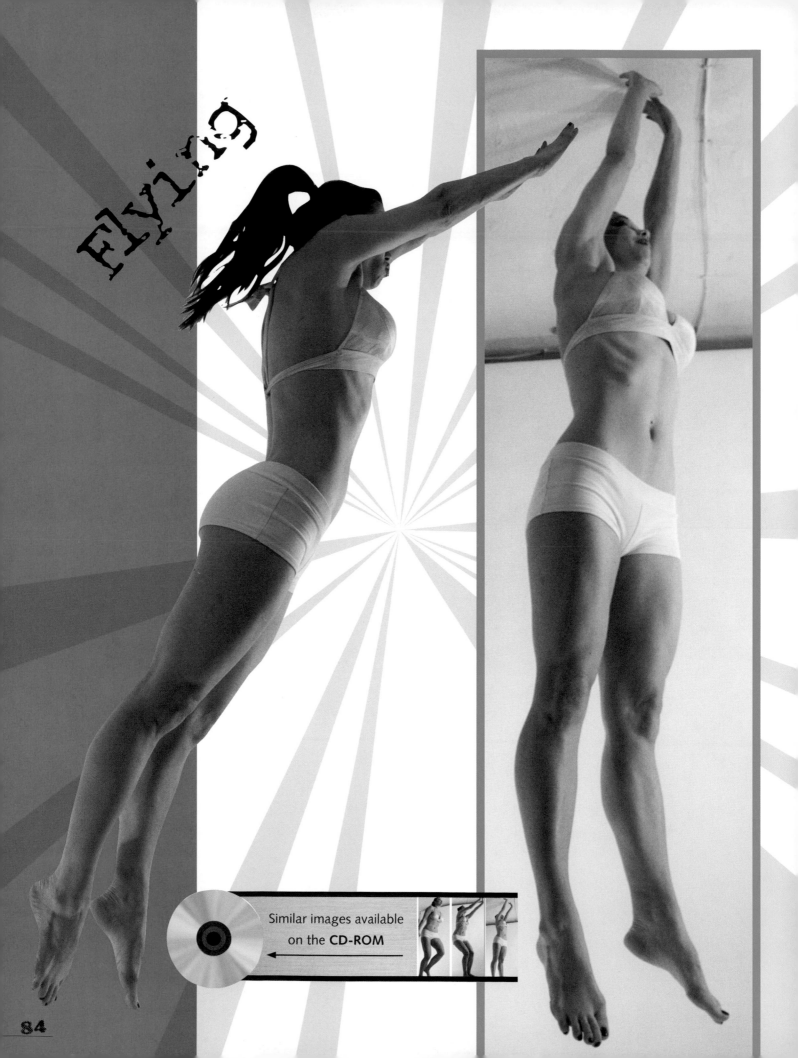

Flying

Similar images available on the **CD-ROM**

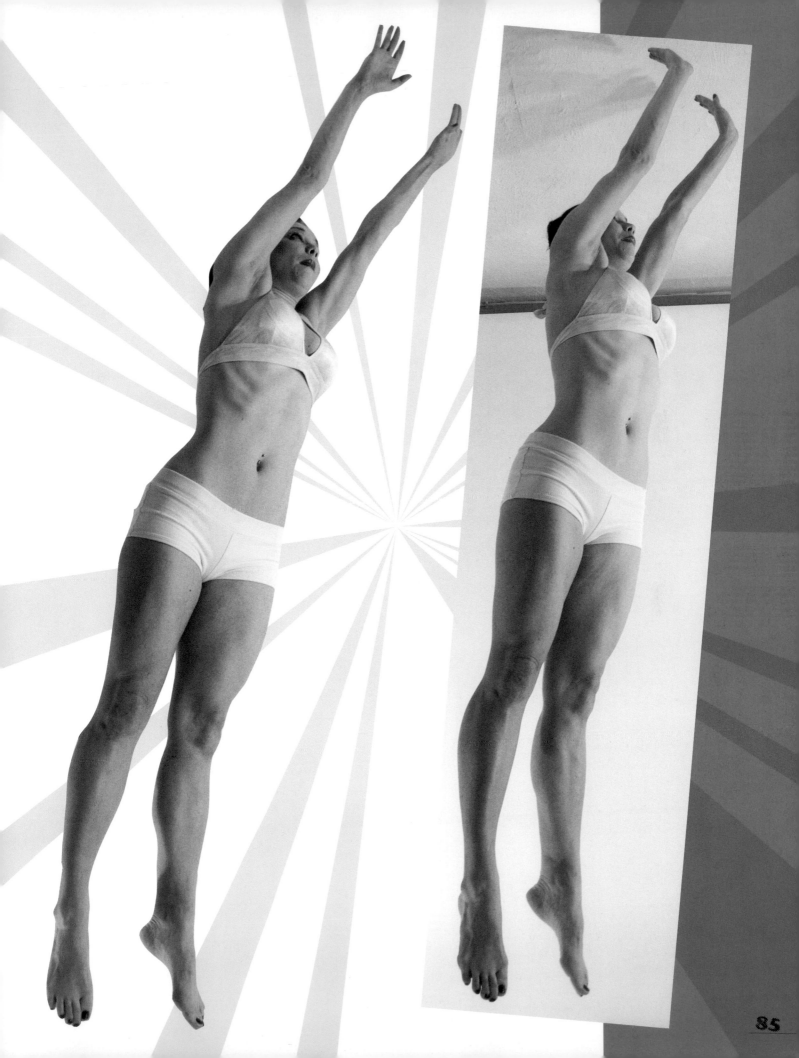

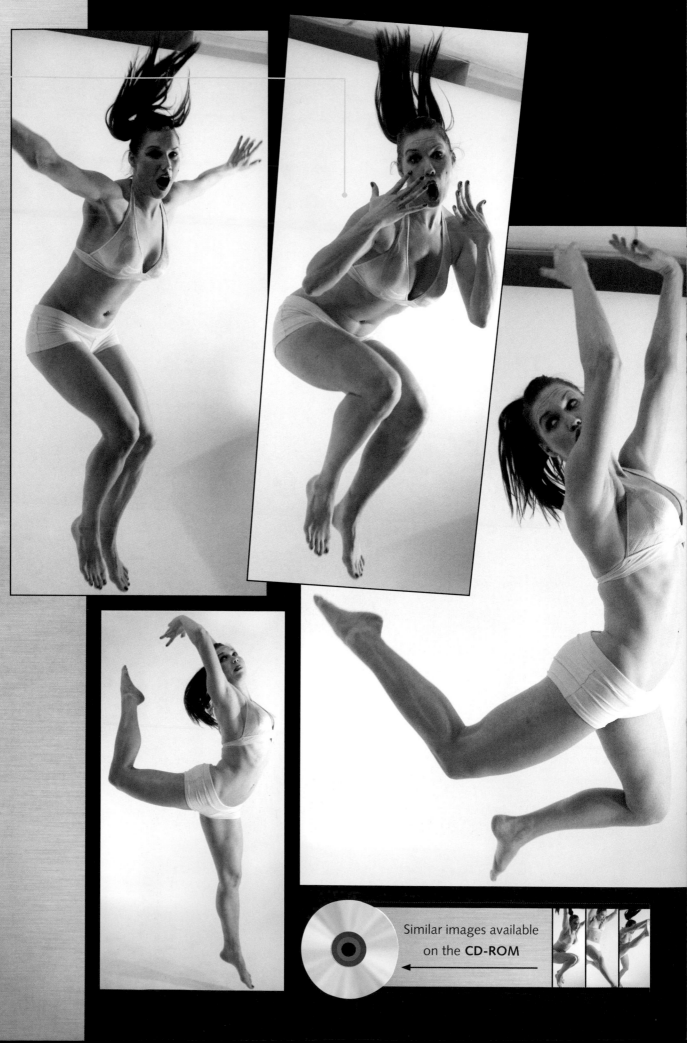

Jumping

Similar images available on the **CD-ROM**

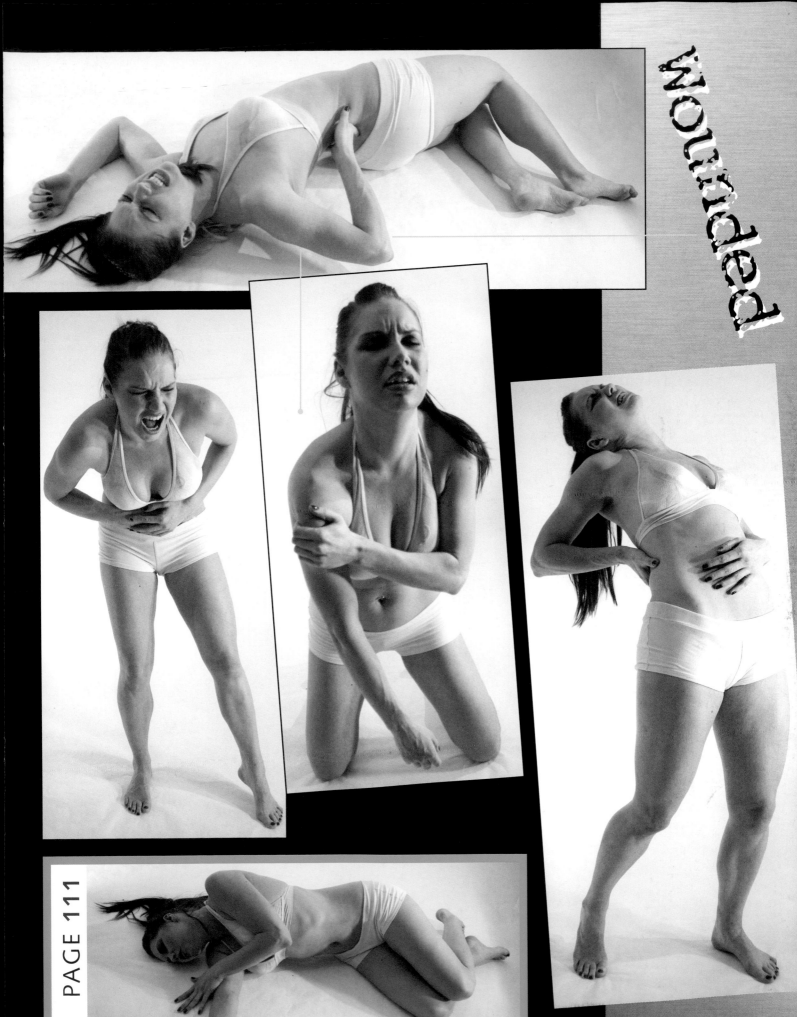

PAGE 111

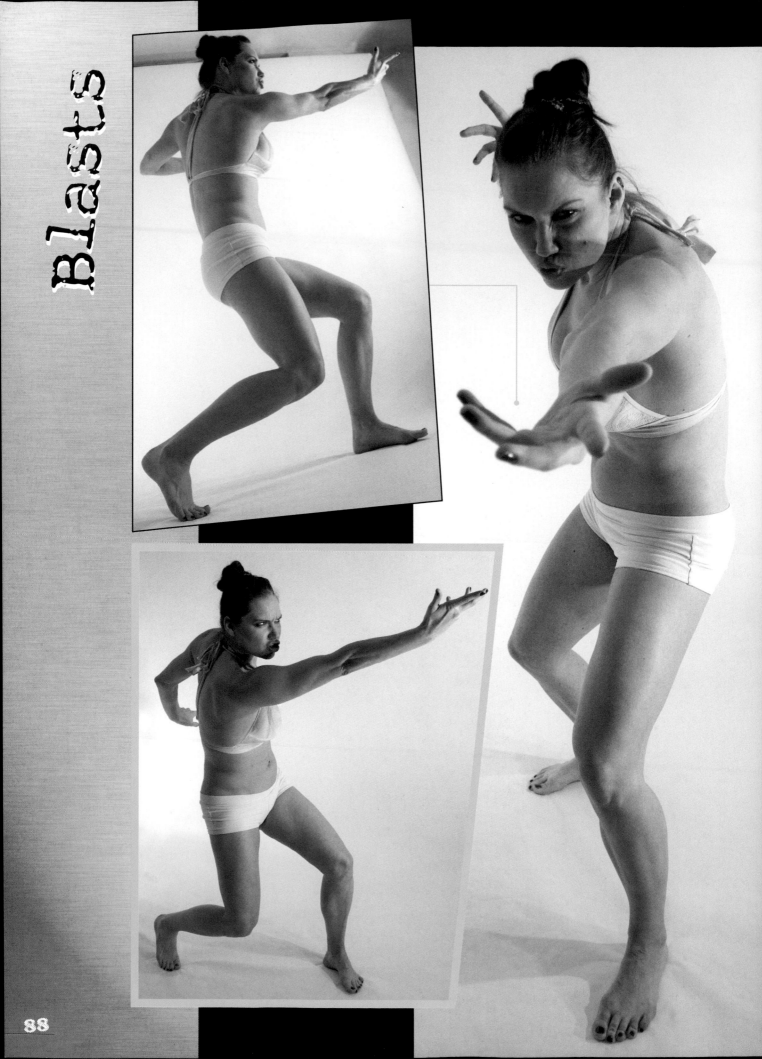

Blasts

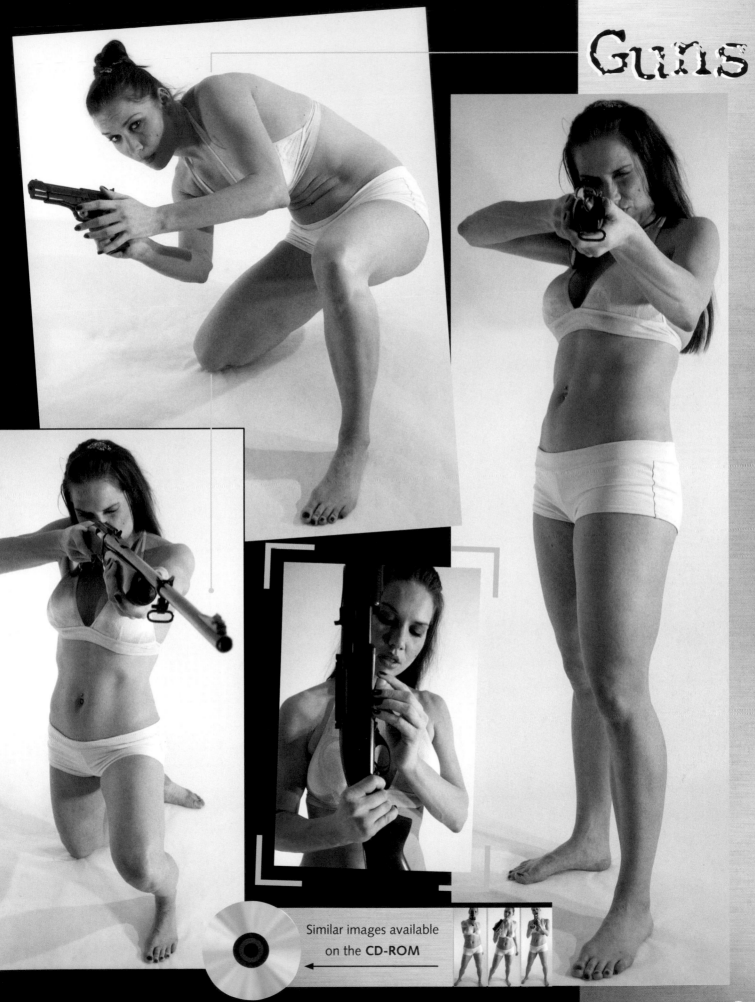

Guns

Similar images available on the **CD-ROM**

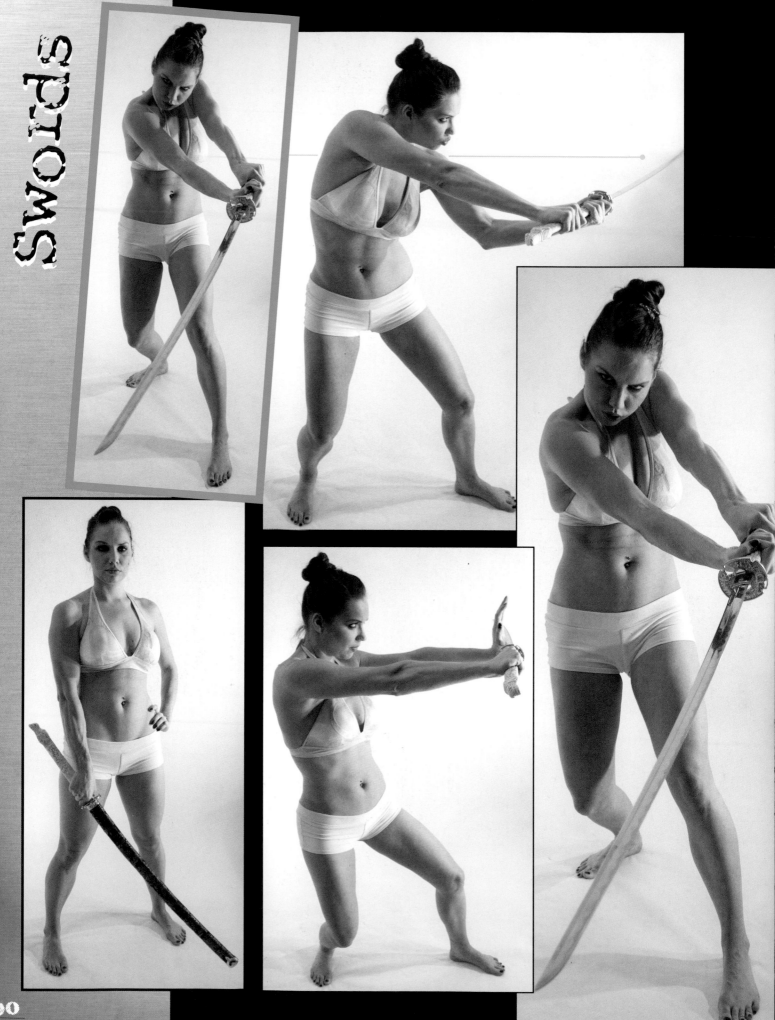

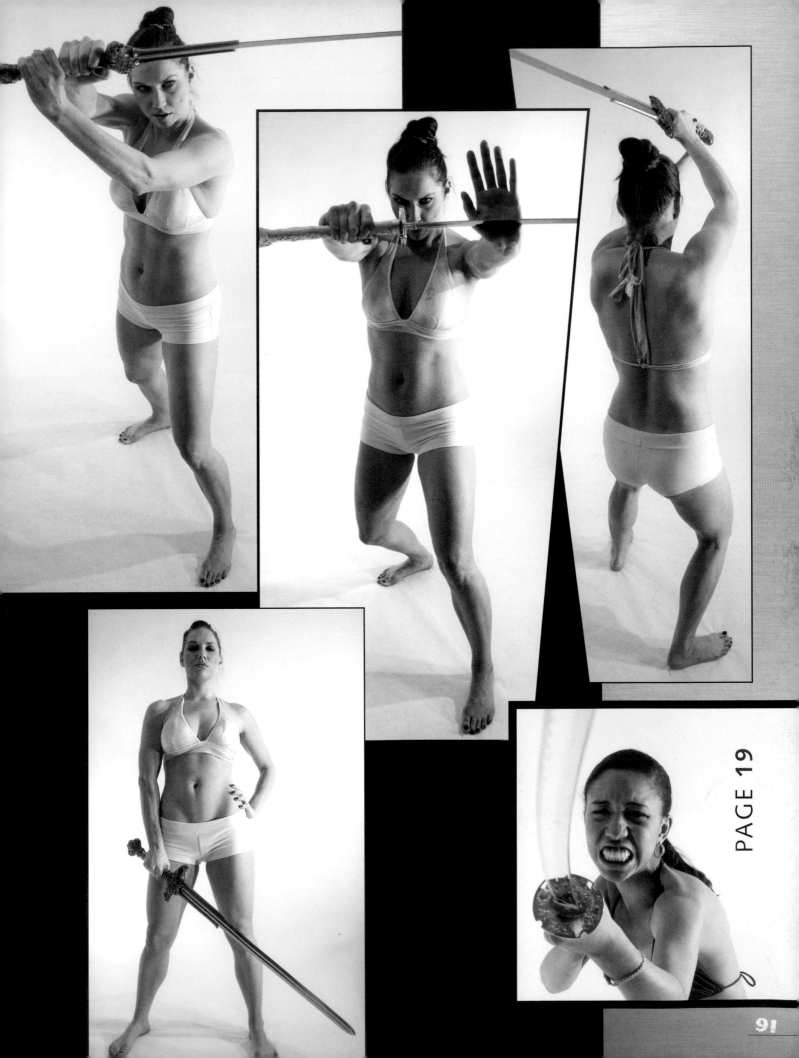

PAGE 19

Art Demo

Evolution of a Cover

BY JG JONES
WITH COVER DESIGNER TERRI WOESNER

We all know we're not supposed to judge a book by its cover, but that's what people do when they browse bookstore shelves. For this project, IMPACT Books needed cover art with attention-grabbing action, color and energy. We knew superstar cover artist JG Jones had the artistic stopping power to help this book leap off the shelves.

In this lesson, JG Jones gives you a behind-the-scenes look at his sketches, studies and notes, while Buddy Scalera and IMPACT designer Terri Woesner share their recollections and observations about the cover development process.

1 TERRI

I asked JG to choose two of Buddy's photos to use as the basis for a piece of dynamic cover art that would engage the reader at first glance. JG picked these photos of Pamela. In the sword photo, she really grabs the viewer with her direct gaze and aggressive pose. JG thought the cape from the other photo could be incorporated to create contrast and visual interest in the background.

I agreed that the concept was cover-worthy. I asked JG for art with a science-fiction/fantasy theme.

3 BUDDY

JG flops the image back and forth using his computer. In this early sketch, he uses both photos backwards, testing whether the image "reads" more naturally that way.

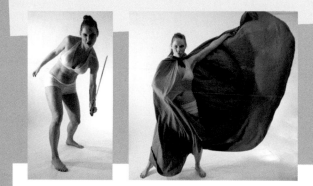

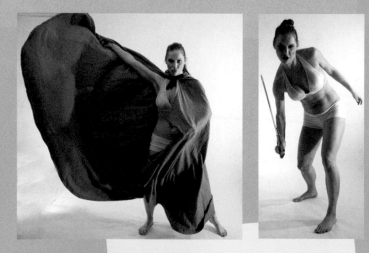

2 BUDDY

If you want the subject of a photo to look strong and dominant, you shoot from a low angle. That's what I was doing here.

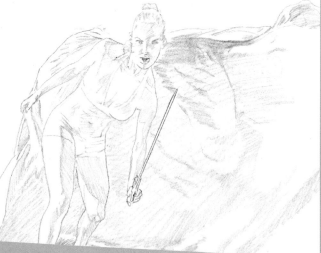

4 TERRI

This rough thumbnail sketch let me see how JG was planning to pull the two photos together, so that I could give him my input before he started to invest a lot of time in creating final art.

5 TERRI

JG said this concept was inspired by the warrior women on various covers from the science-fiction classic *John Carter, Warlord of Mars*. Here, you can see him starting to add costume elements that are in that spirit.

For this sketch, JG flopped the photos back to their original orientations. In a minute, you'll see why.

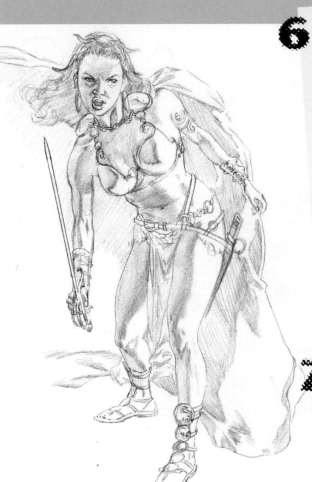

6 BUDDY

As JG takes Pamela's core pose and starts to add props and costume, he doesn't just paste them on like paper-doll clothes; he wraps them around the figure. The scabbard of the sword hangs behind the leg; the bracelets curve around the wrists; the straps and chains drape around the hips; the loincloth partly disappears behind the leading leg. All of these details contribute depth and realism, enhancing our sense of this character as a 3-D woman.

7 BUDDY

Pamela was in motion when both of the reference photos were shot. JG does a great job of adding visual cues that capture this sense of motion: the flowing cape, the flying hair.

8 BUDDY

A figure in motion is inherently off balance. If you draw the lines of Pamela's frame on the photo, you get subtle clues as to how she was moving when I snapped the picture. In this pose, Pamela was pretending to duel with an unseen opponent. Even though her body and shoulders are tilted, she keeps her eye level almost perfectly horizontal, which is typical of people with good physical control.

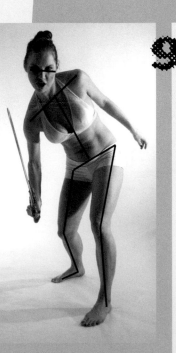

9 BUDDY

When I photographed Pamela, I was using more than one light. The most intense light was coming from her left. Additional studio lights made it easier to see details that would otherwise have been lost in the shadows.

The sketch above clearly shows the direction of the light source, even though JG had no specific knowledge of how I had set up the photo studio.

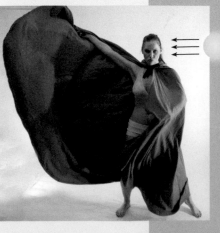

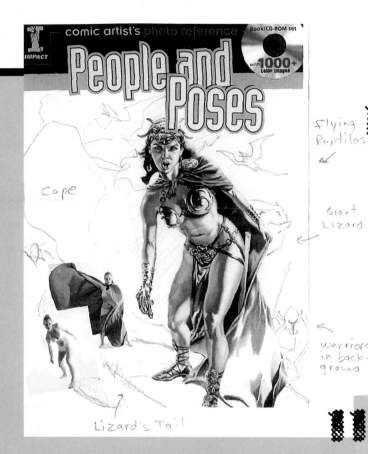

Cape

Flying Reptiles

Giant Lizard

warriors in background

Lizard's Tail

10 TERRI

JG scanned the cover of the first book in Buddy's series, *People and Poses*, and used it as a template for a mock-up. I didn't ask him to do this; he just did it, and I was thrilled because it made it much easier for everyone at IMPACT to visualize the final product. Also at this stage, JG started painting with watercolors to show me the color notes he had in mind.

The first cover in the series featured reference photos in the lower left corner. For consistency, I wanted to keep the photos at the lower left for this cover as well. So JG flopped the pose again, back to the original orientation, to make room for the photos.

11 TERRI

You can see JG's handwritten notes in the margins here. The creatures and other background touches were all his idea. I was excited to see JG's vision for the entire piece starting to materialize.

12 TERRI

I really liked the red tones JG used for the loincloth, and I asked him to repeat those colors in the background of the image.

13 TERRI

The red-orange palette worked well with Pamela's warm skin tones. The hint of purple amid the orange in the loincloth was an exciting contrast.

14 BUDDY

As JG roughs in the background creatures and other elements, the cover is gaining depth and context. With just a few carefully chosen details, he is creating a complete and believable environment for the character.

15 TERRI

Buddy's studio floor was of course flat, yet just by curving those long shadows in the foreground, JG was able to make the character look as if she is standing on uneven ground or even stepping over something!

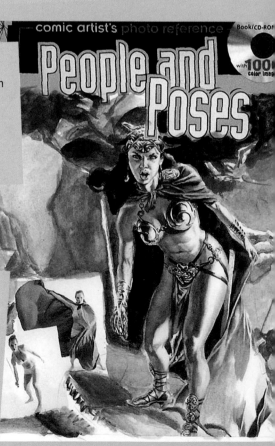

TERRI

The colors in the studies were pretty muted, so I asked JG if he could brighten them up a little for the final. I was impressed by how much punch he was able to add with watercolors.

To make the character work with the red-and-orange theme, JG changed the color of the character's hair from brunette to blonde so that it wouldn't get lost in the background.

17 TERRI

Books in a series need to have a unified design, yet they also need to be easily distinguished from one another. The green title treatment in JG's mock-ups came from the first book in the series. For the second book (this one), I knew I would be changing the color behind the title. I allowed JG's artwork to guide my choice. The purple that started out as just a hint of color in the loincloth became a powerful yet feminine color for the title treatment.

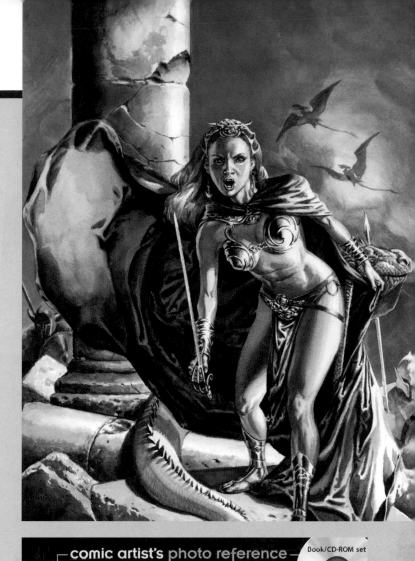

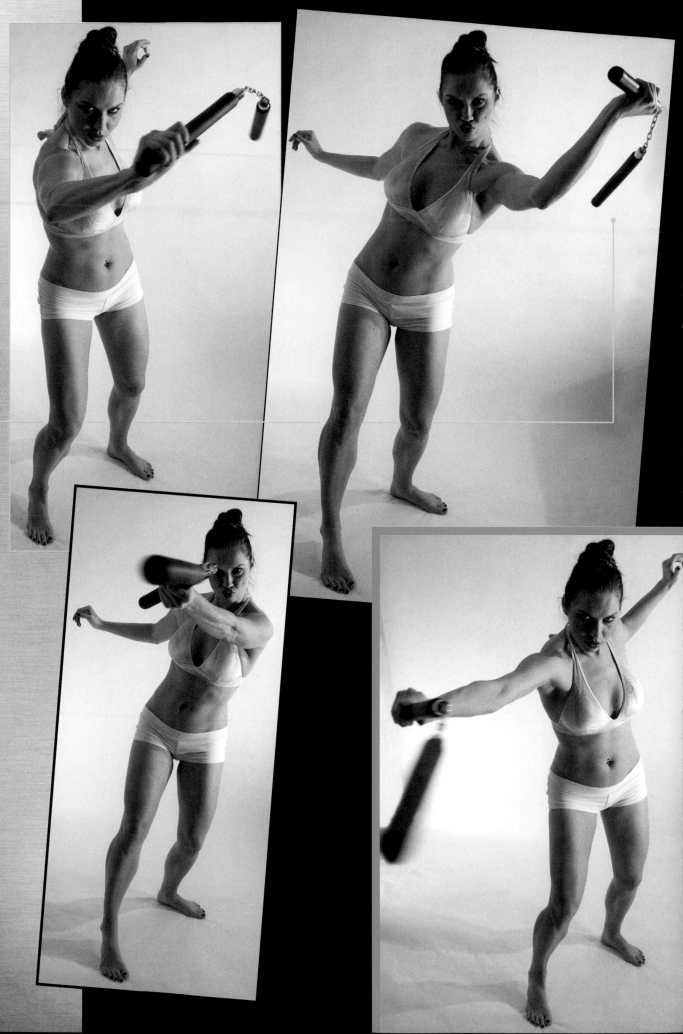

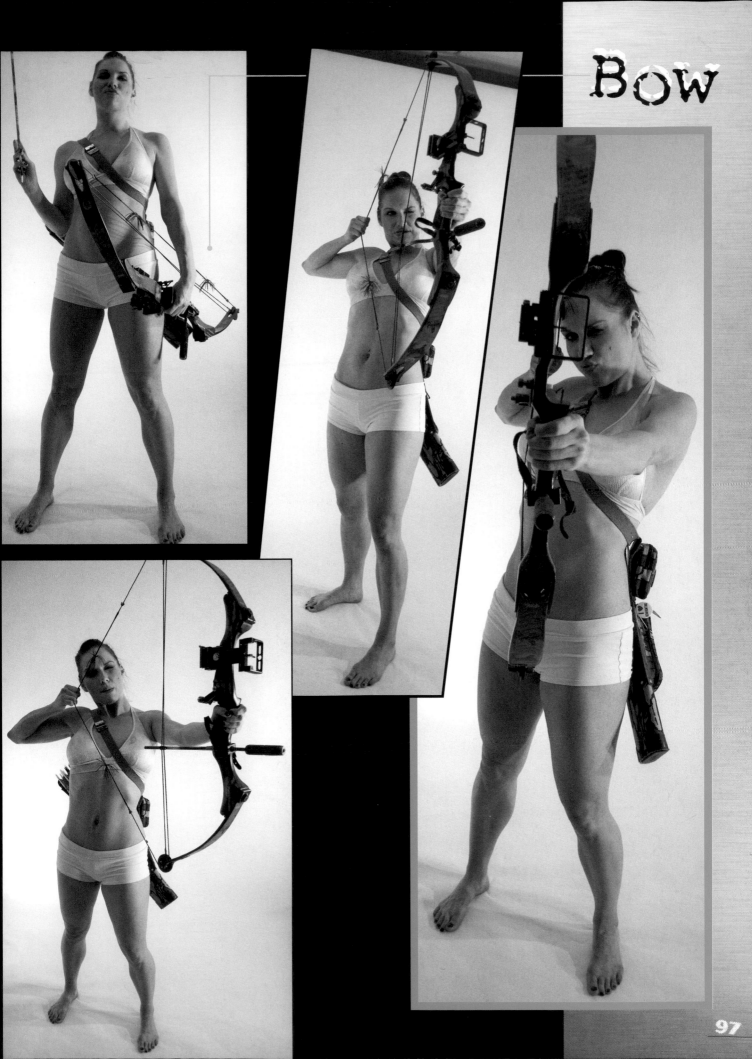

Expressions

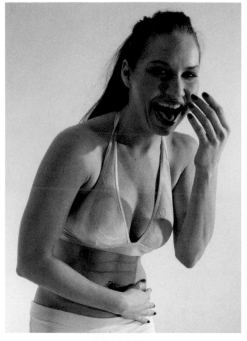

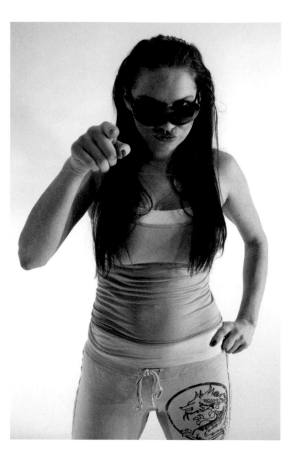

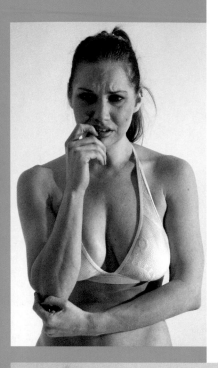

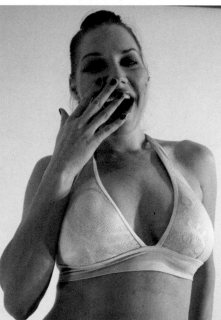

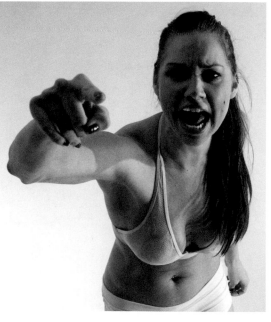

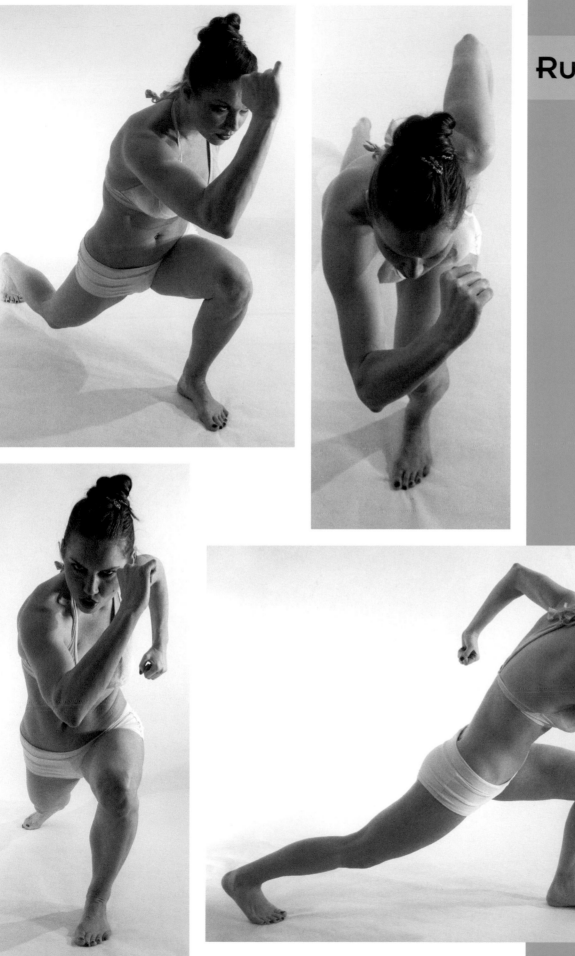

Lifting

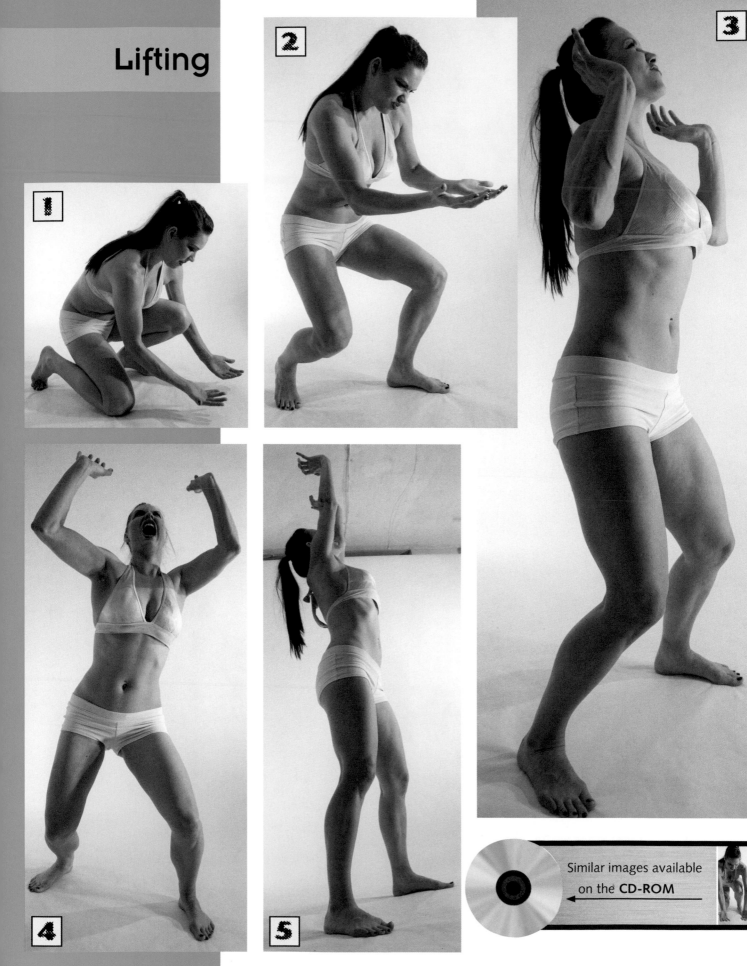

Similar images available on the **CD-ROM**

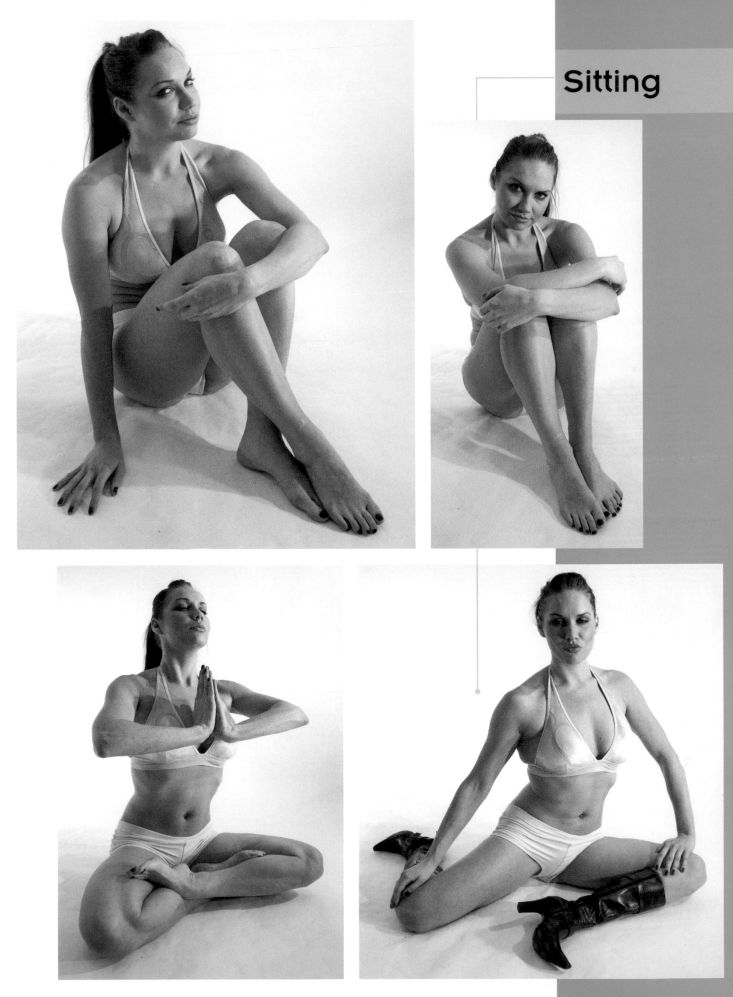

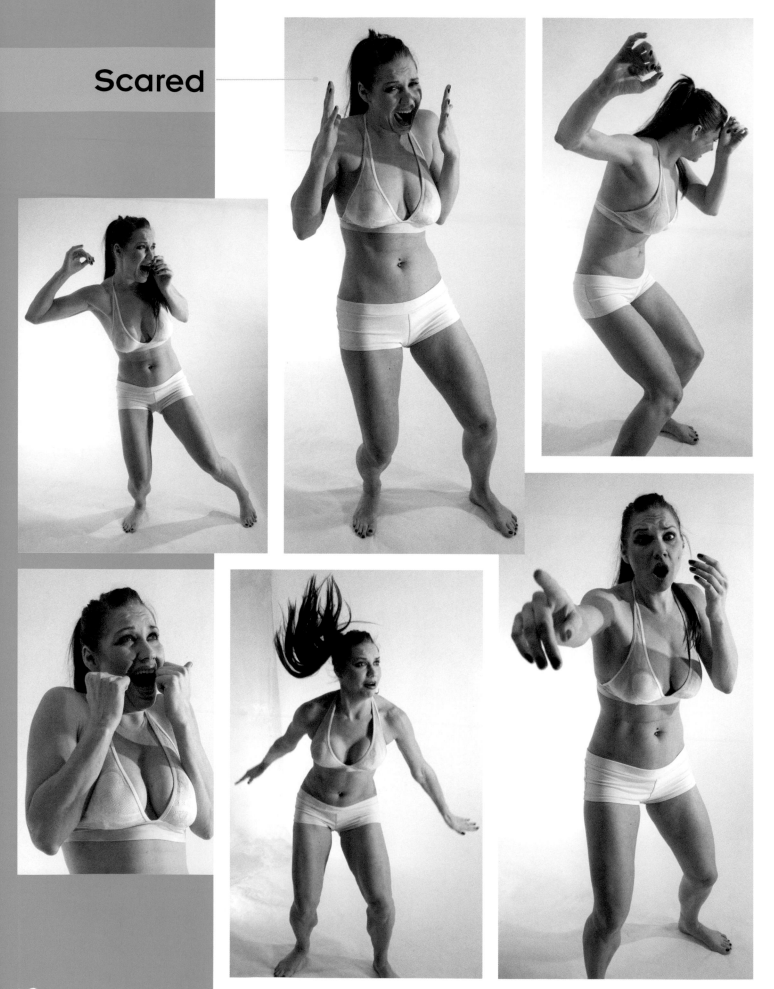

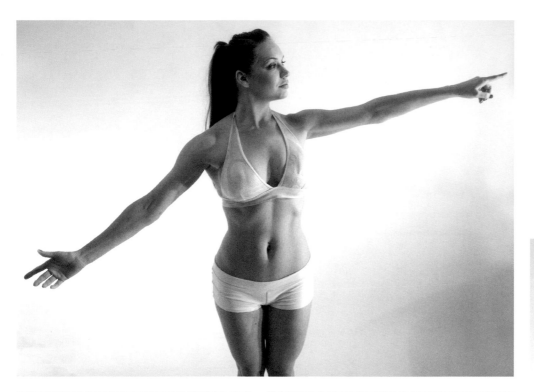

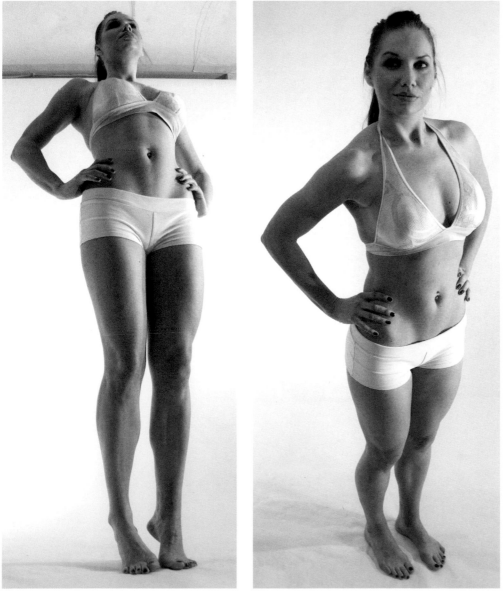

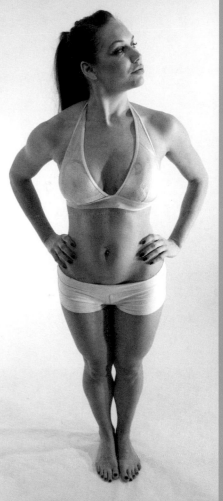

Makeup

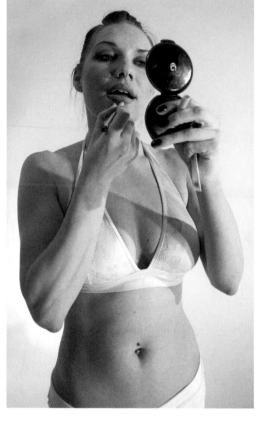

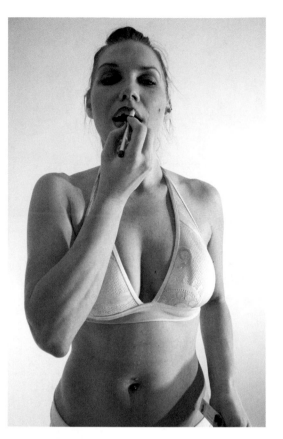

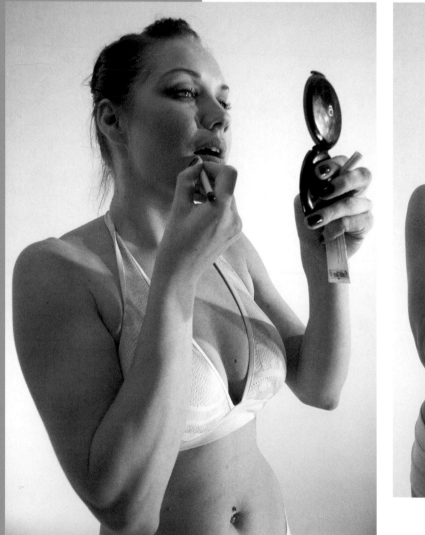

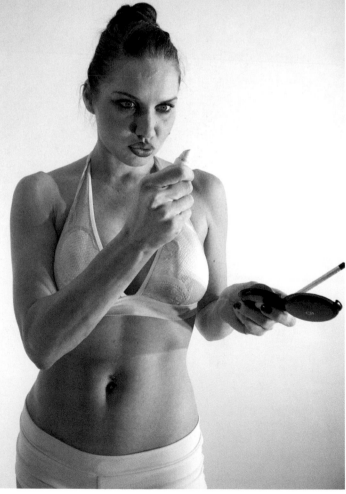

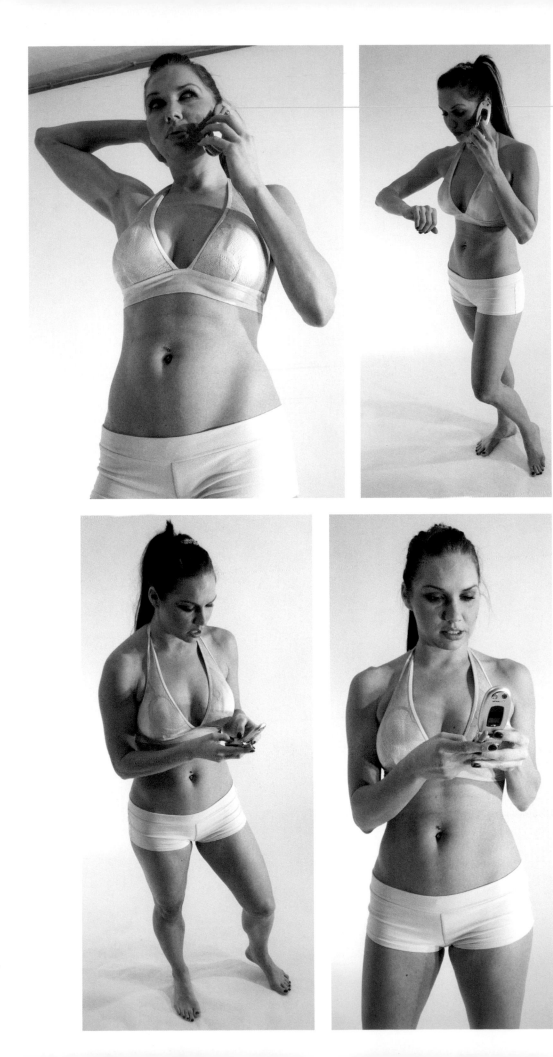
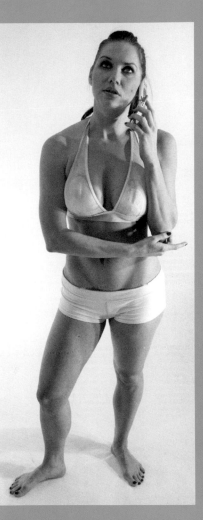

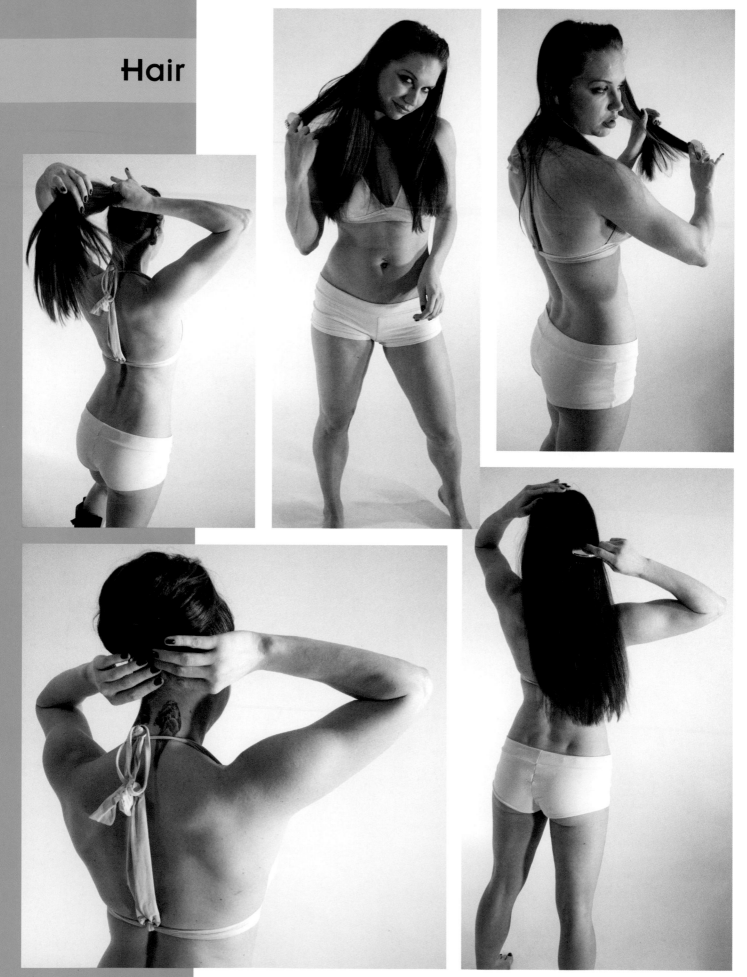

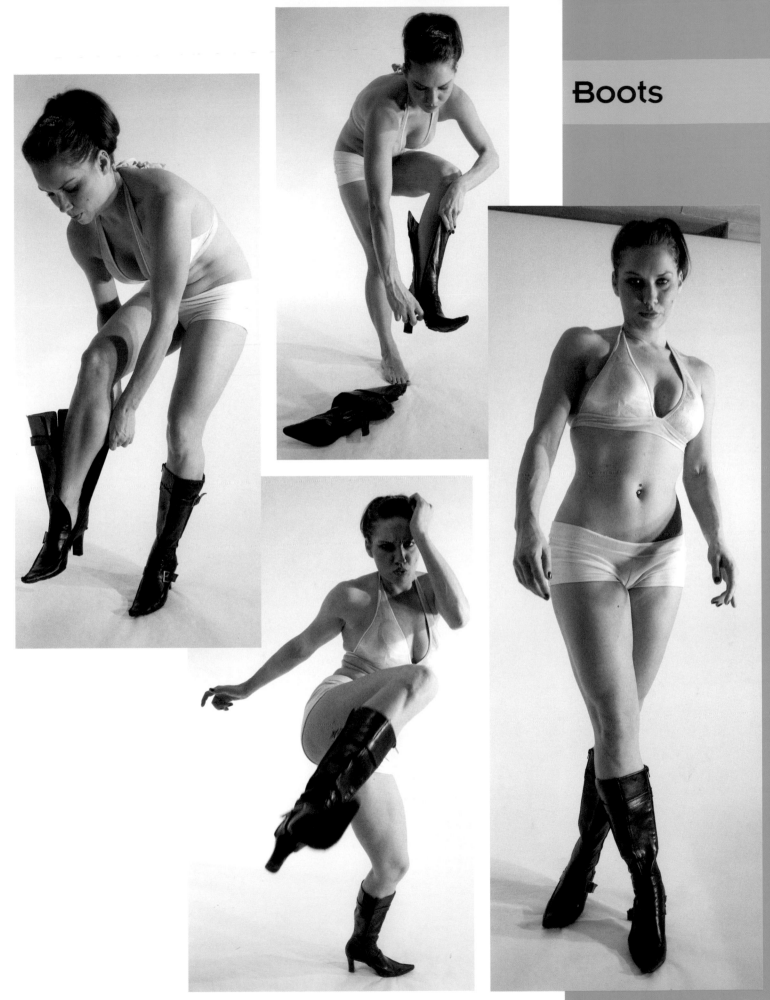

Dressing

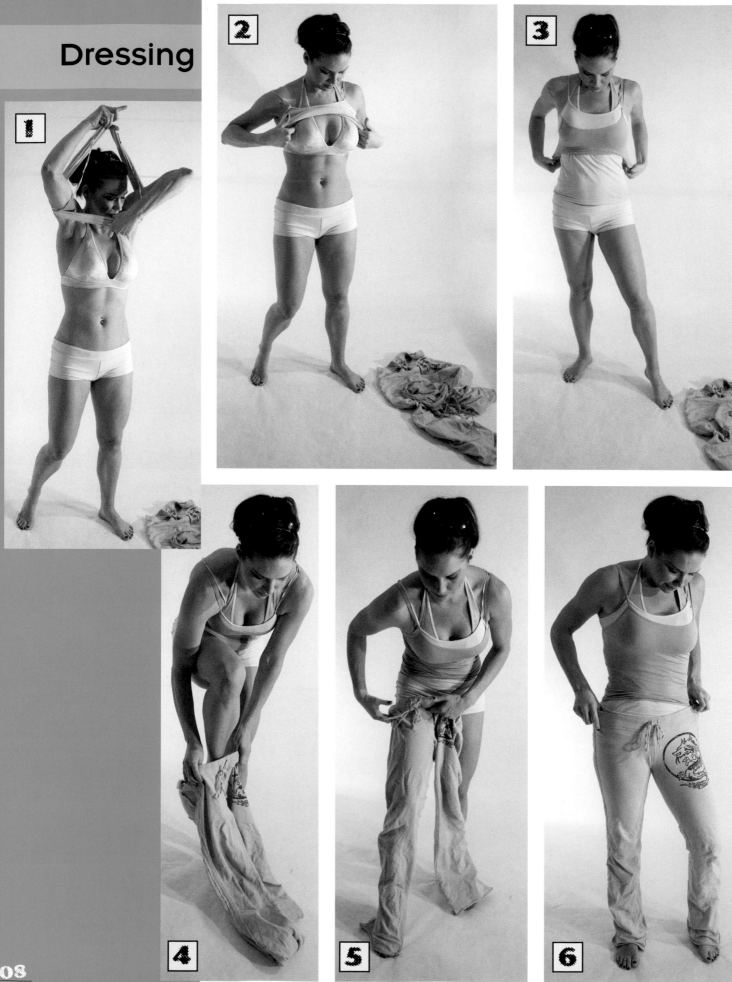

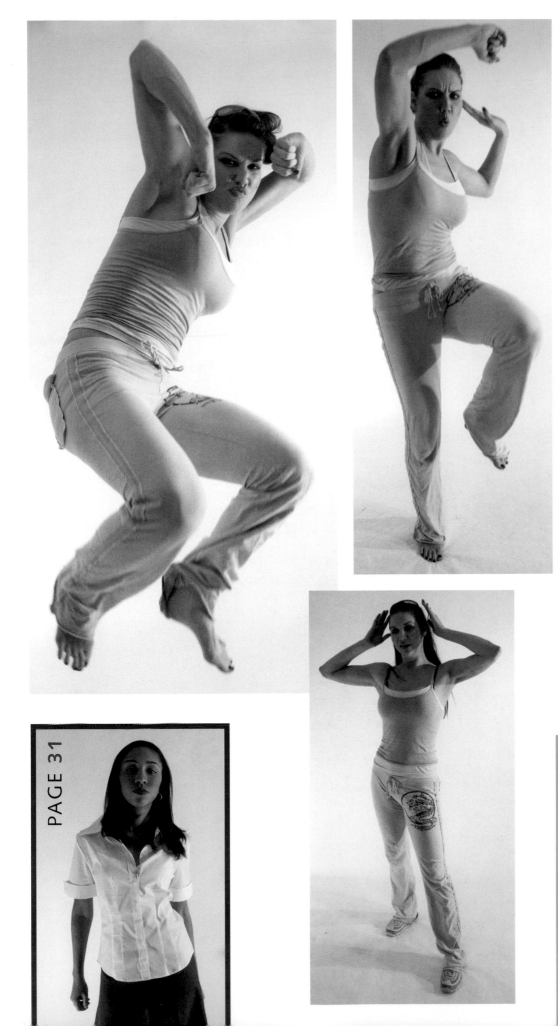

PAGE 31

PAGE 72

Cape

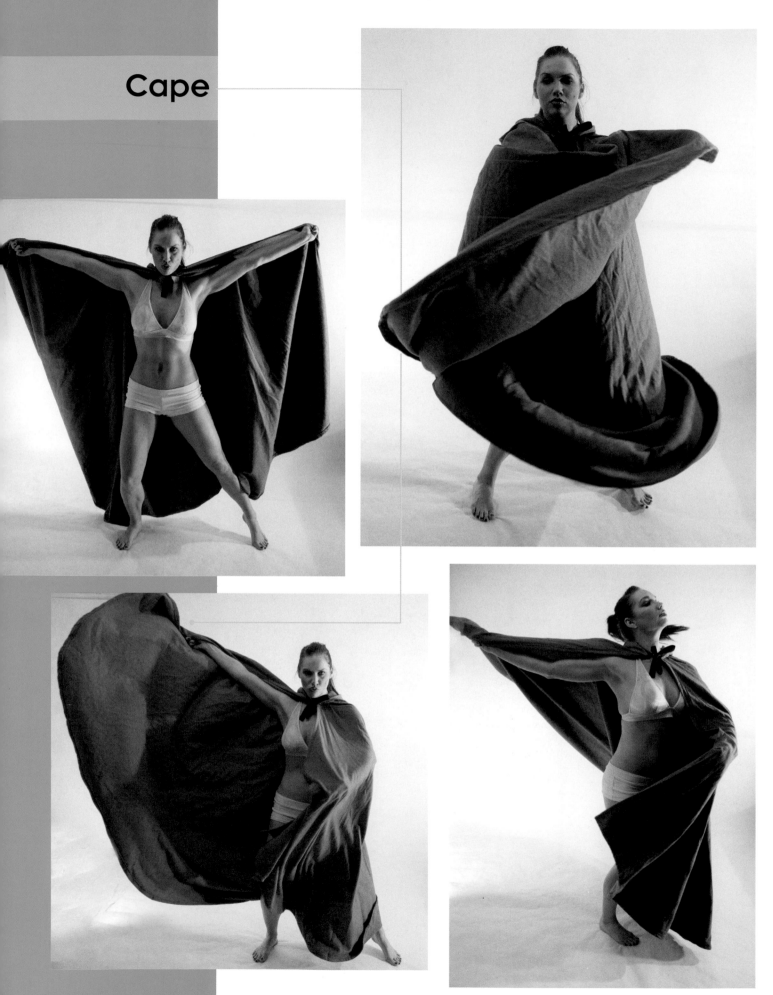

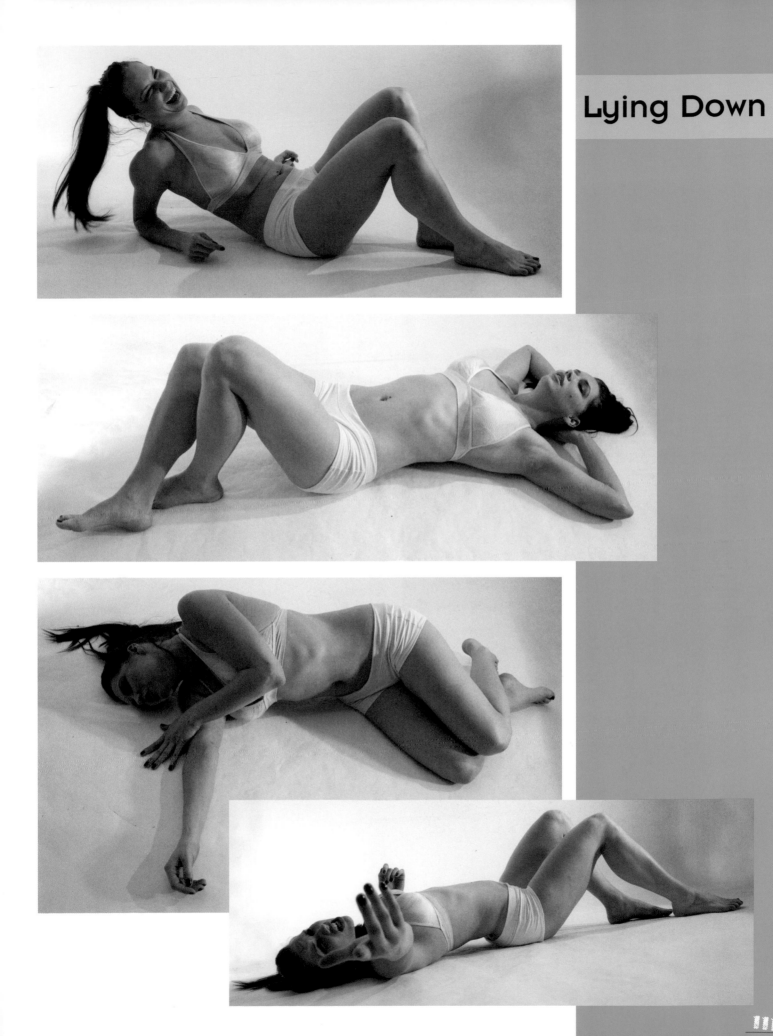

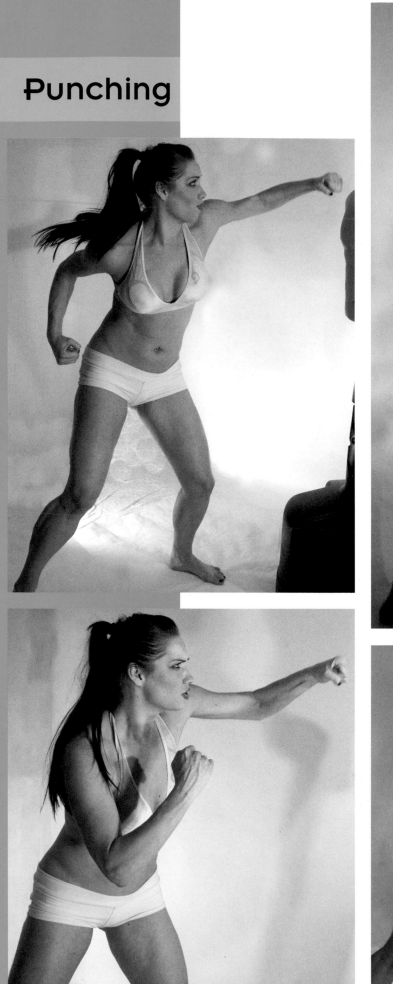

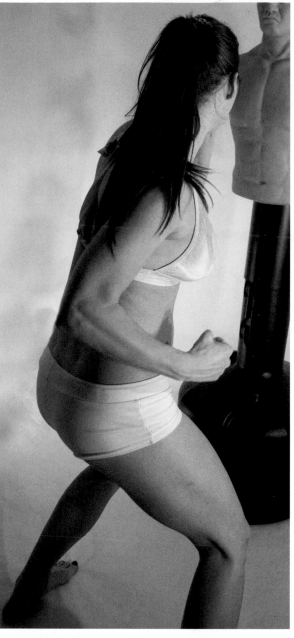

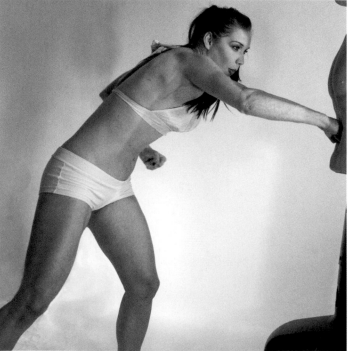

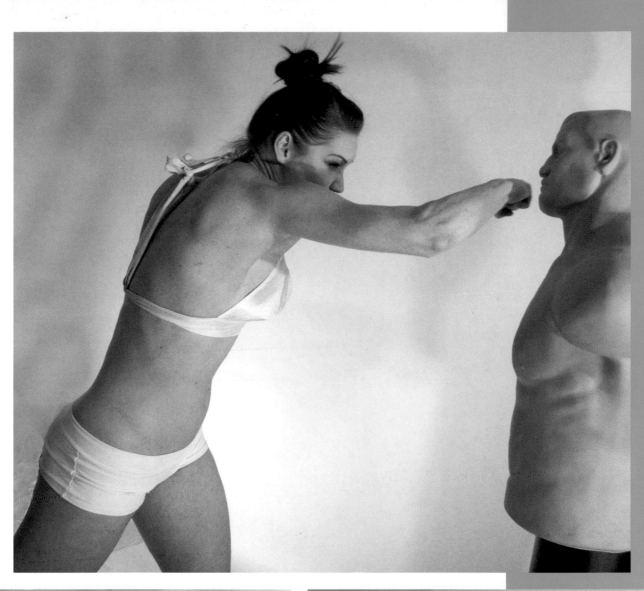

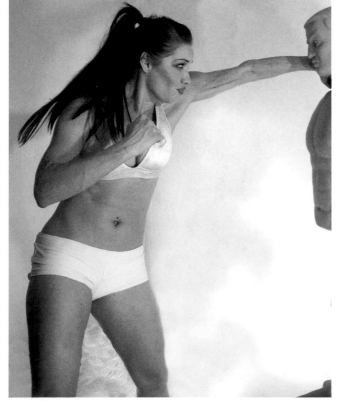

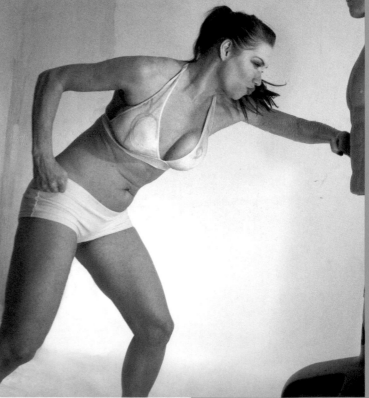

Vanessa

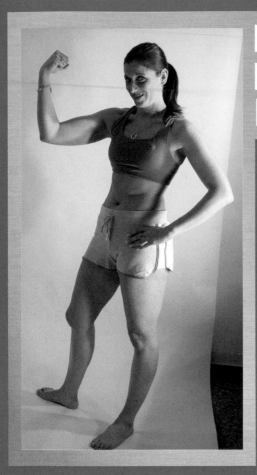

Age: 34

Height: 5' 10" (1.8m)

Weight: 146 lbs. (66kg)

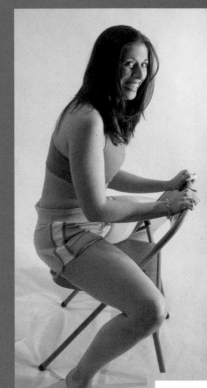

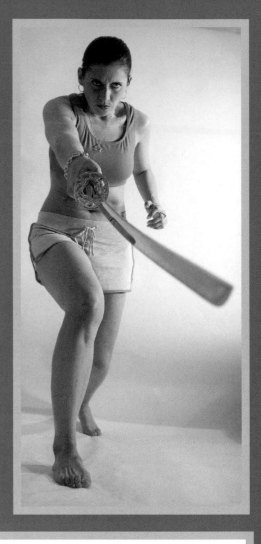

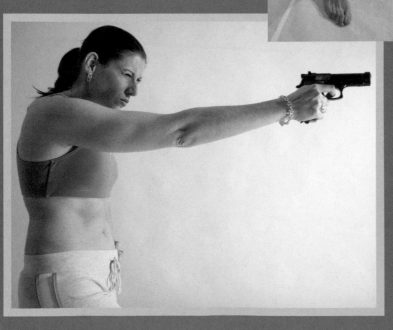

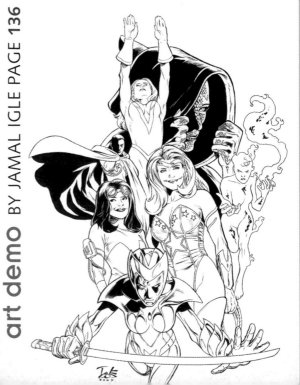

art demo BY JAMAL IGLE PAGE 136

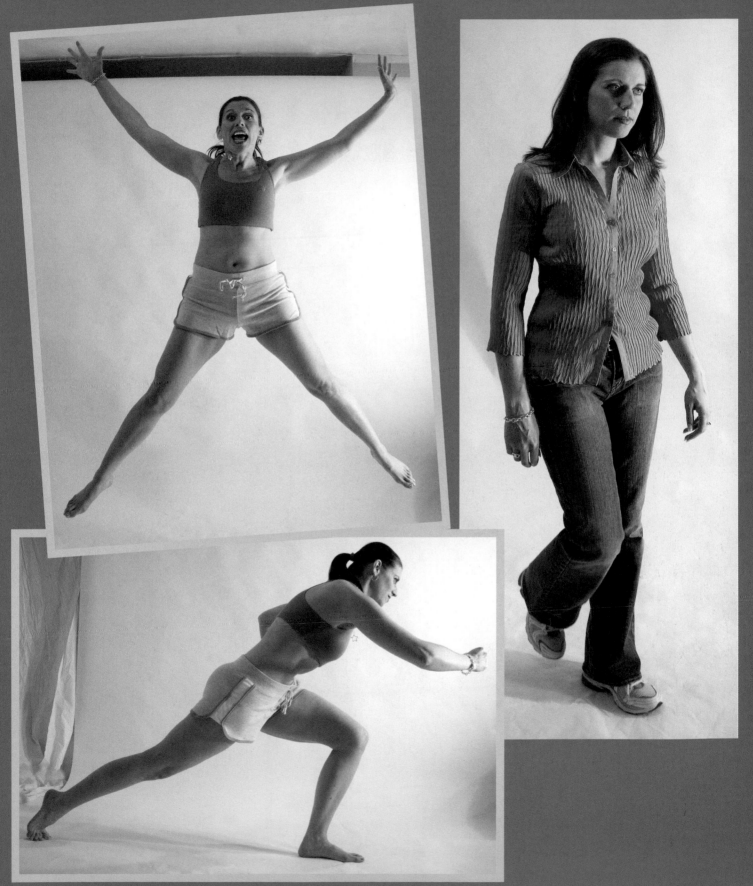

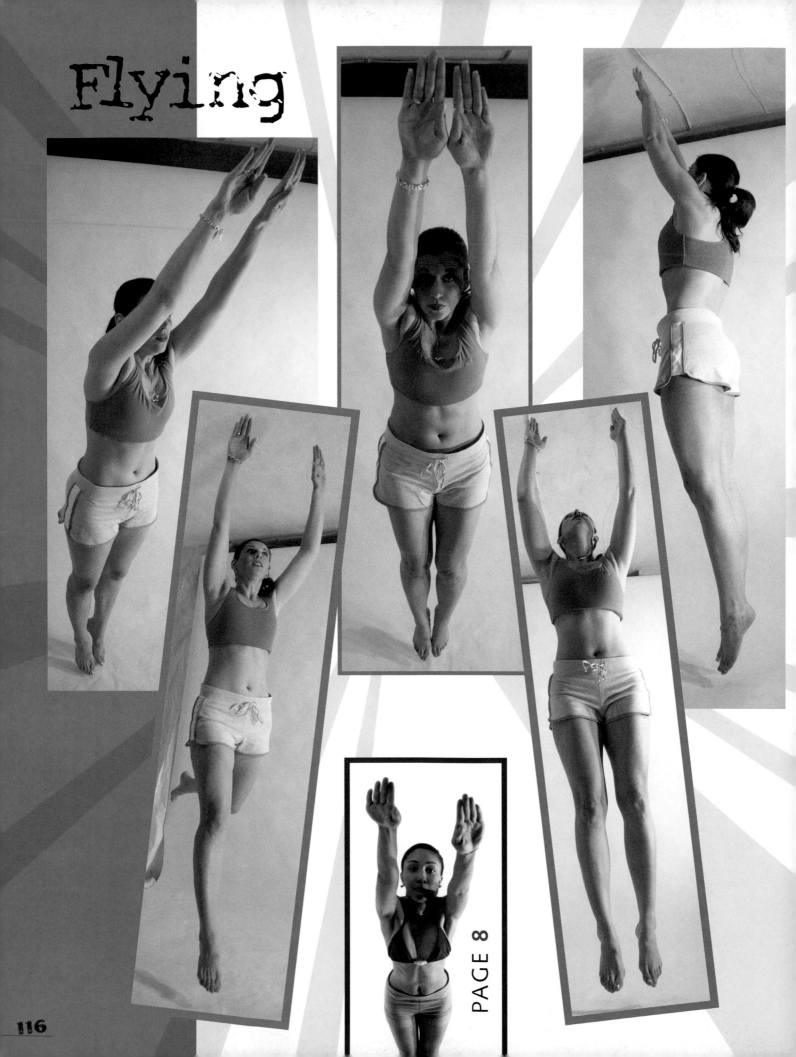

Flying

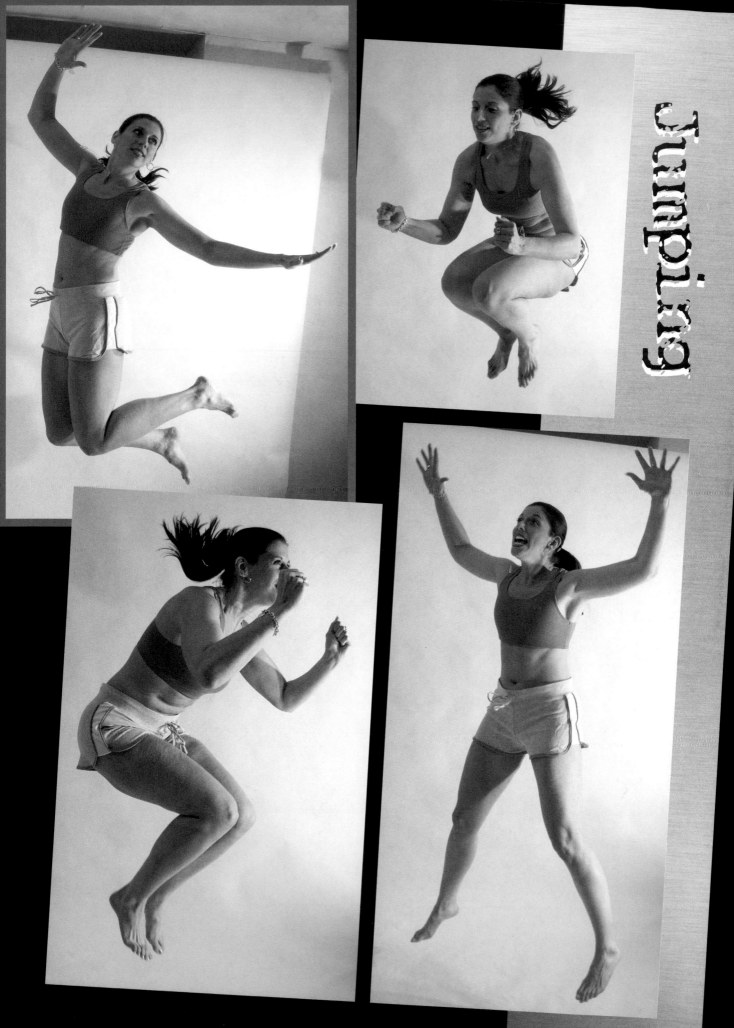

Jumping

Wounded

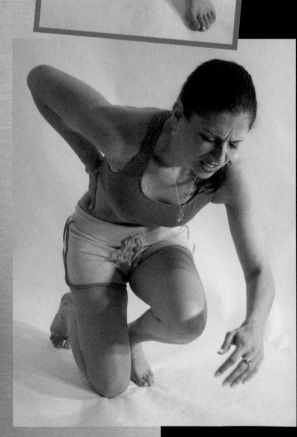

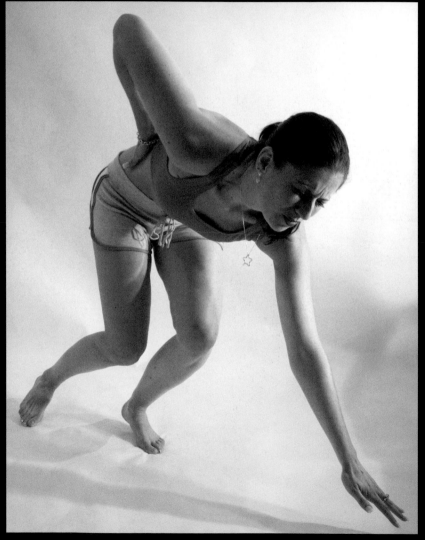

Similar images available on the **CD-ROM**

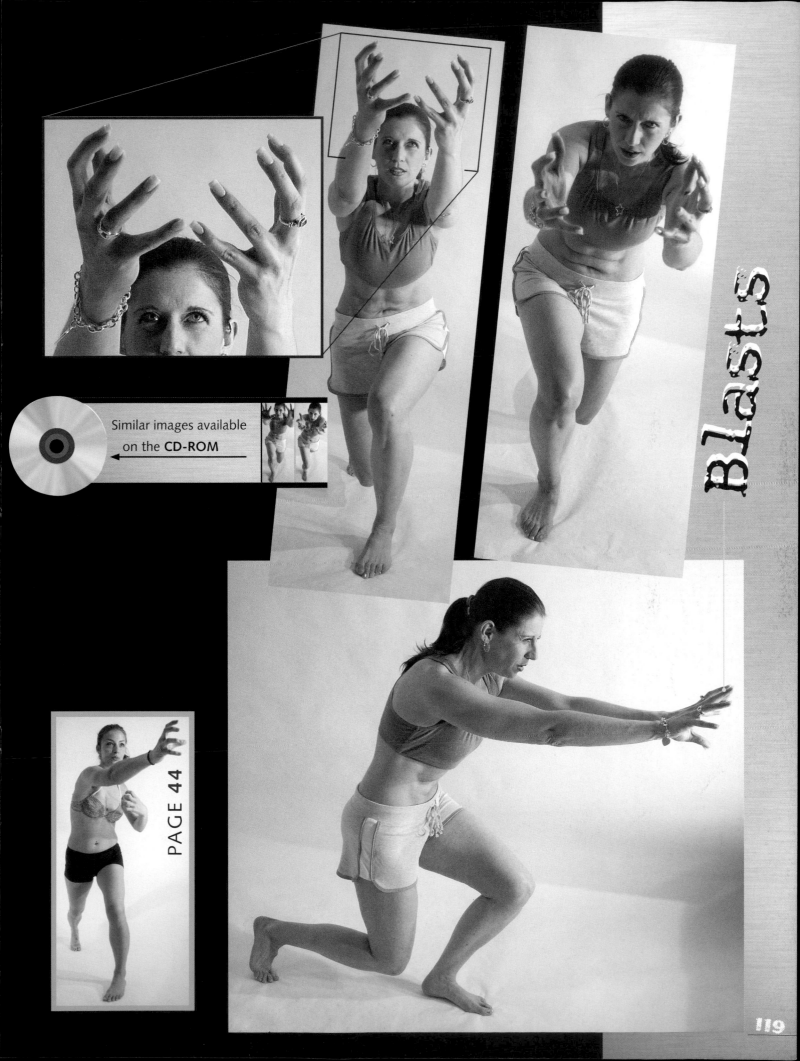

Similar images available on the **CD-ROM**

PAGE 44

Blasts

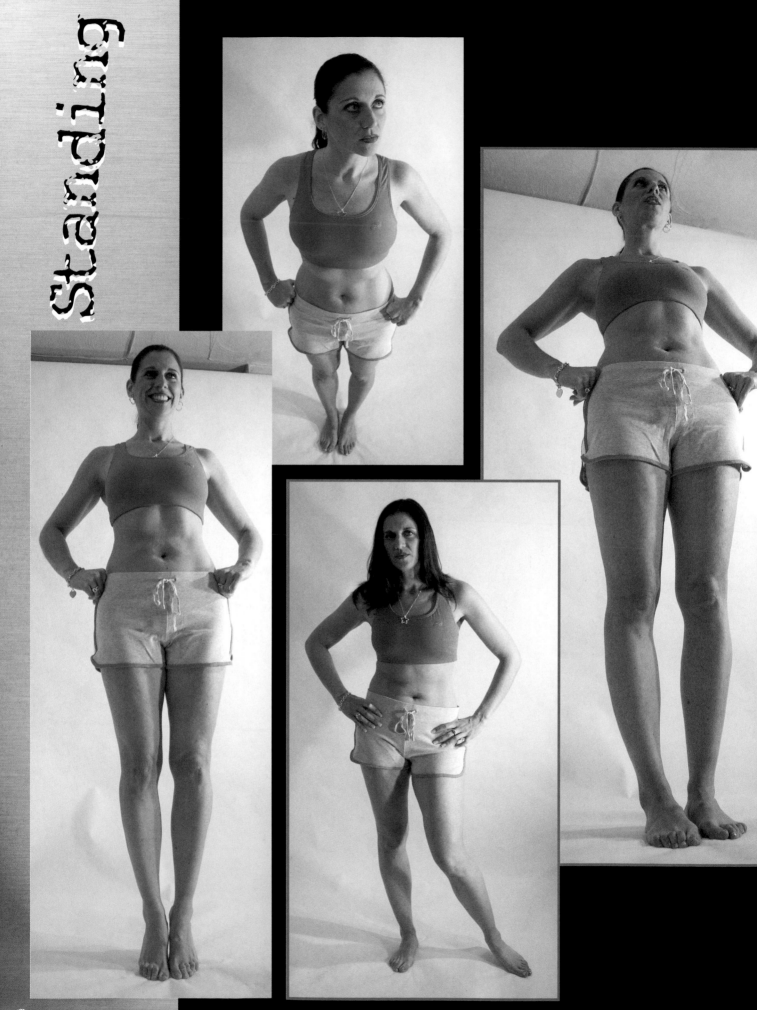

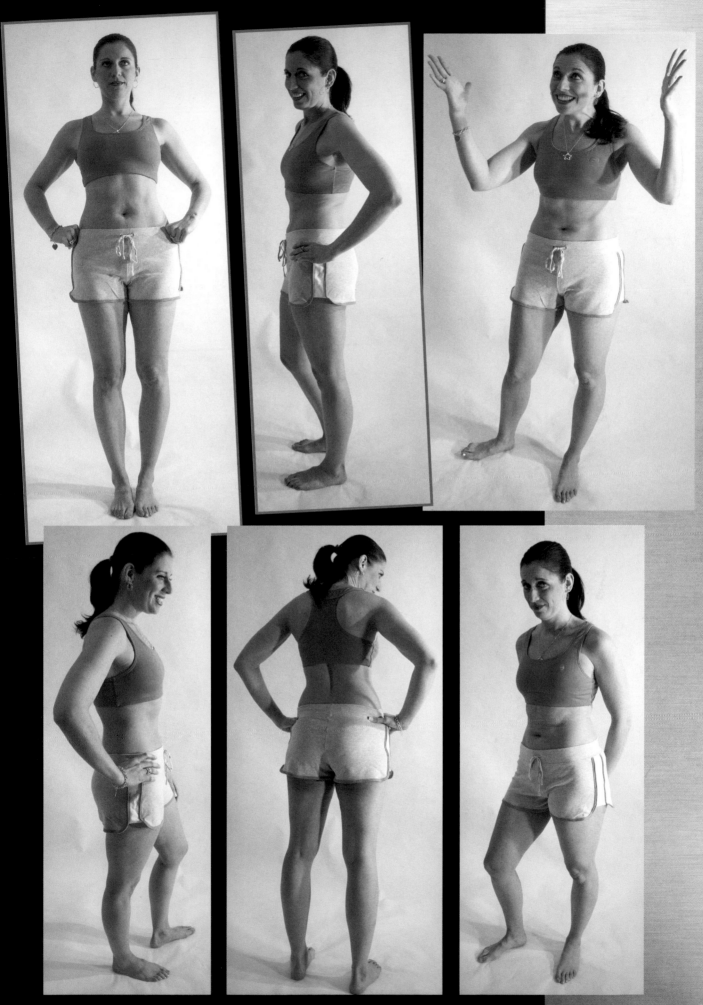

Guns

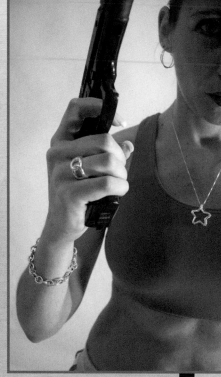

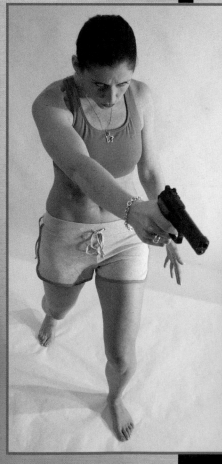

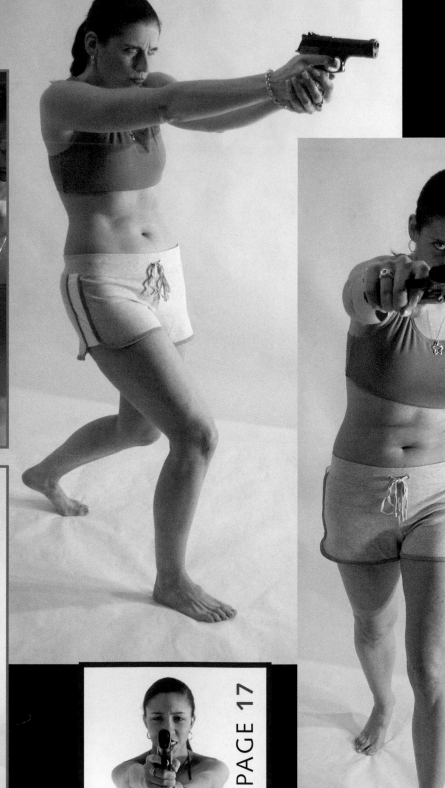

PAGE 17

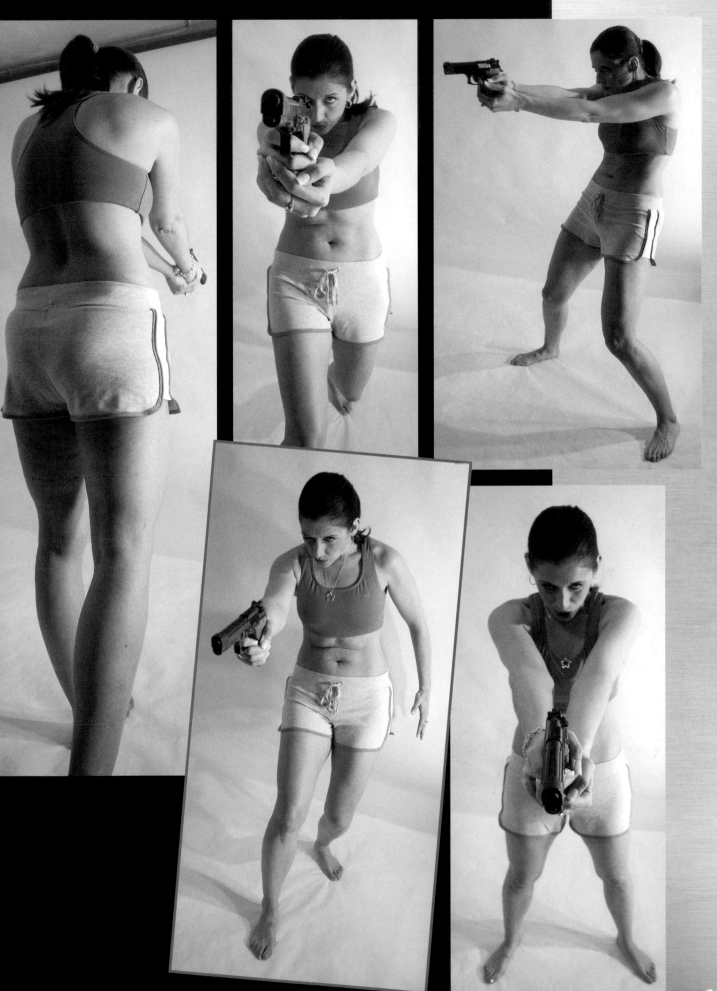

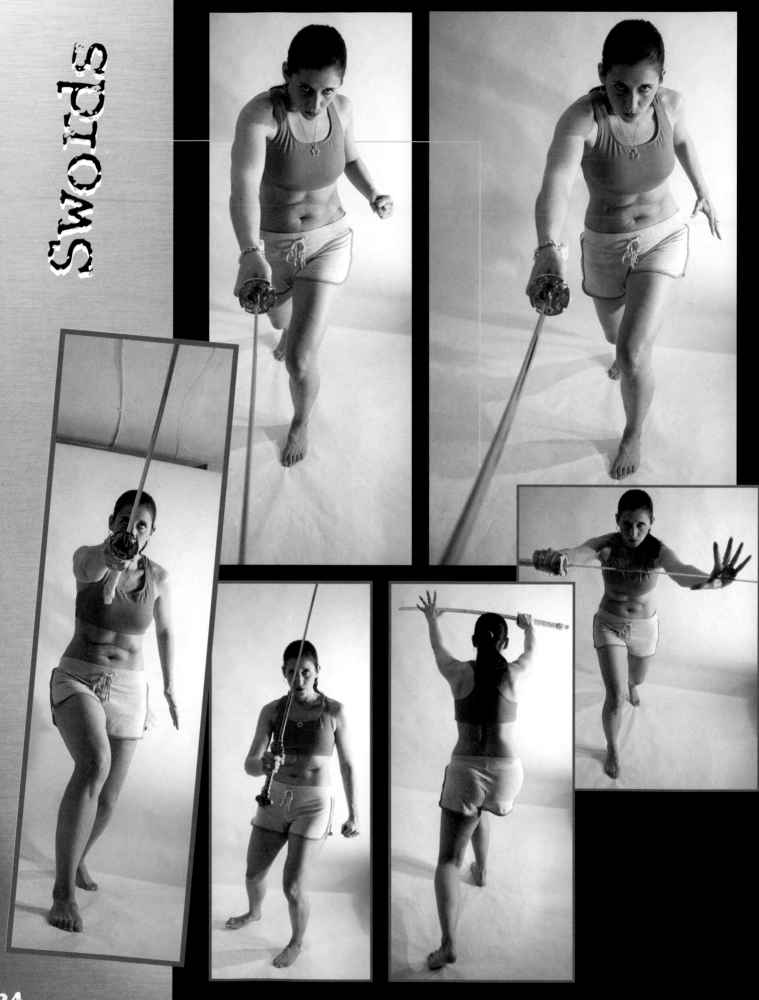

Swords

124

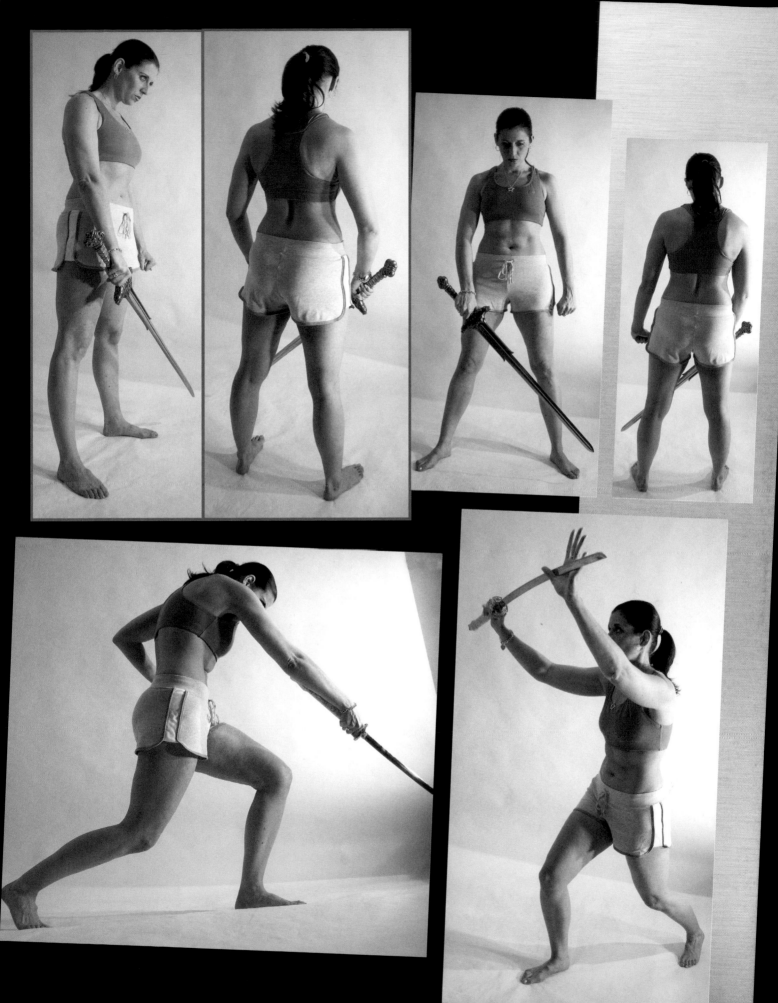

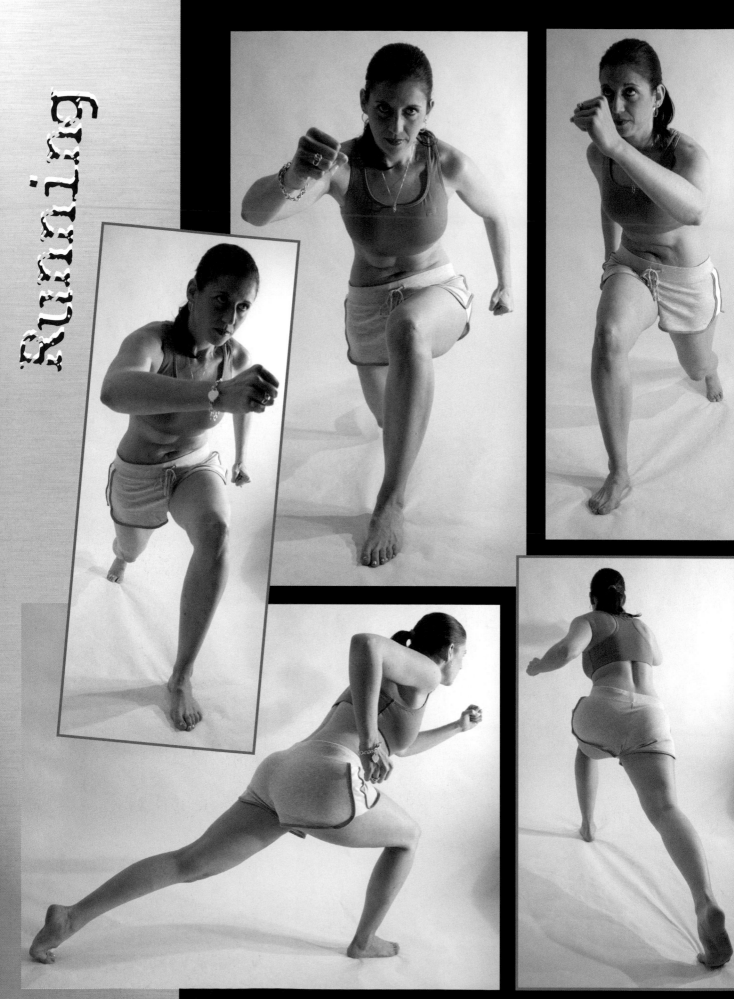

Running

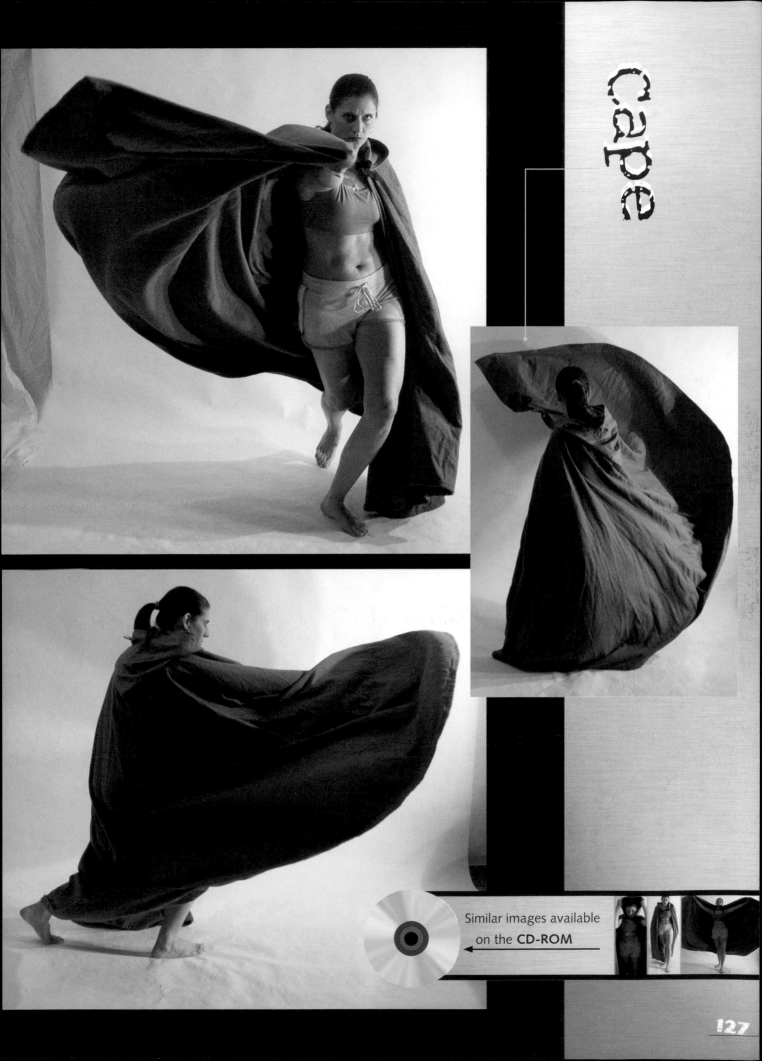

Cape

Similar images available on the **CD-ROM**

Dressing

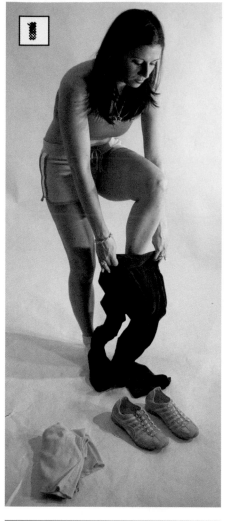

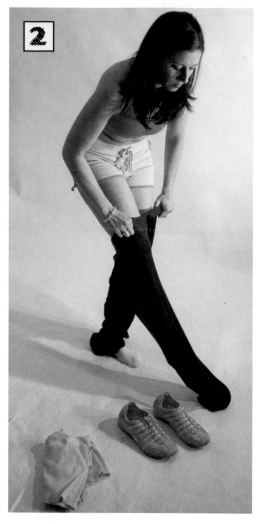

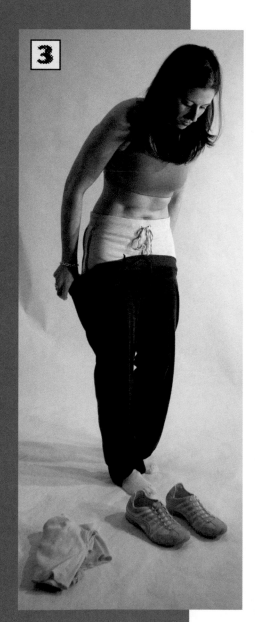

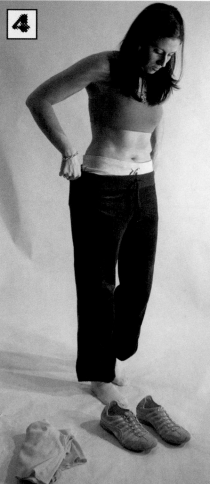

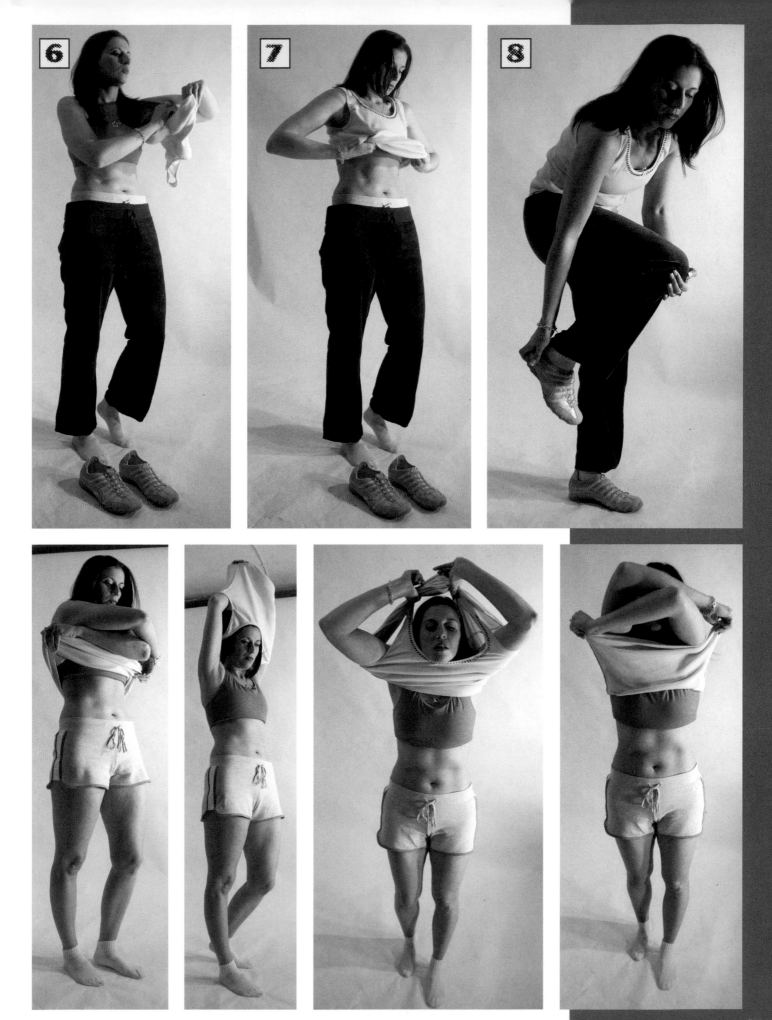

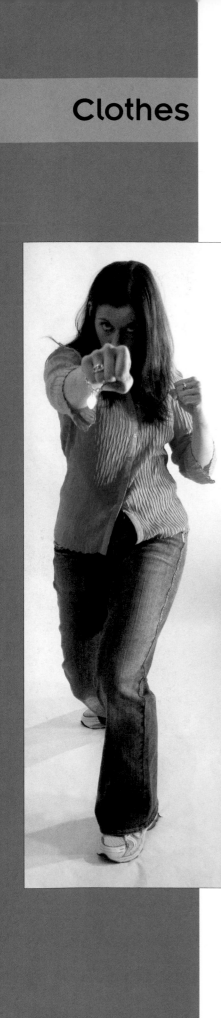

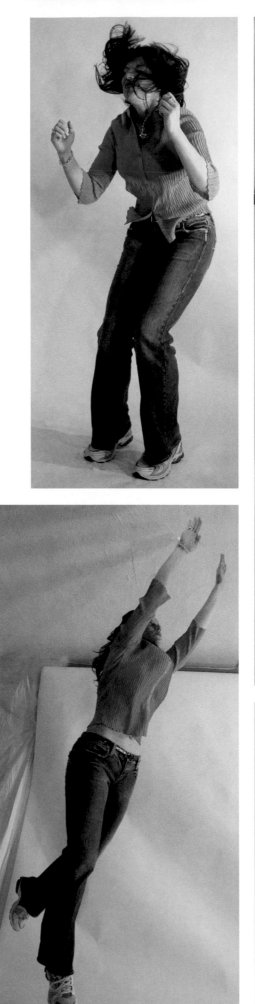

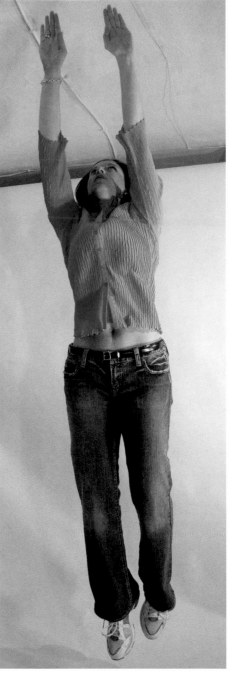

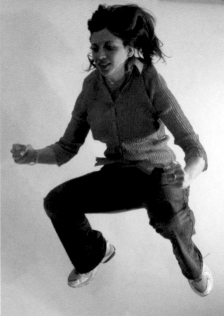

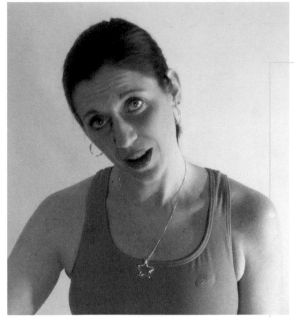

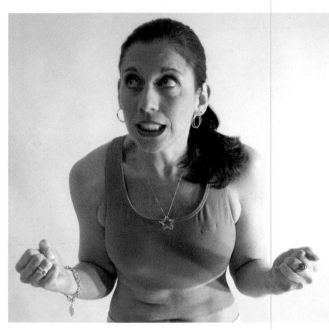

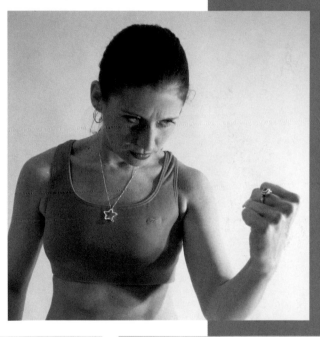

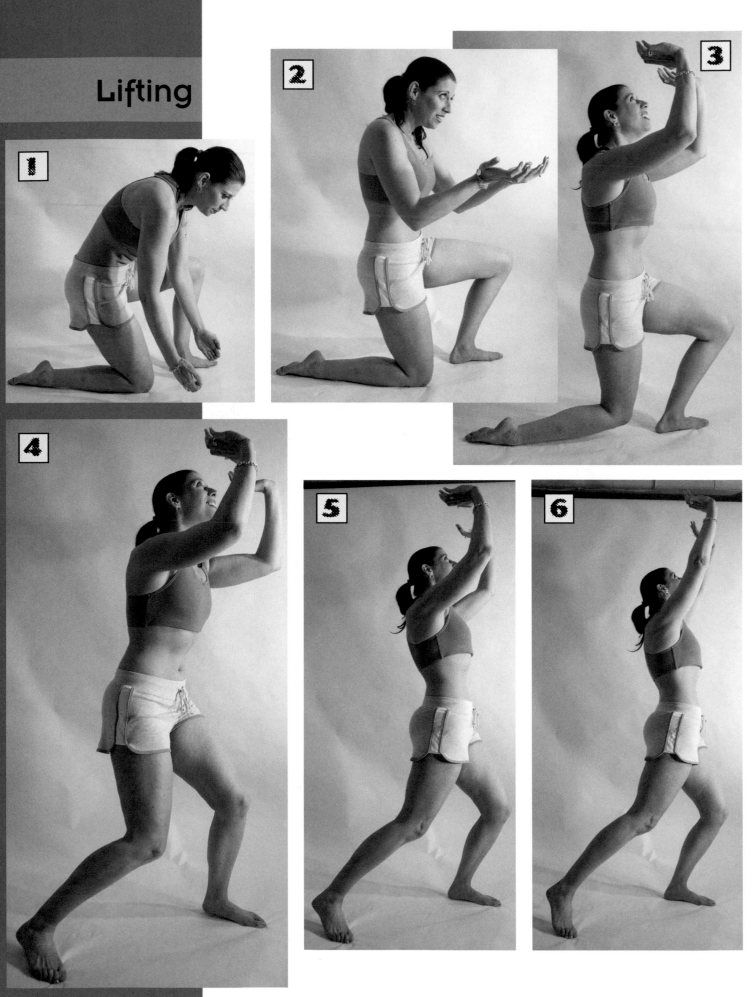

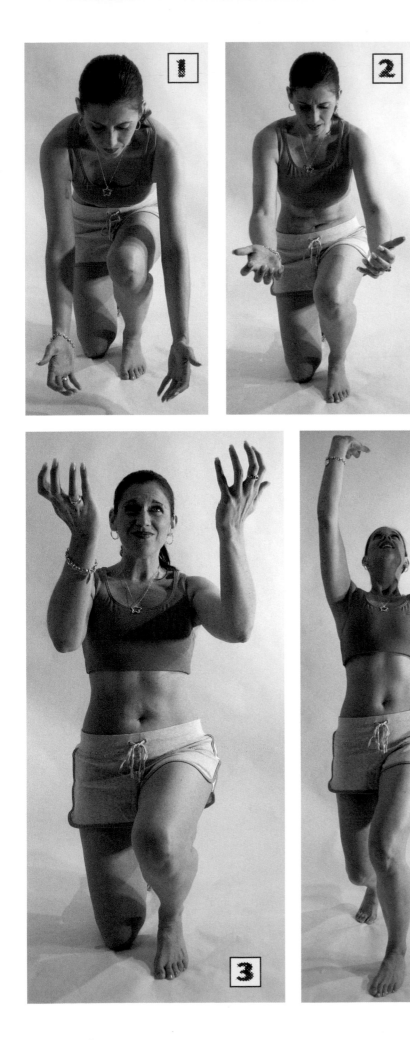

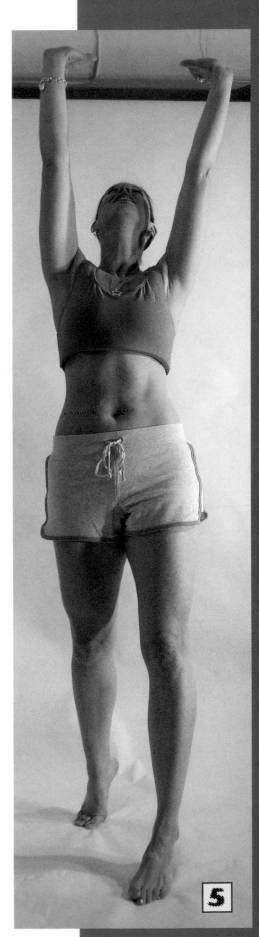

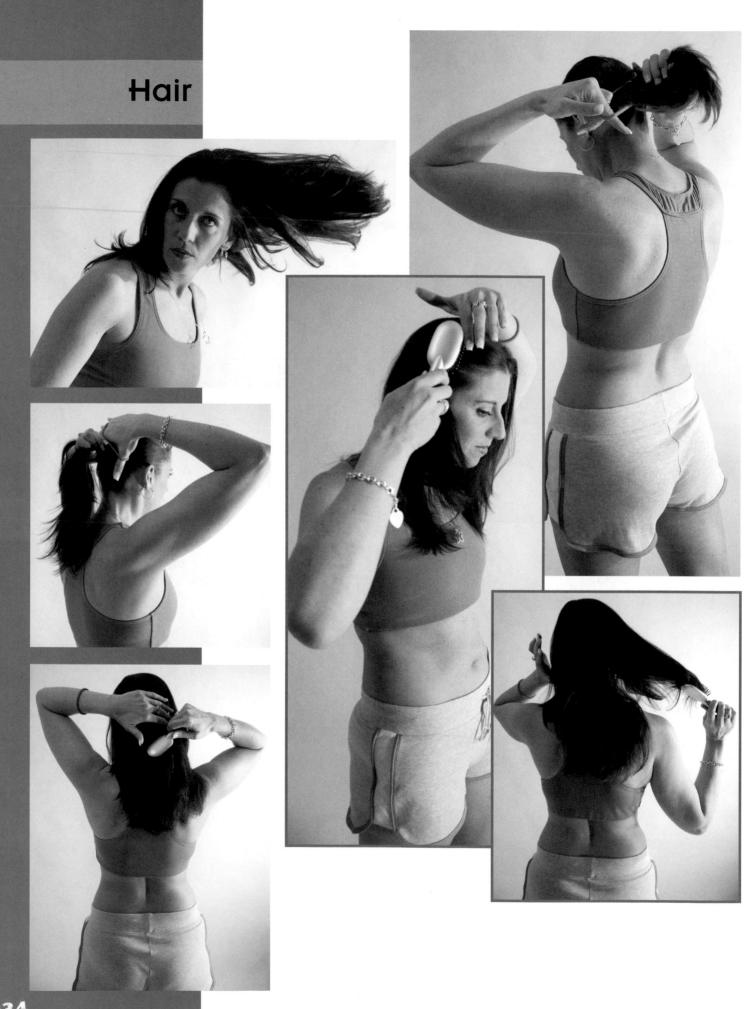

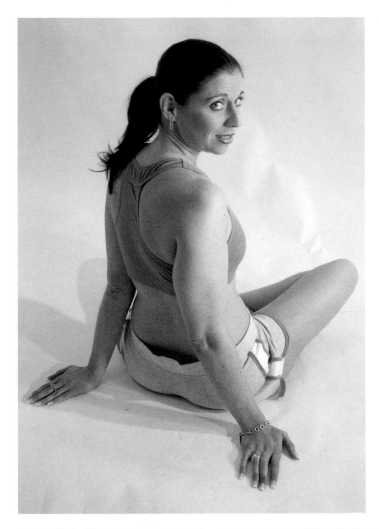

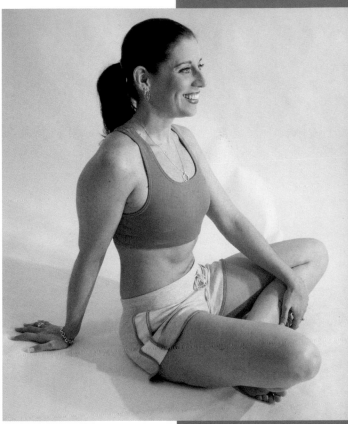

Art Demo

Team of Heroes, Collage-Style

BY JAMAL IGLE

I'm a big fan of collage-style art that features a team of characters—such as Drew Struzan's movie posters for *Indiana Jones*, *Star Wars*, *Harry Potter* and many others. I'm going to show you how to design a collage-style team portrait that could be used for a first-issue cover.

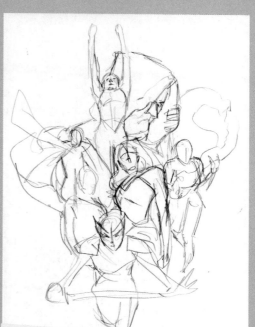

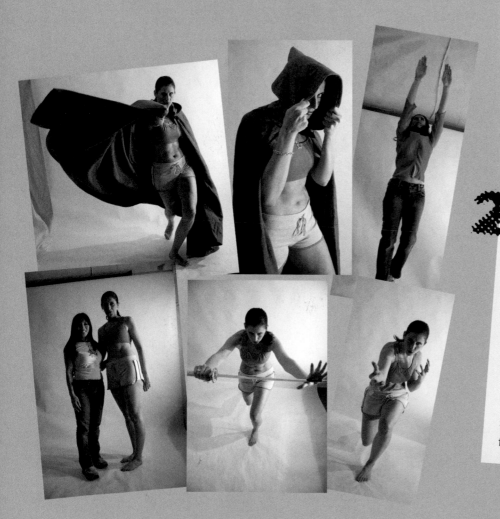

2 Sketch Your Concept

Create a rough sketch of the overall idea. The purpose of this sketch is to plan the placement of all the elements of the collage. At the same time, you are beginning to design your characters' costumes and powers. The idea is to skirt familiar archetypes without using existing characters. The team I'm creating here, "Strikeforce Sappho," includes a star-spangled warrior princess, a samurai droid, a fiery hothead, a high-flying character, a techno-girl, and also a scaly creature whose role is mysterious (is she friend or foe?).

1 Choose a Variety of Photos

Pick at least half a dozen poses to draw from. The members of a comic-book team need to be memorable and distinct from each other, so each photo you choose should show different body language and a different mood. Try to find photos with similar lighting as well, to help unify the images in the collage. As you make your selections, think about what heroic type or personality each photo suggests to you.

As a rule, don't trace reference photos. Draw *from* the photos, not *to* them, so that your natural style flows through.

136

I believe in symmetry in art. As human beings we are drawn to symmetry; it should be a priority for any artist.

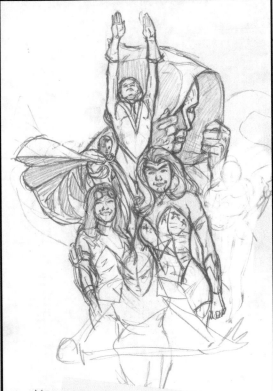

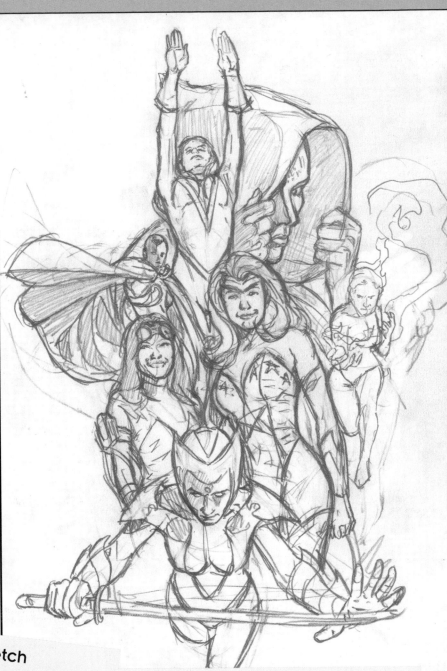

Do a More Detailed Sketch

Sketch again on ordinary copier paper. Continue referring to the photos, but tweak the poses a bit; you don't want to copy them exactly. Your goal should be to capture the lighting and the attitude of the pose. Rough in the details that individualize each character. Create symmetry and balance.

As you place the lights and darks, play with the negative spaces around the characters. The characters in the middle ground and foreground have very few shadows in them. I've put the dark, hooded figure in the background so that its dark tones can peek through the spaces between the other characters. This contrast helps the other characters pop out of the image.

When you feel this sketch is done, put down your pencil and just look things over. Is the lighting the way you want it? Is there anything about the design that needs tweaking to make it more balanced or more exciting? Make any needed changes.

Rough In With Nonphoto Blue

Enlarge the sketch from step 3 on a photocopier from 8½"
× 11" (22cm × 28cm) to 11" × 17" (28cm × 43cm), a 140
percent enlargement. Tape the photocopy face down on
the back of a sheet of 11" × 17" (28cm × 43cm) blueline
board or any two-ply bristol board. Turn the board face
up, lay it on a light table, and transfer the sketch onto the
board with a nonphoto blue pencil. This kind of pencil
won't reproduce when scanned or photocopied, so it is
an ideal base for your final drawing. You can make minor
tweaks to the drawing as you go.

When you're done transferring your sketch, use a gum
eraser to remove all nonessential lines. Nonphoto blue
pencils, being wax-based, don't take graphite pencil very
well, so you want the finished blueline drawing to be very
light and unobtrusive.

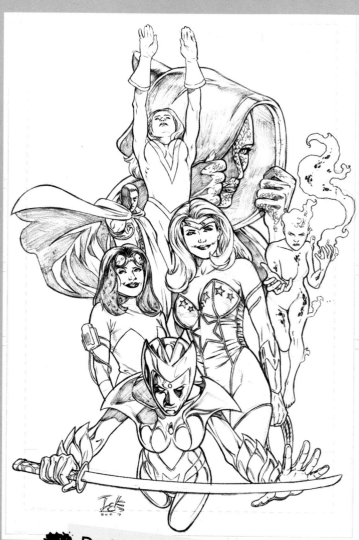

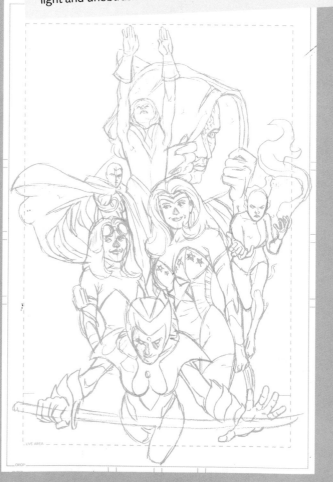

Do the Pencils

Draw on top of the blueline drawing with an HB pencil.
As you're pencilling, you may find yourself redrawing a
bit. This stage can be a long process because as you're
penciling, you're sometimes redrawing, making the final
determination about how the art will look.

Tighten the pencil drawing until it contains all the
information you'll need for inking.

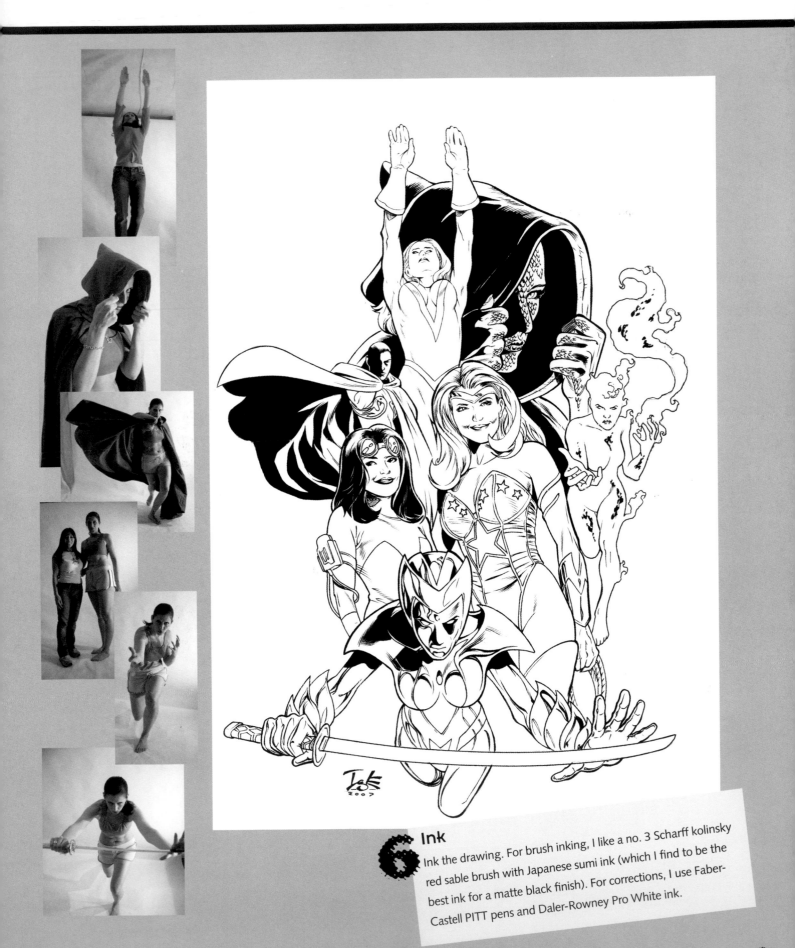

6 Ink

Ink the drawing. For brush inking, I like a no. 3 Scharff kolinsky red sable brush with Japanese sumi ink (which I find to be the best ink for a matte black finish). For corrections, I use Faber-Castell PITT pens and Daler-Rowney Pro White ink.

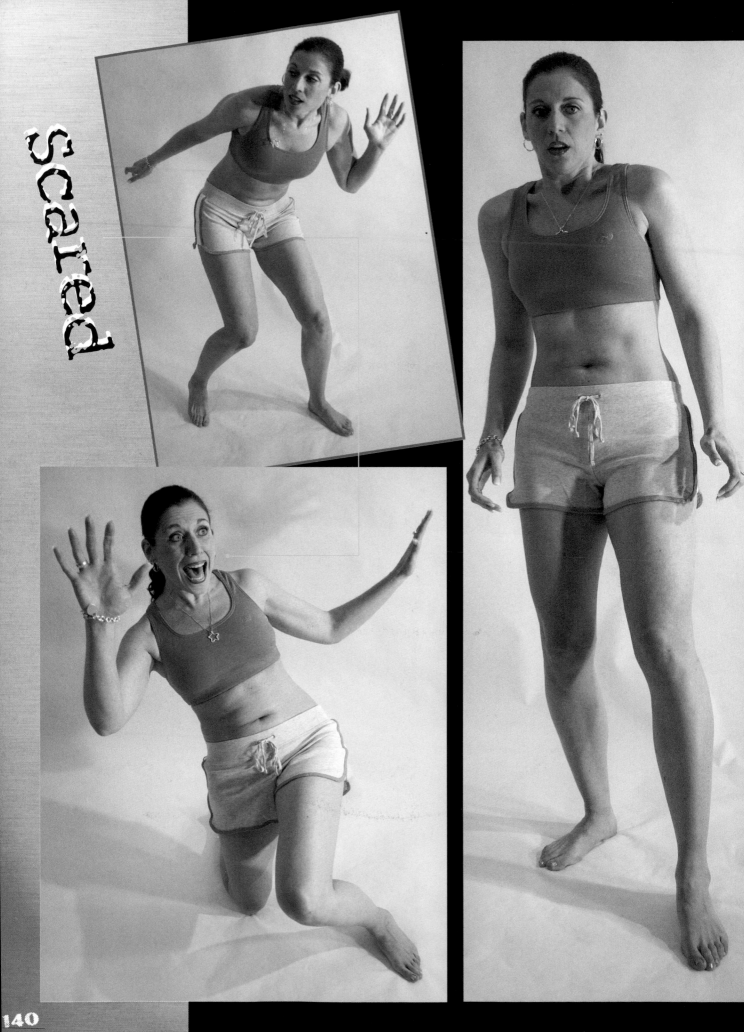

Scared

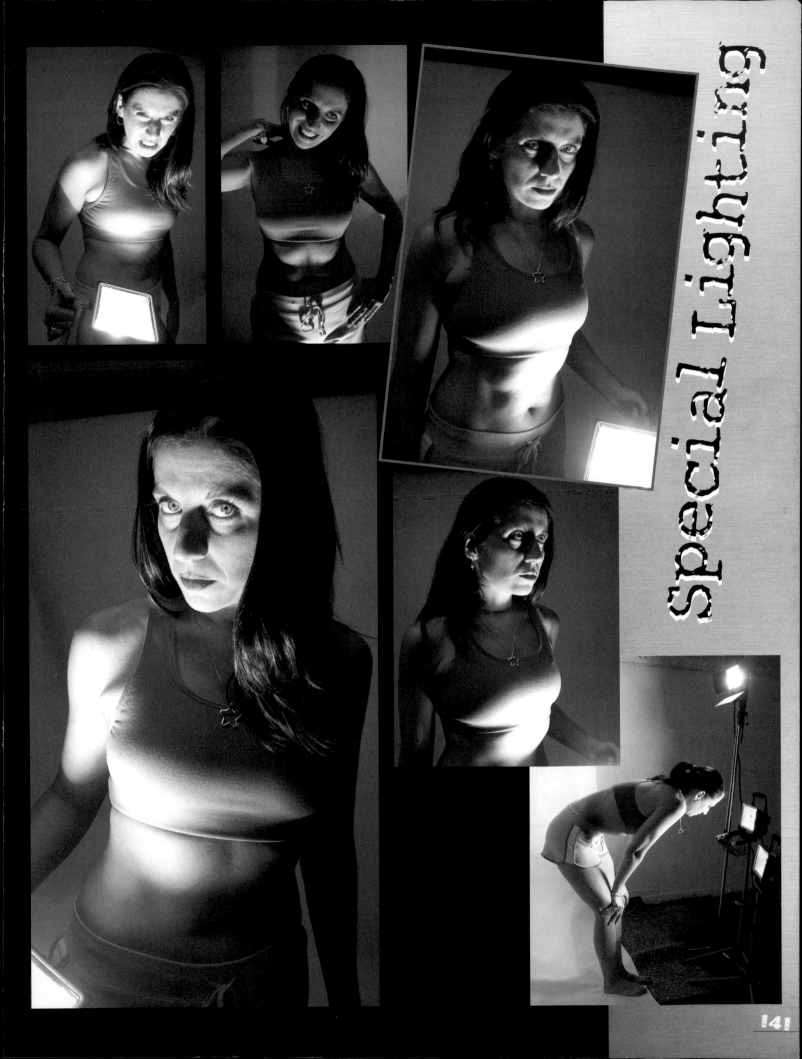

about the artists

Artist photos supplied by the artists.

JG Jones is one of the most exciting and influential cover artists working in comics today. His art has appeared on countless covers, including DC's *52*, *Wonder Woman* and *Y: the Last Man*; Marvel's *Marvel Boy*; and *Wizard* magazine. The depth, texture and energy that he brings to his artwork are simply stunning. His use of color brings power and impact to every image. I've been fortunate enough to know JG many years, so I've seen his work develop and mature. He is a true gentleman and one of the nicest people I've ever met in this business. I'm incredibly proud that JG's artwork is featured on the cover of this project. Check out the progression of his cover on page 92 to see how he works his magic.

Terry Moore is an accomplished and revered comic writer-artist. His award-winning series *Strangers in Paradise* stands as one of the finest stories ever to be published in the medium. I'd first discovered Terry's work when SiP was bubbling up as an underground sensation. Even then, his art and writing could steal your breath away. As you read his lesson on page 73, you will understand why Terry is a modern master of the art form. He reveals how he not only draws the model but actually thinks about her as a person. I've known Terry for many years, and I'm thrilled and honored to have him be part of this project.

When I first discovered his work, **Jamal Igle** was a young kid breaking in on a respected indie comic called *Blackjack*. Even then, he had an incredible sense of energy and motion. Jamal is known for his influential art on *Green Lantern*, *New Warriors*, *Firestorm*, *Nightwing* and his own co-created book, *Venture*. He's drawn hundreds of pages for Marvel, DC and Image, yet he remains accessible to his fans. Early in his career, I tried to snag Jamal for a small, indie comic I wanted to publish, but our schedules didn't cooperate. Fortunately we got to work together on the lesson on page 136, where you'll see Jamal go above and beyond the call of duty. I asked for a drawing of one woman, and Jamal gave me an entire superteam.

Josh Howard stormed the indie comic scene with his creator-owned *Dead@17*, in which he skillfully blended modern horror, action and gorgeous women all in one fun story. Everything Josh draws is so fluid and natural—cartoony, yet rooted in realism. It's amazing what he accomplishes with a few well-placed lines. He seamlessly meshes several art styles to produce a look that is unique and exciting. I'd never met Josh prior to this project, but I jumped at the chance to see how he would interpret my photographs. Check out his lesson on page 20 to see how he combines fun and danger in one subtle illustration.

the book team

Bob
Stunt Double

Pam Wissman
Acquisitions Editor

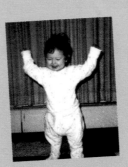

Amy Jeynes
Editor

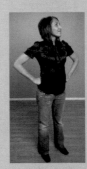

Terri Woesner
Cover Designer

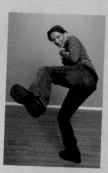

Kelly Piller
Design Intern

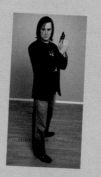

Nancy Harward
Copyeditor

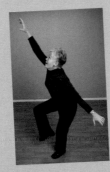

Matt Wagner
Production Coordinator

Aric Lui (left)
Customer Service Assistant
Leo Wong (right)
Customer Service Officer
Regent Publishing Services, Ltd.,
Hong Kong

The Women of IMPACT

If you're going to create comics—do it with *IMPACT*

IMPACT

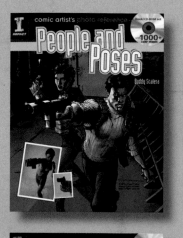

Comic Artist's Photo Reference: People and Poses
by Buddy Scalera
ISBN-13: 978-1-58180-758-5
ISBN-10: 1-58180-758-9
Paperback, 144 pages, #33425

The ultimate reference for comic artists, this unique book/CD set is packed with photos of men and women in basic and dramatic superhero poses uniquely tailored to the comic artist's needs.

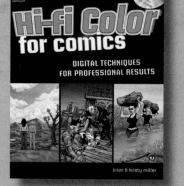

Hi-fi Color for Comics: Digital Techniques for Professional Results
by Brian and Kristy Miller
ISBN-13: 978-1-58180-992-3
ISBN-10: 1-58180-992-1
Paperback, 160 pages, #Z0939

This exciting and complete instructional package starts with the basics and progresses through step-by-step demos that will take you from line art to full, awe-inspiring color. Includes instruction on equipment, scanning, setting up pages, color theory, flattening, rendering, special effects, color holds, color separations, and even details on the business of becoming a professional colorist. The CD-ROM includes Photoshop tools and actions that artists can use to streamline their coloring work, plus professionally drawn bonus art to practice coloring.

ABOUT THE CD-ROM

I shot over ten thousand pictures for this book. We included the best images on the pages, but we were still left with hundreds of unseen photographs.

This CD-ROM is packed with more than six hundred alternate photos of the actors in different poses. So if you see something in the book that isn't quite what you are looking for, pop the disc into your computer.

If there's a straight-on pose in the book, the CD-ROM may have that same pose from a bird's-eye view. Or from a worm's-eye view. Or even from behind. In some cases, there may be a slightly different lighting scenario, as I moved the lights around the studio.

You'll discover some intriguing bonus material on the disc, like funny outtakes and other behind-the-scenes shots. We've even got videos of some of the actors to give you a sense of how they actually move in real life.

Buddy